ns
PORTRAYING THE GURU

Portraying the Guru

ART, DEVOTION AND IDENTITY IN SIKHISM

ATSUSHI IKEDA

BOYDELL·MANOHAR

© Atsushi Ikeda, 2024

All Rights Reserved. Except as permitted under current legislation no part of this work may be photocopied, stored in a retrieval system, published, performed in public, adapted, broadcast, transmitted, recorded or reproduced in any form or by any means, without the prior permission of the copyright owner

The right of Atsushi Ikeda to be identified as the author of this work has been asserted in accordance with sections 77 and 78 of the Copyright, Designs and Patents Act 1988

ISBN 978-81-19139-94-1 (Manohar Publishers & Distributors)
ISBN 978-1-83765-238-9 (Boydell ♦ Manohar)

First published 2024 by
Ajay Jain for
Manohar Publishers & Distributors
4753/23 Ansari Road, Daryaganj
New Delhi 110 002

First published Worldwide excluding India, Sri Lanka, Nepal, Bangladesh, Afghanistan, Pakistan and Bhutan, 2024 by Boydell ♦ Manohar
A joint imprint of Boydell & Brewer Ltd and
Manohar Publishers & Distributors
PO Box 9, Woodbridge, Suffolk IP12 3DF, UK
and of Boydell & Brewer Inc.
668 Mt Hope Avenue, Rochester, NY 14620–2731, USA
website: www.boydellandbrewer.com

A CIP catalogue record for this book is available
from the British Library

The publisher has no responsibility for the continued existence or accuracy of URLs for external or third-party internet websites referred to in this book, and does not guarantee that any content on such websites is, or will remain, accurate or appropriate

Typeset by Ravi Shanker, Delhi 110095

Contents

List of Illustrations 7

Acknowledgements 23

Introduction 25

1. History of Sikhism and the Punjab Region 59
2. Early Sikh Imagery in Narrative Painting 78
3. Portraiture of Guru Nanak till 1849 112
4. Portraiture of Later Gurus up to 1849 157
5. Colonial Portraiture of the Sikh Gurus 217

Conclusion 253

Bibliography 261

Index 275

Illustrations

I.1 Guru Nanak Darbar. Rajpura, Punjab, India. 26

I.2 Receptionist at a hotel in Punjab, India. 27

I.3 *Guru Nanak Dressed in an Inscribed Robe.* Lahore. Late nineteenth century. 36 × 28.6 cm. Government Museum and Art Gallery, Chandigarh. Acc. no. 2401. Goswamy (2006), plate 2.1. 29

I.4 *Guru Nanak in an Ashirwad Pose.* A digital print of the most popular Guru Nanak portrait. Purchased from the artist Sohan Singh, Amritsar. Photographed by the author in October 2010. The original was painted by Sobha Singh in 1964 (as cited in Kaur [1990]). 29

2.1 *Baba Nanak and Mardana with a Sikh.* From the B-40 set of *Janam-sakhi* paintings. By Alam Chand. Punjab. 1733. Gouache on paper. Hans (1987), plate 11. 83

2.2 *Baba Nanak and Mardana, Three Jogeshwaras with Kamla.* From the B-40 set of *Janam-sakhi* paintings. By Alam Chand. Punjab. 1733. Gouache on paper. Hans (1987), plate 57. 85

2.3 *Baba Nanak, Abdul Rehman, Mian Mitha and Mardana.* From the B-40 set of *Janam-sakhi* paintings. By Alam Chand. Punjab. 1733. Gouache on paper. Hans (1987), plate 7. 87

2.4 *Baba Nanak in the Presence of God.* From the B-40 set of *Janam-sakhi* paintings. By Alam Chand. Punjab. 1733. Gouache on paper. Hans (1987), plate 28. 89

List of Illustrations

2.5 *Janam-sakhi*. Artist unknown. Punjab. Eighteenth century. 50.8 × 63.5 cm. Black ink on paper. The Samrai Collection, London. Goswamy (2006), plate 1.29. — 90

2.6 *Baba Nanak and Mardana with Dancing Pathans*. From the B-40 set of *Janam-sakhi* paintings. By Alam Chand. Punjab. 1733. Gouache on paper. Hans (1987), plate 16. — 92

2.7 *Baba Nanak and Mardana with Fakirs on their way to Mecca*. From the B-40 set of *Janam-sakhi* paintings. By Alam Chand. Punjab. 1733. Gouache on paper. Hans (1987), plate 30. — 93

2.8 *Baba Nanak Gave Boons to the Visitors*. From the B-40 set of *Janam-sakhi* paintings. By Alam Chand. Punjab. 1733. Gouache on paper. Hans (1987), plate 25. — 94

2.9 *Baba Nanak and Mardana in a Country*. From the B-40 set of *Janam-sakhi* paintings. By Alam Chand. Punjab. 1733. Gouache on paper. Hans (1987), plate 37. — 96

2.10 *A King Pays Homage to Guru Nanak*. From the Guler set of *Janam-sakhi* paintings. Attributed to the Seu-Nainsukh workshop. Pahari. Last quarter of the eighteenth century. 22.6 × 16.5 cm. Opaque watercolour on paper. Acc. no. 4072(3), Government Museum and Art Gallery, Chandigarh. Goswamy (2006), plate 1.7. — 100

2.11 *Guru Nanak in Conversation with Two Muslim Holy Men*. From the Guler set of *Janam-sakhi* paintings. Attributed to the Seu-Nainsukh workshop. Pahari. Last quarter of the eighteenth century. 22.6 × 16.5 cm. Opaque watercolour on paper. Acc. no. 4072(6), Government Museum and Art Gallery, Chandigarh. Goswamy (2006), plate 1.9. — 101

2.12 *A Scene of Revelation*. From the Guler set of *Janam-sakhi* paintings. Attributed to the Seu-Nainsukh workshop. Pahari. Last quarter of the eighteenth century. 22.6 × 16.5 cm. Opaque watercolour on paper. Acc. no. 2369, Government Museum and Art Gallery, Chandigarh. Copied from the museum album in 2016. — 103

List of Illustrations

2.13 *Guru Nanak at School*. From the Unbound set of Janam-sakhi paintings. Artist unknown. Last quarter of the eighteenth century. Punjab. Acc. no. 1998.58.2, Asian Art Museum, San Francisco. Downloaded by the author in 2016. (http://searchcollection.asianart.org). 107

2.14 *Bhai Bala Recites the Life Story of Guru Nanak to Guru Angad and Onlookers*. From the Unbound set of Janam-sakhi painting. Artist unknown. Last quarter of the eighteenth century. Punjab. Acc.no.1998.58.1, Asian Art Museum, San Francisco. Downloaded by the author in 2016. (http://searchcollection.asianart.org). 109

2.15 *Guru Nanak Meets with Bal Nath Yogi's Disciples*. From the Unbound set of *Janam-sakhi* paintings. Artist unknown. Last quarter of the eighteenth century. Punjab. Acc. no. 1998.58.36, Asian Art Museum, San Francisco. Downloaded by the author in 2016 (http://searchcollection.asianart.org). 110

3.1 *Guru Nanak and Har Rai Listening to Music*. Randhawa (1971). 115

3.2 *Guru Nanak Listening to Music*. Randhawa (1971). 116

3.3 *Guru Nanak Listening to Music*. Acc. no. 1685. Possibly the Government Museum and Art Gallery, Chandigarh. Photographed by the author at Vijay Sharma's house in 2010. 117

3.4 *Guru Nanak Listening to Music*. Acc. no. 2135. Possibly the Government Museum and Art Gallery, Chandigarh. Photographed by the author at Vijay Sharma's house in 2010. 118

3.5 *Guru Nanak (?) Approached by Guru Gobind Singh (?)*. Opaque watercolour on paper. Pahari. Possibly from a Bilaspur workshop. Second quarter of the eighteenth century. 21 × 26.7 cm. Acc. no. 1843. Government Museum and Art Gallery, Chandigarh. Goswamy (2000), plate 15. 119

3.6 *Guru Nanak Listening to Music*. Himachal State Museum, Shimla. Photographed by the author in 2017. 121

3.7 *Guru Nanak Listening to Music.* Early nineteenth century. 122
18.5 × 13.8 cm. Acc. no. 1922,1214,0.2, British Museum. Downloaded by the author in 2017 (https://www.britishmuseum.org/collection).

3.8 *An Imaginary Meeting between Guru Nanak and Gobind* 123 *Singh.* Mandi, *c.*1780. Opaque water, silver and ink on paper. Sheet: 5 × 7⅝ in. (12.7 × 19.37 cm); Image: 4 ⅛ × 6⅜ in. (10.48 × 16.19 cm). Acc. no. M.75.114.2, The Los Angeles County Museum of Art. Downloaded by the author from the museum website in 2017 (https://collections.lacma.org/).

3.9 *Guru Nanak with Bhai Mardana Singing.* Punjab plains, 125 possibly Patiala. Last quarter of the nineteenth century. Opaque watercolour on paper. 43 × 32 cm. The collection of Sardarini Kanwal Ajit Singh, Chandigarh. Goswamy (2000), plate 18. Some editions have a different picture on plate 18.

3.10 *Guru Nanak and His Companions Mardana and Bhai* 126 *Mala.* Punjab. *c.*1700–1800. Opaque watercolour on paper. 21.6 × 17.8 cm. Acc. no. 1998.93, Asian Art Museum, San Francisco. Downloaded by the author in 2017 (http://searchcollection.asianart.org).

3.11 *Guru Nanak Speaking to Guru Gobind Singh (?).* Punjab. 128 Early nineteenth century. By the Seu-Nainsukh workshop of Guler. Acc. no. F-39, Lahore Museum. Courtesy of the Lahore Museum in 2017.

3.12 *Guru Nana with Followers.* Pahari, from the family 129 workshop of Nainsukh of Guler. Last quarter of the eighteenth century. Lightly tinted brush drawing on paper. 11.5 × 14.9 cm. Acc. no. F-38, Government Museum and Art Gallery, Chandigarh.

3.13 *Rustam Slaying a Dragon; On the Borders Diverse Scenes,* 131 *Including One of Guru Nanak Seated with Mardana.* Folio, possibly from a dispersed Shahnama manuscript, mounted as an album page. Lucknow or Patna. *c.*1780. Opaque.

List of Illustrations

watercolour and gold on paper. 40.64 × 29.21 cm. The Samrai Collection, London. Goswamy (2006), plate 2.8

3.14 *Guru Nanak with Disciples and Attendant.* Painted leaf from a manuscript. Kashmir/Punjab. First quarter of the nineteenth century. Opaque watercolour on paper. 11.3 × 17.8 cm. Acc. no. 3507, Government Museum and Art Gallery, Chandigarh. 132

3.15 *Guru Nanak and Bhai Mardana.* Pahari. *c.*1800. Paper, 20.2 × 15 cm. Acc. no. 76.35, National Museum, New Delhi. Daljeet (2009). 134

3.16 *Guru Nanak and Guru Gobind Singh Seated, Flanked by Brahma, Vishnu, Shiva, Ganesh, and Devi.* Punjab Plains. First half of the nineteenth century. Opaque watercolour on paper. 23 × 18.7 cm. Acc. no. 974, Government Museum and Art Gallery, Chandigarh. Singh, Kavita (2003), plate 1. 135

3.17 *Guru Nanak with Followers and Other Holy Men.* Kashmir/Punjab. First quarter of the nineteenth century. Opaque watercolour and gold on paper. 28.1 × 24.6 cm. Acc. no. 75.246. Himachal State Museum, Shimla. Goswamy (2000), plate 20. 137

3.18 *Guru Nanak with Mardana.* Nineteenth century. Watercolour on paper. 18.9 × 14.5 cm. Acc. no. 3661, Government Museum and Art Gallery, Chandigarh. Photographed by the author in 2016. 138

3.19 *Guru Nanak.* From *Military Manual of Maharaja Ranjit Singh.* Probably the workshop of Imam Bakhsh Lahori. 1822-30. Acc. no. 1035, Maharaja Ranjit Singh Museum, Amritsar. Lafont (2002), plate 110. 139

3.20 *Guru Nanak with Followers and Attendants.* Goswamy (2000), plate 18. Some editions include another image. 141

3.21 *Imaginary Meeting of Guru Nanak, Mardana Sahib, and Other Sikh Gurus.* Hyderabad. *c.*1780. Opaque watercolour and gold on paper. 44.13 (38.1) × 25.4 (19.69) cm. Acc. no. M.74.88.3. Downloaded by the author in 2017. The 143

Los Angeles County Museum of Art. Downloaded by the author from the museum website in 2017 (https://collections.lacma.org/).

3.22 *Sodhi Bhan Singh Offering Prayers*. Leaf, possibly formerly appended to a manuscript of the *Guru Granth Sahib*. Kashmir/Punjab. *c.*1840. 52 × 47 cm. Acc. no. 59.525, National Museum, New Delhi. Photographed by the author in 2016. 145

3.23 *From Guru Nanak to Guru Gobind Singh, the Ten Sovereigns*. From the workshop of Purkhu of Kangra. Pahari. Early nineteenth century. Opaque watercolour on paper. 42 × 42 cm. Collection of Satinder and Narinder Kapany. Goswamy (2006), plate 3.1. 146

3.24 *The Nine Sikh Gurus Seated in a Circle under a Tree*. Punjab. *c.*1840. Opaque watercolour and gold on paper. 28.8 × 23.6 cm. Acc. no. 1990.1347, The San Diego Museum of Art. Downloaded by the author in 2017 (https://collection.sdmart.org/kiosk/search.htm). 148

3.25 *Guru Nanak Seated in Meditation*. Opaque watercolour on paper. Pahari, possibly from a Mankot workshop. Second quarter of the eighteenth century. 18 × 11.2 cm. Acc. no. 248. Government Museum and Art Gallery, Chandigarh. Goswamy (2000), plate 16. 149

3.26 *Guru Nanak Seated in Meditation*. Pahari, possibly from a Mankot workshop. Second quarter of the eighteenth century. In Diamond (eds.), 2013. 150

3.27 *Guru Nanak Reading from a Text*. Folio, possibly from a series of portraits of religious men. Late Mughal. Last quarter of the eighteenth century. Opaque watercolour on paper. 16.7 × 15.5 cm. Collection of Satinder and Narinder Kapany. In Goswamy (2006), plate 3.7. 151

3.28 *Guru Nanak, the First Guru of the Sikhs*. Hyderabad, Deccan. *c.*1730-40. Paper. 35.5 × 24.5 cm. Acc. no. 59.314, National Museum, New Delhi. Photographed by the author in 2016. 153

List of Illustrations 13

3.29 *Guru Nanak*. By artist Jodh Singh. 1848. Shreesh pigment on canvas. Sonia Dhami Collection. Courtesy of its owners. 154

3.30 *Guru Nanak with Ganesh and Soldiers*. Lahore. Second quarter of the nineteenth century. Possibly from the workshop of Imam Bakhsh Lahori. Fakir Khana Museum, Lahore. Photographed by the author in 2010. 155

4.1 *Guru Angad*. Gouache on paper. 19.6 × 15.2 cm. Acc. no. 1844, Government Museum and Art Gallery, Chandigarh. Photographed from the album by the author in 2016. 160

4.2 *Guru Angad*. From *Military Manual of Maharaja Ranjit Singh*. Probably the workshop of Imam Bakhsh Lahori. 1822–30. Acc. no. 1035. Maharaja Ranjit Singh Museum, Amritsar. Lafont (2002), plate 111. 161

4.3 *Guru Amar Das ji*. Artist unknown. First half of the eighteenth century. Punjab. Acc. no. 74.284. Himachal State Museum, Shimla. Photographed by the author in 2016. 162

4.4 *Guru Amar Das*. Artist unknown. Pahari. Acc. no.1845b. Government Museum and Art Gallery, Chandigarh. Photographed by the author in 2016. 163

4.5 *Guru Amar Das*. From the *Military Album of Maharaja Ranjit Singh*. Attributed to the Imam Baksh workshop. 1822-30. Acc. no. 1035. Maharaja Ranjit Singh Museum, Amritsar. Lafont (2002), plate 112. 164

4.6 *Guru Ram Das, the Fourth Guru*. Artist unknown. A series of portraits of the Gurus. Punjab plains. First half of the eighteenth century. 24.9 (21) × 16.5 (12.3) cm. Opaque watercolour on paper. Acc. no. 74.285. Himachal Pradesh State Museum, Shimla. Goswamy (2000), plate 24. 166

4.7 *Guru Ram Das, the Fourth Guru*. Leaf from a series of portraits of the Gurus. Pahari. From the family workshop of Nainsukh of Guler. c. 1800. 21.9 × 16.1 cm. Acc. no. F-42, Government Museum and Art Gallery, Chandigarh. Goswamy (2006), plate 3.9. 167

4.8 *Guru Ram Das*. Attributed to the second generation after Nainsukh. Guler, Punjab Hills. *c.*1825–30. 26 × 30 cm. Opaque watercolour and gold on paper. Photographed at the Braharad Babbar in 2017. 168

4.9 *Guru Ram Das*. From *Military Manual of Maharaja Ranjit Singh*. Attributed to the Imam Bakhsh workshop. Lahore, 1822-30. Acc. no. 1035, Maharaja Ranjit Singh Museum, Amritsar. Lafont (2002), plate 112. 170

4.10 *Guru Arjan ji (Fifth Guru)*. Artist unknown. Punjab. First half of the eighteenth century. Acc. no. 74.286, Himachal State Museum, Shimla. Photographed by the author in 2016. 171

4.11 *Portrait of Guru Arjan Dev, the Fifth Guru*. Attributed to Purkhu's workshop of Kangra. Pahari. *c.*1800. 21.9 × 16.1 cm. Acc. No. 1847, Government Museum and Art Gallery, Chandigarh. Goswamy (2006), plate 3.10. 172

4.12 *Guru Arjan*. Artist unknown. Punjab. *c.*1800. Acc. no. 1846, Government Museum and Art Gallery, Chandigarh. Photographed by the author in 2016. 173

4.13 *Guru Arjan*. From the folio of *Military Manual of Maharaja Ranjit Singh*. Attributed to the Imam Bakhsh workshop. Lahore. 1822-30. Acc. no. 1035, Maharaja Ranjit Singh Museum, Amritsar. Lafont (2002), plate 114. 174

4.14 *Guru Hargobind, the Sixth Guru*. Leaf from portraits of the Gurus. Artist unknown. Punjab plains, first half of the eighteenth century. 24.9 (21) × 16.5 (12.2) cm. Opaque watercolour on paper. Acc. no. 74.287. Himachal State Museum, Shimla. Goswamy (2000), plate 25. 176

4.15 *Guru Har Gobind (?) with an Attendant*. From a group of works of different themes but sold to the same person in the eighteenth century. Artist unknown. Punjab plains, *c.*1750. 25.4 × 18.4 cm. Opaque watercolour on paper. Acc. no. 1998.59. Asian Art Museum, San Francisco. Goswamy (2006), plate 3.11. 177

List of Illustrations 15

4.16 *Guru Har Gobind Singh*. Attributed to the Seu-Nainsukh 178 workshop. Pahari, first quarter of the nineteenth century. See Archer (1978), plate 3. Photographed by the author at Braharad Bhabbar in 2017.

4.17 *Portrait of Guru Har Gobind, the Sixth Guru*. From a 179 family workshop active at Kangra. Pahari. *c.*1790. 20.1 × 15.3 cm. Opaque watercolour on paper. Acc. no. 1848, Government Museum and Art Gallery, Chandigarh. Goswamy (2000), plate 3.13.

4.18 *Guru Hargobind Out Riding*. Leaf from a series of portraits 180 of the Gurus. Artist unknown. Kashmir/Punjab; first quarter of the nineteenth century. 35 (28.7) × 27.5 (22.5) cm. Shri Harish Chander, Chamba. Goswamy (2000), plate 26.

4.19 *Guru Har Gobind, the Sixth Guru, with Followers and* 181 *Attendants*. Painted leaf from the prayer book manuscript. Kashmiri/Punjab, first quarter of the nineteenth century. 11.3 × 17.8 cm. Opaque watercolour on paper. Acc. no. 3508, Government Museum and Art Gallery, Chandigarh. Goswamy (2006), plate 3.12.

4.20 *Guru Hargobind*. From *Military Manual of Maharaja* 183 *Ranjit Singh*. Attributed to the Imam Bakhsh workshop. 1822-30. Acc. no. 1035, Maharaja Ranjit Singh Museum, Chandigarh. Lafont (2002), plate 115.

4.21 *Guru Hargobind Singh and a Courtier*. Punjab plains, 184 second quarter of the nineteenth century. 20.5 × 15.2 cm. Watercolour on paper. Acc. no. 3663, Government Museum and Art Gallery, Chandigarh. Photographed by the author in 2016.

4.22 *Guru Har Rae ji (Seventh Guru)*. Artist unknown. Punjab. 185 First half of the eighteenth century. Acc. no. 74.288, Himachal State Museum, Shimla. Photographed by the author in 2016.

4.23 *Guru Har Rai, the Seventh Guru*. Leaf from a series of portraits of the Gurus. Attributed to the Seu-Nainsukh workshop. Pahari. First quarter of the nineteenth century. 22 × 16.2 cm. Acc. no. F-45, Government Museum and Art Gallery, Chandigarh. Goswamy (2006), plate 3.14. 186

4.24 *Guru Har Rai*. Folio from *Military Manual of Maharaja Ranjit Singh*. Attributed to the Imam Bakhsh workshop. Lahore. 1822-30. Acc. no. 1035, Maharaja Ranjit Singh Museum, Amritsar. Lafont (2002), plate 116. 188

4.25 *A Fresco of Har Krishan*. Gurdwara Pothimala. *c*.1745. Wikipedia (https://commons.wikimedia.org/wiki/File:Sri_Guru_Har_Krishan_Ji_Gurudwara_Pothi_Mala.jpg). 189

4.26 *Guru Har Krishan*. Probably from the workshop of Nainsukh of Guler. Pahari. *c*.1820. Photographed by the author at Prahlad Bubbar, London, 2016. 191

4.27 *Guru Har Krishan*. Punjab. First half of the eighteenth century. Acc. no. 74.289, Himachal State Museum, Shimla. Photographed by the author in 2016. 192

4.28 *Guru Har Krishan*. From *Military Manual of Maharaja Ranjit Singh*. 1822-30. Acc. no. 1035, Maharaja Ranjit Singh Museum, Amritsar. Lafont (2002), plate 117. 193

4.29 *Guru Tegh Bahadur, the Ninth Guru*. A series of portraits of the Gurus. Artist unknown. Punjab plains. First half of the eighteenth century. 24.9 (21) × 16.3 (12.3) cm. Opaque watercolour on paper. Acc. no. 74.290. Himachal State Museum, Shimla. Copied from Goswamy 2000. 195

4.30 *Portrait of the Ninth Sikh Guru, Tegh Bahadur*. Artist unknown. Northern India or Pakistan. *c*.1670 (?). 27.3 (22.2) × 20.9 (16.5) cm. Opaque watercolour on paper. Acc. no. 1998.94. Asian Art Museum, San Francisco. Downloaded by the author in 2016 (http://search collection.asianart.org/). 196

List of Illustrations 17

4.31 *Guru Tegh Bahadur*. Attributed to the Imam Bakhsh workshop. From *Military Album of Maharaja Ranjit Singh*. Lahore. 1822-30. Acc. no. 1035, Maharaja Ranjit Singh Museum, Amritsar. Lafont (2002), plate 118. 197

4.32 *Guru Gobind Singh Encounters Guru Nanak Dev*. Eighteenth century. From Singh, Patwant (1989). 199

4.33 *Guru Gobind Singh with an Attendant*. Punjab. First half of the eighteenth century. Acc. no. 74.291, Himachal State Museum, Shimla. Photographed by the author in 2016. 200

4.34 *Guru Gobind Singh on Horseback*. Patiala. End of the eighteenth century. Opaque watercolour on paper. 39.9 (28.5) × 25.3 (23.4) cm. Acc. no. 75.158. Himachal State Museum, Shimla. Goswamy (2000), plate 30. 202

4.35 *Guru Gobind Singh, the Tenth Guru*. Leaf from a series of portraits of the Gurus. From the family workshop of Nainsukh of Guler. Pahari. First quarter of the nineteenth century. 21.4 × 16.2 cm. Acc. no. F-48, Government Museum and Art Gallery, Chandigarh. Goswamy (2000), plate 29. 203

4.36 *Equestrian Portrait of the Tenth Guru of Sikhs, Gobind Singh*. Attributed to the Nainsukh family. Punjab. *c.*1800. Opaque watercolour on paper. 21.4 (23.5) × 14.6 (16.5) cm. Acc. no. 17.27.29, Museum of Fine Art, Boston. Downloaded by the author in 2017 (https://www.mfa.org/collections). 204

4.37 *Guru Nanak and Guru Gobind Singh*. Punjab. Nineteenth century. Courtesy Dr C.S. Chan, London. Srivastava (1983), plate XIII. 206

4.38 *Guru Gobind Singh Seated in Majesty*. Folio, possibly from a series envisioning the great Gurus. From the family workshop of Nainsukh of Guler. Pahari. *c.*1815. Opaque watercolour, gold and silver on paper. 17.5 × 15.6 cm. The Samrai Collection, London. Goswamy (2006), plate 3.16. 207

4.39 *Guru Gobind Singh*. From *Military Manual of Maharaja Ranjit Singh*. Probably from the workshop of Imam Bakhsh Lahori. Lahore. 1822-30. Acc. no. 1035. Maharaja Ranjit Singh Museum, Amritsar. Lafont (2002), plate 119. 208

4.40 *A Sikh Guru Seated in the Golden Temple at Amritsar*. From the family workshop of Nainsukh of Guler. Pahari. *c.*1825. Opaque watercolour and gold on paper. 17.8 × 15.2 cm. The Samrai Collection, London. Goswamy (2006), plate 2.3. 210

4.41 *Portrait of the Tenth Guru, Gobind Singh*. Punjab. *c.*1830. Opaque watercolour and gold on paper. 24.1 (18.4) × 20.9 (15.2) cm. Acc. no. 1998.95, Asian Art Museum, San Francisco. Downloaded by the author in 2016. (http://searchcollection.asianart.org/). 211

4.42 *Harimandir Sahib, the Golden Temple at Amritsar*. Punjab. *c.*1840. Watercolour and gold on paper. 25.4 × 27.6 cm. Asian Art Museum of San Francisco. Goswamy (2006), plate 2.2. 212

4.43 *Guru Gobind Singh with His Four Sons, the Sahibzadas*. Punjab plains. Second quarter of the nineteenth century. 32.4 × 27.6 cm. Acc. no. 1842. Government Museum and Art Gallery, Chandigarh. Goswamy (2006), plate 3.17. 213

4.44 *A Sikh Guru and a Prince in Conversation*. Guler workshop. Himachal Pradesh. 1800-25. Opaque watercolour on paper. 21.9 (29.2) × 16.2 (22.9) cm. Acc. no. P.2001.13.1, Norton Simon Museum. Downloaded by the author in 2017 (https://www.nortonsimon.org/art/explore-the-collection/). 215

5.1 *Guru Gobind Singh*. Artist unknown. Punjab, nineteenth century. Opaque watercolour on paper. Acc. no. IM.2:128-1917, Victoria and Albert Museum. Downloaded by the author in 2015 (https://collections.vam.ac.uk/search/). 221

List of Illustrations

5.2 *Guru Gobind Singh*. From an album of Company painting. 222
Artist unknown. Late nineteenth century. Watercolour on paper. Welcome Library, London. Downloaded by the author in 2016 (https://catalogue.wellcomelibrary.org/).

5.3 *Guru Gobind Singh and Five Khalsas*. Artist unknown. 223
Late nineteenth century. Chromolithograph. Welcome Library, London. Downloaded by the author in 2016 (https://catalogue.wellcomelibrary.org/).

5.4 *Guru Gobind Singh*. From an album of Company painting. 224
Artist unknown. Late nineteenth century. Watercolour on paper. Acc. no. 651529i, Welcome Library, London. Photographed by the author in 2015.

5.5 *Guru Gobind Singh*. From an album of Company painting. 225
Artist unknown. Late nineteenth century. Watercolour on paper. Welcome Library, London. Photographed by the author in 2016.

5.6 *Guru Gobind Singh*. From an album of Company painting. 226
Artist unknown. Late nineteenth century. Watercolour on paper. Welcome Library, London. Photographed by the author in 2016.

5.7 *Guru Nanak with the Other Nine Gurus*. By Bhai Puran 227
Singh. Punjab. 1882. Watercolour on machine-made paper. 33.7 × 46.2 cm. Acc. no. 3787, Government Museum and Art Gallery, Chandigarh. Goswamy (2000), plate 23.

5.8 *Guru Nanak*. Artist unknown. Punjab. Late nineteenth 229
century. Watercolour on paper. $9^{7}/_{8} \times 13^{7}/_{16}$ in. Acc. no. 2608, Government Museum and Art Gallery, Chandigarh. Photographed by the author in 2016.

5.9 *Guru Nanak*. Artist unknown. Punjab. Late nineteenth 230
century. 10 × 13 in. Watercolour on paper. Acc. no. 2598, Government Museum and Art Gallery, Chandigarh. Photographed by the author in 2016.

5.10 *Guru Nanak with Bala and Mardana*. Artist unknown. Punjab. Late nineteenth century. Watercolour on paper. 11¼ × 10¼ in. Acc. no. 2615, Government Museum and Art Gallery, Chandigarh. Courtesy of the museum. 231

5.11 *Guru Nanak Dev with Bala and Mardana*. By Alam Chand, artist. Punjab. Nineteenth century. Courtesy Dr C.S. Chan, London (UK). Srivastava (1983), plate XII. 232

5.12 *Guru Nanak with Bala and Mardana*. Punjab. Late nineteenth century. Watercolour on paper. 8¼ × 13⅜ cm. Acc. no. 2643, Government Museum and Art Gallery, Chandigarh. Photographed by the author in 2016. 234

5.13 *Guru Nanak*. Punjab. Late nineteenth century. 13 × 10 in. Watercolour on paper. Acc. no. 2630, Government Museum and Art Gallery, Chandigarh. Courtesy of the museum in 2016. 235

5.14 *Guru Nanak at Panja Sahib*. Punjab. Last quarter of the nineteenth century. Watercolour on machine-made paper. 20.9 × 27.9 cm. Acc. no. 2619, Government Museum and Art Gallery, Chandigarh. Goswamy (2000), plate 22. 236

5.15 *Guru Nanak with Bala, Mardana, Sri Chand and Lakshmi Das*. Artist unknown. Punjab. Late nineteenth century. Watercolour on paper. 16 × 12⅛ in. Acc. no. 2639, Government Museum and Art Gallery, Chandigarh. Singh (2003), plate 2. 238

5.16 *Guru Nanak with Bala, Mardana and His Two Sons*. Artist unknown. Punjab. Late nineteenth century. 8¼ × 11 in. Acc. no. 2641, Government Museum and Art Gallery, Chandigarh. 239

5.17 *Guru Nanak*. Artist unknown. Punjab. Late nineteenth century. Watercolour on paper. 8⅛ × 5⅞ in. Acc. no. 2636, Government Museum and Art Gallery, Chandigarh. Courtesy of the museum in 2016. 240

5.18 *Guru Nanak*. Artist unknown. Punjab. *c.*nineteenth century. Watercolour on paper. 11⅛ × 8 3/16 in. Acc. no. 2594, Government Museum and Art Gallery, Chandigarh. Photographed by the author in 2016. 241

List of Illustrations 21

5.19 *Guru Nanak*. Artist unknown. Lahore. *c*.1850–*c*.1870. 243
Painted on ivory. Diameter 5.1 cm. Acc. no. IS.150-1954,
Victoria and Albert Museum. Downloaded by the author
in 2015 (https://collections.vam.ac.uk/search/).

5.20 *Guru Nanak Dressed in an Inscribed Robe*. Lahore. Late 244
nineteenth century. 36 × 28.6 cm. The Government
Museum and Art Gallery, Chandigarh. Acc. no. 2401.
Photographed by the author in 2010.

5.21 *Guru Nanak Dressed in an Inscribed Robe (Detail)*. Lahore. 244
Late nineteenth century. The Government Museum and
Art Gallery, Chandigarh. Acc. no. 2401. Photographed
by the author in 2010.

5.22 *Guru Nanak Dressed in an Inscribed Robe (Detail)*. Lahore. 245
Late nineteenth century. The Government Museum and
Art Gallery, Chandigarh. Acc. no. 2401. Photographed
by the author in 2010.

5.23 *Guru Nanak*. By Ustad Haji Sharifis. Punjab. First quarter 247
of the twentieth century. Acc. no. 1469, Lahore Museum.
Photographed by the author in 2010.

5.24 *Guru Nanak Dev*. By N.[athdwara], artist, or Pannalal 248
Gopilal. *c*.1930s. Chromolithograph. 50.7 × 35.8 cm.
Acc. no. CP-9, Collection of Robert J. Del Bonta. Brown
(1999), plate 21.

5.25 *Guru Nanak*. By Shan Pratap Salwans. Patiala. 1947. See 248
Singh (2004, 62).

5.26 *Guru Nanak Cross-legged*. Artist unknown. Punjab. First 249
quarter of the twentieth century. Watercolour on
cardboard. Acc. no. 1545, Lahore Museum. Photographed
by the author in 2010.

5.27 *Guru Nanak Cross-legged*. By Arjun Singh. Punjab. 1935. 250
Oil on canvas. Baba Baghel Singh Museum, Bangla Sahib
Gurudwara, New Delhi.

Acknowledgements

I would like to thank Akio Tanabe, professor emeritus at the University of Tokyo, who offered me the chance to work with him at his former institution, the Graduate School of Asian and African Area Studies (ASAFAS), Kyoto University. Although he specialized in anthropology, his supervision was indispensable for my PhD application to the School of Oriental and African Studies (SOAS), University of London, as well as the completion of my dissertation and subsequent acquisition of my Master's degree. Yasushi Tonaga, a professor at Kyoto University, also supported my research as a second supervisor at ASAFAS and wrote a reference for my transfer to SOAS.

My huge thanks to Crispin Branfoot, reader in the SOAS Department of the History of Art and Archaeology, who accepted my speculative PhD proposal. Under his supervision, I formed the original idea for my research, gained perspective and developed my methodology, which to some extent relied on the rich human, documentary and visual resources in London. I will remain forever grateful to him. I would also like to express my appreciation for my committee members, Charles Gore and Gurharpal Singh. Gurharpal Singh provided enormous help in understanding Sikhism and the history of Punjab, about which I never received professional mentorship in Japan.

I take this opportunity to thank B.N. Goswamy, F. S. Aijazuddin and Nadhra Khan, distinguished scholars who helped my fieldwork in India and Pakistan. My gratitude goes to Seema Gera (curator, Government Museum and Art Gallery in Chandigarh), Ujaa Usmani (assistant curator, Lahore Museum) and Fakir Saifuddin (owner and curator, Fakir Khana Museum in Lahore). I would also like to express my appreciation for the financial support I received from the Japan Society for the Promotion of Science and the Japan Student Services

Organization, as well as the Saraswati Dalmia Scholarship at SOAS. My sincere thanks go to the Japanese Association for South Asian Studies, namely JASAS Grant for Publication Programme, and Manohar Publishers & Distributors, which helped me publish this book.

In addition to the above, I want to express my thanks to my parents, who have supported my life as a student and researcher in both Japan and the UK for a long time. Last but not the least, I am grateful to my wife, Patoomporn Maneesangpratip, who always gives me her dedicated support.

Fukuoka, Japan ATSUSHI IKEDA
21 July 2023

Introduction

Sikhism is a relatively new religion in the world. It was founded by Guru Nanak (1469–1539) in the Punjab region at the end of the fifteenth century. With globalization and subsequent migration, the total population of Sikhs has reached 27 million worldwide. This accounts for 0.39 per cent of the world's population. Of these, 76 per cent of all Sikhs live in the Punjab province, Republic of India, particularly in three major areas: Majha, Doba and Malwa. As a result, two-thirds of Punjab's population comprises Sikhs. The Sikh population marks 13.11 per cent in the state capital, Chandigarh, according to the 2011 Sikh Religion Census. Moreover, significant communities of Sikhs exist in the United Kingdom, the United States and Canada, as well as some former British colonies and English-speaking countries. The 2011 National Household Survey of Canada reports that Sikhs comprise 1.4 per cent of the Canadian population.

In recent times, single portraits representing Guru Nanak (1469–1539) are very popular among Sikhs and are frequently hung on the walls of their temples, stores and houses. Portraits of Guru Nanak are often displayed next to those of Guru Gobind Singh, who is the second most respected great reformer after Guru Nanak. Interestingly, while investigating portraits of Sikhs in the Punjab State of India in 2010, I learned from the staff of a portrait shop at Hall Bazaar in Amritsar, that many Sikhs actually prefer Guru Nanak over all other portrait subjects. I support his observations on the basis of the market research I performed as part of my fieldwork.

The photo (Figure I.1) below is from the Guru Nanak Darbar (court) in Rajpura, Panjab, India, where portraits of Guru Nanak and Guru Gobind Singh are hung on the wall behind the *Adi Granth*, the Sikh sacred text. Here, I deliberately selected a Sikh temple (*gurdwara*)

with portraits of the Gurus. If the temple has portraits of the Gurus, this display arrangement is standard in most places. However, many temples have no portraits of the Gurus indoors.

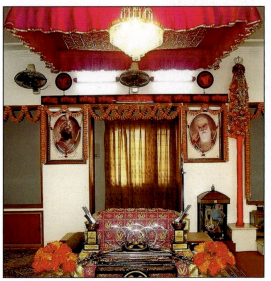

Figure I.1: Guru Nanak Darbar. Rajpura, Punjab, India

We can discern a thought-provoking difference between theory and practice, namely the Sikhs' avoidance of idolatry and their actual practices. While portraits of the Gurus are prevalent in Sikh society, the Sikh doctrine has prohibited idolatry since its inception in the late fifteenth century. For example, the *Guru Granth Sahib* is known as the second edition of the *Adi Granth*, which the fifth Guru Arjan (1563–1606) compiled (Kapoor 2003). The *Guru Granth Sahib* was presumably completed when the tenth Guru, Gobind Singh (1666–1708), added his own verses and the ones of the ninth Guru, Tegh Bahadur, his father. The major characteristics of the sacred text are to be inserted into the verses of Hindu ascetics such as Kabir (1398–1448) and Muslim Sufis as well as the Sikh Gurus. When Guru Gobind Singh passed away in 1708, he abolished the human Guru, which was easily targeted by the Mughal Empire. As a result, the *Guru Granth Sahib* is installed instead of ten human Gurus in the Darbar Sahib,

Introduction 27

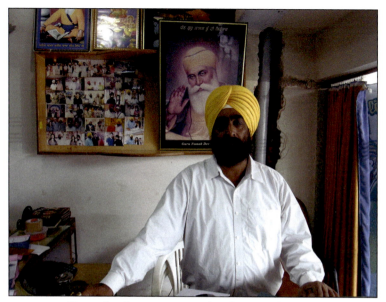

Figure I.2: Receptionist at a hotel in Punjab, India

the contemporary Sikh headquarters. Since the sacred text includes about 20 descriptions of idolatry, I will pick four of them to include here.

The Hindus have forgotten the Primal Lord; they are going the wrong way. As Naarad instructed them, they are worshipping idols. They are blind and mute, the blindest of the blind. The ignorant fools pick up stones and worship them. But when those stones themselves sink, who will carry you across? (Khalsa 2018: 556).

With the home of his own, he does not even come to see his Lord and Master. And yet, around his neck, he hangs a stone god. The faithless cynic wanders around, deluded by doubt. He churns water, and after wasting his life away, he dies. That stone, which he calls his god, that stone pulls him down and drowns him. O sinner, you are untrue to your own self; a boat of stone will not carry you across. Meeting the Guru, O Nanak, I know my Lord and Master. The Perfect Architect of Destiny is pervading and permeating the water, the land and the sky. (Khalsa 2018: 739).

Their service is useless. Those who fall at the feet of a stone, god their work is wasted in vain. My Lord and Master speaks forever. God gives His gifts to

all living beings. The Divine Lord is within the self, but the spiritually blind one does not know this. Deluded by doubt, he is caught in the noose. The stone does not speak; it does not give anything to anyone. Such religious rituals are useless; such service is fruitless (Khalsa 2018: 1160).

In your home is the Lord God, along with all your other gods. You wash your stone gods and worship them. You offer saffron, sandalwood and flowers. Falling at their feet, you try so hard to appease them. Begging, begging from other people, you get things to wear and eat. For your blind deeds, you will be blindly punished. (Khalsa 2018: 1240)

The above descriptions mention the uselessness of Hindu idol worship and, as a result, demonstrate that idolatry is forbidden in Sikhism. Thus, the current prevalence of portraits of the Gurus, especially Guru Nanak, evokes ambiguous feelings of devotion and commandment. It seems to me that the theoretical and practical contradiction was generated in Sikhism's transformative period during the British colonial period between 1849 and 1947. This is because the Sikhs had to encounter other cultural entities, such as Christian propagation and British colonialism, which spurred them to reform their traditions and beliefs. This phenomenon was at its peak from the 1870s to the 1920s and is currently known as the Singh Sabha Movement, a socio-religious reform led by the Sikh intellectuals who comprised the urban middle class. Since the newly-formed urban middle class accepted Western culture in a positive light, the custom of hanging paintings on the wall is believed to have been absorbed as part of Western culture. It is significant that the Lahore Museum was founded in 1865 and brought together the urban middle class from throughout Punjab, where the traditional paintings known as miniatures were displayed on the walls.

Given the above, this book explores the colonial transformation of portraiture of the Sikh Gurus, with a special focus on portraits of Guru Nanak, the founder of Sikhism. The most important work of art in my research is the late nineteenth-century portrait *Guru Nanak Dressed in an Inscribed Robe* (Figure I.3). According to my review of existing visual materials, this painting is a prototype of the most popular Guru Nanak print at present (Figure I.4). In addition, the regional range of this book is almost equivalent to that of British Punjab. In the 1881 census conducted by the British, only Punjab province accommodated all major South Asian religions, such as Islam,

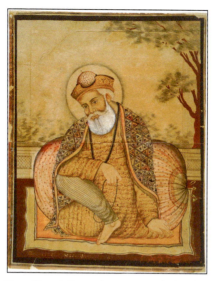

Figure I.3: *Guru Nanak Dressed in an Inscribed Robe*. Lahore. Late nineteenth century. 36 × 28.6 cm. Government Museum and Art Gallery, Chandigarh. Acc. no. 2401. Goswamy (2006), plate 2.1

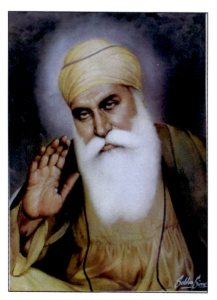

Figure I.4: *Guru Nanak in an Ashirwad Pose*. A digital print of the most popular Guru Nanak portrait. Purchased from the artist Sohan Singh, Amritsar. Photographed by the author in October 2010. The original was painted by Sobha Singh in 1964 (as cited in Kaur [1990])

Hinduism, Sikhism and Christianity. I believe that the Punjab region is the best place to consider religious identity. Thus, this book argues that these wall-hung portraits expressed the uniqueness and variety of the Sikh identity and that they played the role of socially integrating the Sikhs, who belonged to different factions.

Before we look at the historical development of portraits of Guru Nanak, I will review previous studies on Sikh art. Next, explain the theoretical framework of the study. Lastly, I will summarize the chapters of this book. Thus, this introductory chapter comprises three sections: (1) Literature Review, (2) Methodology, and (3) Organization.

1. Literature Review

(i) 1966-1998

I begin my review of previous studies on Sikh art with special reference to the period between 1966 and 2022. I do so because W.G. Archer (1966: 79-103) offers an extensive list of literature, including abstracts, ranging from 1830 to 1965. He classifies literature into three categories or phases: (1) records and first impressions by early travellers (1830-70); (2) official surveys, opinions and reports (1870–1900); and (3) art historians and critics (1900-1965). Following Archer, I would like to place this literature review in a fourth category: second generation of art historians and critics (1966–2022), which is further divided into two subsections: 1966-98 and 1999-2022. This grouping is associated with the Khalsa tercentenary of 1999, which led to worldwide exhibitions and relevant studies of Sikh art in the 2000s.

To begin with, W.G. Archer's 1966 volume, *Paintings of the Sikhs*, is the first and possibly the only monograph in this field. He introduces some important issues and approaches in his preface. Later, he outlines the history of the Sikhs from the age of the Gurus to the end of the Sikh Kingdom in 1849. It is evident that Archer's definition of Sikh art is limited to the period of the early nineteenth century. In particular, he regards the inception of Sikh painting as occurring only after the second quarter of the nineteenth century. Next, he details the artistic milieu of the Punjab hills, with special attention to Guler and Kangra, where the so-called Kangra style (*qalam*) flourished in the late

eighteenth century. Archer argues that Ranjit Singh's rule over some parts of the Pahari district influenced the Sikh patronage of Pahari painters and the regional development of Sikh art from 1810 to 1830. The prominent figure of the time was Desa Singh Majithia, the Sikh governor of the hills and possibly the earliest patron of Sikh painting. Finally, Archer explains the establishment of Ranjit Singh's hegemony and its decline after his death, referring to historical accounts written by contemporary English travellers and officers. However, the most valuable aspects of Archer's volume are a lengthy description of literature, catalogue information of plates and the abundant illustrations that come primarily from the collection of the Victoria and Albert Museum.

M.S. Randhawa's 1971 article, 'Two Panjabi artists of the 19th century: Kehar Singh and Kapur Singh', in *Chhavi* (vol. 1: 13-20), discusses two local painters who worked in Lahore. With regard to patronage, he provides evidence that the collection of the Chandigarh Museum contains a portrait of an English officer who could have been a patron, as well as the style and iconography of Company painting that was painted by local artists and patronized by the British. Kehar Singh was fond of the depiction of the traditional vehicle (*ekka*), the colourful hair decorations, or *paranda,* worn by Punjabi women and contemporary people engaging in household work and traditional occupations. In contrast to Kehar Singh, Kapur Singh rendered a Kuka or a Namdhari Sikh, who were the followers of Balak Singh and his famous disciple, Ram Singh. He also liked to portray a pandit, or a Hindu priest as well as Nihangs who were fully armed and aimed at the realization of Gobind Singh's mission.

B.N. Goswamy's 1975 corpus, *Painters at the Sikh Court: A Study Based on Twenty Documents* (reprinted in 1999), seeks to explore the relationship between Pahari artists and Sikh patrons in the early nineteenth century. The documents come from the same family as Chandu Lal, who is a descendant of Nainsukh, the most famous Pahari painter. In this book, Goswamy points out that Devi Ditta and Chhajju, from this family, worked in a Sikh court. In addition, he mentions that Purkhu, a prominent Pahari painter, worked for a Sikh patron in Lahore. Regarding patrons, Goswamy supports Archer's view that Sher Singh was a passionate patron of art because the

evidence says that the Sikh raja employed the painter Gokal through a grant. In addition, Goswamy proposes the new idea of patronage by the powerful Sandhanwalias in Ranjit Singh's court.

F.S. Aijazuddin's 1979 work, *Sikh Portraits by European Artists*, is a retrospective account of his personal origins. He is a descendant of the famous Muslim family, Fakir, in Ranjit Singh's court. His primary focus is a large painting, *The Court of Lahore*, rendered perhaps in Vienna, *c.*1850, by Hungarian painter August Schoefft; Aijazuddin assumes Schoefft visited Lahore in the last quarter of 1841. He splits the characters depicted in this large painting into five main groups, providing biographical notes on 49 of the principal characters as well as comments on the robe of Akalis, troopers, falconers, gatekeepers, servants and others. Aijazuddin explains the history of the Sikh dynasty by portraying the lives of Dalip Singh and Rani Jindan during their decline in India and exile in Europe. They are also illustrated in further works by Beechey, Schoefft, Goldingham, Winterhalter, Richmond and even Queen Victoria herself.

In 1981, Mulk Raj Anand edited a collection of academic papers entitled *Maharaja Ranjit Singh as Patron of the Arts*. This anthology is the first systematic attempt to explore Sikh art in the early nineteenth century. His introductory chapter says, 'It is likely that the patronage he [Ranjit Singh] gave to the artisans was in emulation of the example set by the previous monarchs, especially the Mughal' (Anand 1981a: 4). Moreover, he claims that art under Ranjit Singh was for the sake of pleasure or 'hedonism' and was produced as gifts to his large family (Anand 1981a: 6). Ultimately, Anand points out, 'the abundance of portraiture shows how almost everyone, including the Maharaja, were in search of an identity in their new exalted status, which they had acquired from modest origins in the villages of the Punjab plains' (1981a: 7).

Anand's second chapter, 'Transformation of Folk Impulse into Awareness of Beauty in Art Expression', repeats and details the arguments in his introductory chapter. He claims:

Such was the pride in the new dispensation of the peoples, that many of the craftsmen of the decaying Mughal court, as well as the guilds of masons, carpenters, ironsmiths, coppersmiths, goldsmiths, jewel merchants, painters, and shawl makers came to Lahore in search of patronage. The traditional

families of artisans from the village, who had so far built the big houses of the leaders of the various clans, also gathered in and around the capital. The sheer necessity of physically building up the architectural complexes, on a bigger scale than in the villages and small towns, brought employment to the many guilds of craftsmen. (Anand 1981b: 10)

Anand emphasizes the role of Ranjit Singh as a patron of the arts. He again mentions, 'The generals, courtiers and the aristocrats all wanted to recognise themselves in their new roles. So portraiture, in line and colour, flourished as the most important activity in the Lahore court and the provinces' (Anand 1981b: 10).

Kang's first chapter, 'Wall Paintings under the Sikhs', draws attention to the wall painting produced in nineteenth-century Punjab. Her methodology is predominantly iconographic. She mentions the Gurus, Sikh royalty and aristocracy, including Ranjit Singh, martyrs, Nihang Singhs, female celebrities and erotic scenes in the bedroom, with a detailed description of the figure's identification and the painting's composition. She points out, 'more than half of the murals portray Guru Nanak and Guru Gobind Singh', despite the prohibition of idolatry in Sikhism (Kang 1981a: 51). The earliest depiction of Guru Nanak appears in the late eighteenth century in the mural panel of the temple of Shri Nam Dev, at Ghoman, in the district of Gurdaspur. He is often accompanied by his famous attendants, Bala and Mardana. His meditative pose, reproduced in many modern calendar paintings, goes back to the images in murals. There are extensive representations of the episodes of *Janam-sakhis*. Similarly, Guru Gobind Singh is often represented on horseback, holding a falcon. Other Gurus are depicted waving a yak's-tail flyswatter or peacock-feather fan. A single painting rendering all the Gurus appears to come from the second half of the nineteenth century. Baron Hugel (1845) reports that life-sized portraits of the Gurus from Nanak to Gobind existed in a palace at Wazirabad, which was built by Maharaja Ranjit Singh.

Goswamy's chapter, 'A Matter of Taste: Some Notes on the Context of Painting in Sikh Punjab', aims at challenging Archer's proposition that Ranjit Singh was indifferent to the artistic activities at court. Some of his arguments overlap those of Kang, as she was supervised by Goswamy in her doctoral research. In addition, Goswamy

often refers to his own studies, conducted in 1964 and 1975. His original contribution to this article is to investigate *Umdat-ut-Tawarikh*, by Sohan Lal Suri, from the point of view of art history. Goswamy points out that Ranjit Singh's court held large, active workshops, recalling those of Akbar, as Abu'l Fazl describes in *Ain-i-Akbari*. However, there were orientalists' views about the quality of the arts in the Sikh Empire. William Barr, Baron Charles Hugel, Charles Masson and, to some extent, Emily Eden thought lightly of Sikh painting of that time. Their attention is mostly paid to murals and, to a lesser degree, miniature portraits, which were the most suitable to European visitors' tastes. The rendering of Sikh Gurus and Hindu deities might be used for contemplation. Besides Lahore and Amritsar, other centres of Sikh painting production that were deserving of attention included Patiala, Kapurthala, Ladwa, etc. Goswamy also mentions that according to *Umdat-ut-Tawarikh*, the maharaja's meeting with Lord William Bentinck in 1831 at Ropar best represents his liking of painting.

Aijazuddin's chapter, 'Honoured Images: The Use of Portraiture in Sikh Diplomacy', illustrates the exchange of paintings, including portraits between Sikh rulers and British officers, in the early nineteenth century. As to Ranjit Sigh's liking of painting, Aijazuddin claims:

Ranjit Singh's unwillingness to sit for painters was not simply a matter of over-sensitivity but stemmed from a deeper sense of humility. For the same reasons that he refused to occupy the vacant Mughal *Jharoka* or throne in the Diwan-e-Am even though he held his levees within yards of it in the Lahore Fort, he neglected deliberately to use painters as the Mughals had done to fantasise their imperial pretensions. Painting to him was a pleasing diversion. (Aijazuddin 1981: 92)

In addition, he mentions,

When Ranjit Singh and Lord Bentinck met at Ropar in 1831, Jiwan Ram presented Ranjit Singh with some pictures of 'English ladies' and explained in response to the Maharaja's query that he was not an employee of the East India Company, but had accompanied the Governor-General in an independent capacity. (Aijazuddin 1981: 92)

He maintains,

A portrait intended by its sitter not only to strengthen 'the relations of amity

and friendship' but at the same time to serve as a deterrent to 'those glorious sahibs who would even think of doing anything unlawful in the country of the Maharaja'. (Aijazuddin 1981: 92)

Aijazuddin concludes that the exchange of portraits played a pivotal role in diplomacy and helped Sikhs retain their side of the Sutlej River for almost 30 years.

Man Mohan Singh's first chapter, 'Changing Faces of Maharaja Ranjit Singh in Portraiture', attempts to classify European and local painters by their preference in the depiction of Ranjit Singh's face, as his left eye was blind and covered by an eye patch. On the one hand, European artists such as Emily Eden, G.T. Vigne and August Schoefft rendered the maharaja in the frontal and left views, because they aimed for a depiction that was true to his actual physical appearance. On the other hand, local Indian artists from the hill kingdoms of Guler and Kangra painted Ranjit Singh in the right profile, in both realistic and idealistic manners. The only exception was Jivan Ram, who followed the demands of his patron, Lord Bentinck, and portrayed the maharaja in the frontal view. However, the general tendency of Ranjit Singh's depiction by local artists is divided into three stages: first, they painted the maharaja from the right side; second, full face; and third, with a decked-up horse, golden canopy and radiant halo.

Man Mohan Singh's second chapter, 'Maharaja Ranjit Singh's Court: Painters and Painted', focuses mainly on the activities of European artists at the Lahore court. He introduces G.T. Vigne's *A Personal Narrative of a Visit to Ghuzni, Kabul and Afghanistan* (1840) as an important source, Honigberger's account of August Schoefft's encounters (1829-30), and Emily Eden's *Portraits of the Princes and People of India* (1844). The most interesting account is Baron Hugel's history, *Travels in Kashmir and the Punjab* (1845), regarding the painter Vigne, although it has a few weaknesses: 'Firstly, it refers only to paintings done in a particular period of the history of Punjab that is Maharaja Ranjit Singh's rule and the years after his death. Second, it covers only the work of European painters. Thirdly, even amongst European painters it leaves out many important names' (Singh 1981b: 111).

Kang's second chapter, 'Wood Carving', explains the artistic wood carving produced during the reign of Maharaja Ranjit Singh. She

refers to H.H. Baden-Powell's applause in an exhibition of arts and crafts at Lahore in 1864. Kang points out that the establishment of the Mayo School of Art at Lahore in 1875 ended the local tradition of wood carving.

Man Mohan Singh's third chapter, 'Medals of Maharaja Ranjit Singh', investigates the collection at the Medal Gallery, Patiala, which Maharaja Bhupinder Singh (1900-1938) collected. All medals either directly represent Ranjit Singh or provide information about him. The primary focus is on the one that Ranjit Singh presented to Lord Auckland in 1838. The image of the maharaja is at the centre of the medal. This is a first-class medal for the most privileged guest during the reign of Ranjit Singh.

Lance Dane's chapter, 'Coinage of the Sikh Empire: An Outline', gives an overview of the coins produced during the reign of Ranjit Singh. He proposes that the only study of Sikh coins is Charles James Rodgers' account, 'The Coins of the Sikhs', *Journal of the Asiatic Society of Bengal*, London (1881). Afterwards, this collection was owned by the Government of Punjab, which published its catalogue in 1895.

R.P. Srivastava's 1983 corpus, *Punjab Painting*, is a genuine scholarly achievement in the field of Punjab painting, including Sikh subjects. His primary argument is that a tradition of local art existed in the Punjab plains before the influence of Pahari painting was evident. Furthermore, he draws attention to centres of Punjab painting other than Lahore, such as Patiala, Nabha, Kapurthala and Faridkot. His approach is to investigate murals, miniatures and illuminated manuscripts by means of both literary and visual sources, in terms of their theme, patronage, style and technique. As to the themes of miniatures, Srivastava classifies artworks into four types, depending on their theme: (1) royal/court paintings, (2) religious paintings, (3) secular paintings, and (4) ethnological studies. In contrast, the themes in illustrated manuscripts vary among religious, historical, secular and romantic stories. As to the centres of Punjab painting in the nineteenth century, he indicates Amritsar as the second most important city, partly because the city is the home of the Golden Temple, partly because the city was a summer capital of Ranjit Singh and partly because the city was as commercial a town as Lahore. Amritsar is followed by Kapurthala and Patiala, in turn. With regard to the artists,

he outlines three families working in Lahore: the Chughtai family, the Kehar Singh–Kishan Singh family and the Purkhu–Nainsukh family. The Chughtai family mainly specialized in *naqqashi* or illumination of manuscripts, while the Kehar Singh–Kishan Singh family worked as mussawir or painters of miniatures. The Purkhu–Nainsukh family was of Pahari origin. Lastly, Srivastava proposes a new category of Sikh/Punjab painting as the best regional style of early modern painting in South Asia.

Kang's 1985 volume, *Wall Paintings of Punjab and Haryana*, follows Srivastava's interest in the arts of the Punjab plain, but focuses exclusively on the wall paintings of the Indian Punjab, i.e. the states of Punjab and Haryana, produced in the nineteenth century. As for the Sikh theme, her achievements are almost the same as those of her 1981 article. However, her attention to a nimbus in the depiction of the Gurus is worthy of description. Kang says:

Most of the religious personalities, particularly the Sikh Gurus, were portrayed with a nimbus in the murals. The nimbus often took the shape of a yellow-coloured circle around the head, radiating rays, but in the mural panels of the Akal Takhat at Amritsar, the nimbuses were formed of dark-coloured circles which brought into relief the faces of the Gurus. The figures of Maharaja Ranjit Singh and of some of the rulers of the Cis-Sutlej States were also portrayed with nimbus. (1985: 107)

As for the painters and patrons, she attributes the renowned frescoes in the Shish Mahal at Patiala to either Devi Ditta from the Seu-Nainsukh family or Biba of Guler. She also introduces Karuna Goswamy's idea that the Jaipur painter(s) from Rajasthan worked with Pahari painters in Patiala.

Hans' 1987 catalogue, *B-40 Janamsakhi Guru Baba Nanak Paintings*, reflects the opposite of Archer's view of the predominance of portraiture in Sikh painting. This study represents a rare attempt to investigate a specific artwork rather than general Sikh art, although Hans is not an art historian. Hans claims that the B-40 *Janam-sakhi*, the oldest extant manuscript of the Panjabi language, was painted by a Sikh for the Sikhs, according to the information within the text. He points out for the first time that Guru Nanak is portrayed in three-quarter face, whereas others are in profile. Moreover, he found that

Guru Nanak was always depicted at a higher level and of larger size than the others in the pictures.

W.H. McLeod's 1991 volume, *Popular Sikh Art,* investigates the prints produced in nineteenth-century Punjab and *c.*1965. The former are owned by the Victoria and Albert Museum, while the latter were purchased by him in Amritsar, a holy city for Sikhs. Likewise, he outlines the development of Sikh art in a more elaborate manner than any previous scholar. He argues, 'Sikh art was born in the *Janam-sakhis*' (McLeod 1990: 4), the hagiographic account of Guru Nanak stemming from those of the Sufi. One of his discoveries is to find *Janam-sakhi* illustrations that are earlier than the B-40 set: the Bala set of 1658 from P.N. Kapoor of Delhi and the Bagharian set of 1724 from the family of Bhai Arduman Singh in Patiala. McLeod claims that the arrival of the printing press from Britain ended the manuscript production of the *Janam-sakhis*. In addition, he discovered the earliest portraits of Guru Nanak rendered in the Mughal style in the late seventeenth century. McLeod concluded that 'a simple extension of the Sufi tradition can be regarded as Sikh art, the determinative factor being content rather than style' (McLeod 1990: 8). As to the alien influence, he insists, 'the Pahari work executed under Sikh auspices occupies the margins of Sikh art' (McLeod 1990: 12), especially in the *Janam-sakhi* representation. In addition, one of the most productive parts of McLeod's study is to expand the boundary of Sikh art into the colonial and post-colonial periods. Regarding the shortage of extant works related to Sikh culture during the early twentieth century, he says:

The first is the general disfavor with which members of the Singh Sabha movement regarded popular pictorial art, or indeed pictorial art of any kind.... This attitude is well represented by that ornament of the Singh Sabha movement, Khan Singh's magisterial *Mahan Kos.* Of the encyclopaedia's eighty-one illustrations fifty-eight are photographs and seventeen are maps. Nowhere in the collection are representations of the Gurus to be found. Khan Singh elsewhere explains his unwillingness to sanction pictures of the Gurus. As he rightly claims, there exists no authentic picture of any of the Gurus. (McLeod 1991: 28)

Hasan's 1998 volume, *Painting in the Punjab Plains (1849–1947),*

explores paintings produced in the Punjab from the nineteenth century to the early twentieth century, with attention to the Western influence on local art. Her interest in colonial Punjab follows McLeod's. Her study tends to be a catalogue of illustrations and their descriptions, but most of them are published for the first time. She paid special attention to the art made by painters at the Mayo School of Art, Lahore, for Hasan herself was born and raised in that city. She provides detailed information on the artists and their representative works, some of which are influenced by the Bengal School.

In the period of 1966-98, studies of Sikh art were conducted predominantly by local and South Asian scholars. The exception is W.H. McLeod, who was born in New Zealand and awarded a PhD by the School of Oriental and African Studies at the University of London. Although his *Popular Sikh Art* is the best summary of scholarly works and the crucial textbook of the history of Sikh art, McLeod failed to offer new insight into the field, chiefly because his speciality was not art history, but religious studies. Even among art historians, there is no particular expert in Sikh art. Most historians major in either Mughal art or Pahari art. Srivastava and Kang could be regarded as proper experts on Punjab art but not Sikh art. Little attention has been paid to the field by either Western or South Asian academics, which incurs fragmentation of research outcomes and, although the studies are comprehensive, they lack of development of academic discussion.

(ii) 1999–2022

The period 1999–2022 is characteristic of new materials published in exhibitions celebrating the Khalsa tercentenary. Since 1999, an increasing number of scholars from Western academia have been engaged in the study of Sikh art. Some are British (or American) and French (a country that had a colony in South Asia); others are South Asians and South Asian emigrants who were educated and trained in the West. Susan Stronge's 1999 catalogue, *The Arts of the Sikh Kingdoms*, is the beginning of a series of exhibitions in response to a tercentenary celebration of the union of Khalsa. This edition comprises twelve essays written by historians, art historians and scholars of religious

studies. The exhibition was held in North America and the UK but will not be coming to India or Pakistan.

Nikky-Guninder Kaur Singh's chapter, 'The Sikh Religion', mentions the theological aspects of Sikhism, focusing on its founder, Guru Nanak. She states, 'Their homes, places of business and sacred places resonate with verses of their Guru and reflect images of Guru Nanak dressed in combined elements of Hindu and Muslim garb' (Nikky-Guninder 1999: 33).

A.S. Melikian-Chirvani's chapter, 'Ranjit Singh and the Image of the Past', explores how Ranjit Singh attempted to follow Persian and Mughal traditions. He claims:

Ranjit Singh's pursuit of the Mughal image went far beyond mere iconography. He collected jewels that once belonged to Jahangir and Shah Jahan (plate 64). Was it the bittersweet satisfaction of possessing the regalia of the emperors that had been ruthless to the community? Or did Ranjit Singh give precedence to restoring the grandeur of the past? The latter certainly played a role. (Melikian-Chirvani 1999: 65)

Similarly, 'the artists of the Sikh court painted idealized likenesses of the Gurus in imperial costume' (Melikian-Chirvani 1999: 65). Ranjit Singh restored the Mughal monuments as well.

B.N. Goswamy's first chapter, 'Painting in the Panjab', aims to redefine Punjab painting and detail what constitutes it. He opposes the idea that Punjab painting comprises the arts of the Sikh Punjab, i.e. between 1799 and 1849. He argues that it began in the sixteenth century. Furthermore, Goswamy refutes Archer's observation that the Pahari influence is evident only from 1810 to 1830 and claims that the impact was much earlier.

Goswamy's second chapter, 'Continuing Traditions in the Later Sikh Kingdoms', fills the gaps between previous scholarly works. He focuses on the period between Ranjit Singh's death and the annexation of Punjab into the British Raj, and production centres of Punjab painting other than Lahore. He regards Patiala as the second most important centre after Lahore. Maharaja Narinder Singh (1845-62) was the most prominent patron of art in Patiala. His development of arts was imitated by his successors and the rulers of other Sikh kingdoms, such as Kapurthala, Nabha, Jind and Faridkot. According

to the registers of pilgrims, the famous Devi Ditta from the Seu-Nainsukh family travelled from Patiala to Haridwar in 1866. Earlier, the Guler painter Gohi, who worked in the service of Maharaja Kalam Singh in Patiala, came to Haridwar in 1843. His brother Biba also worked in the service of Maharaja Narinder Singh and came to Haridwar in 1852. In addition, oral and stylistic evidence suggests that Rajasthani painters worked widely in Patiala. Moreover, oral evidence also indicates that Allah Ditta, a Muslim painter possibly from Delhi, was active in Patiala just like his descendants Bashart Ullah and Muhammad Sharif were. In contrast, Kapur Singh and Kehar Singh followed the European style. Kehar Singh is recorded as having worked at Lahore and Kapurthala. Some Rajasthani painters also followed this style in Patiala according to the Devanagari inscriptions.

Goswamy's 2000 catalogue, *Piety and Splendour: Sikh Heritage in Art*, was edited for the exhibition under the auspices of the Indian government. This exhibition, which reflected the editor's idea, displayed numerous new materials stemming from all of India, but in particular from the Government Museum and Art Gallery in Chandigarh. First, Goswamy focuses on the representation of Guru Nanak in the Janamsakhi illustrations produced in the Seu-Nainsukh workshop of Guler. Second, he draws attention to other forms of Guru Nanak representation, such as portraiture. Third, he examines portraits representing other Gurus. Fourth, he explores the origins of Sikh representations, including the Gurus. Fifth, Goswamy expands the subjects of painting to royalty, nobles and ordinary people, as well as architecture and landscape.

Jean-Marie Lafont's 2002 catalogue, *Maharaja Ranjit Singh: Lord of the Five Rivers*, was edited for the exhibition organized by the Government of Punjab, India. This is a bicentenary celebration of Maharaja Ranjit Singh's coronation. This exhibition comprises collections mainly from museums in Punjab and France, such as the Maharaja Ranjit Singh Museum (Amritsar), Musée Jean de La Fontaine (Chateau-Thierry) and Musée Guimet. The editor found it important to draw attention to the Muslim painter Imam Bakhsh Lahori and his activities under the patronage of Sikh chiefs, including Ranjit Singh.

Lafont and Schmitz's 2002 article, 'The Painter Imam Bakhsh of

Lahore', comprises a chapter in Schmitz's edited book, *After the Great Mughals: Painting in Delhi and the Regional Courts in the 18th and 19th Centuries*. In this article, the authors focus on the Muslim painter, who worked in Lahore in the mid-nineteenth century. Lafont and Schmitz (2002: 75-8) mention that Imam Bakhsh was a descendant of the fresco painters at the Sikh court and mansions (haveli), judging from descriptions by the French generals who worked for Ranjit Singh. Lafont and Schmitz argue, '[French generals] must have employed a number of artists to embellish their residences, and that many more artists would have been needed for the extensive programmes of frescos on buildings throughout the Panjab' (2002: 78). The styles of fresco remaining in the Punjab today are different from the Pahari style (Kang 1981, 1985, cited in Lafont and Schmitz 2002: 78). Lafont and Schmitz point out that Imam Bakhsh received patronage from many Westerners, such as General Court, Dr Honigberger and General Allard.

Kavita Singh's 2003 work, *New Insights into Sikh Art*, comprises her introduction and eight essays, which deliberately exclude the topic of the arts of Ranjit Singh's court as it has previously been well studied. In her introductory chapter, she discusses the redefinition of Sikh art and outlines the chapters.

Gurmeet Rai and Kavita Singh's chapter, 'Brick by Sacred Brick: Architectural Projects of Guru Arjan and Guru Hargobind', explores the transformation of the Sikh faith and community by examining the architecture developed under the Gurus' patronage. The authors suggest that the city of Amritsar was established to reflect Guru Arjan's rivalry with Prithi Chand, as the *Adi Granth* was compiled by him for the same purpose. At the same time, three reasons are proposed as to why the sacred tank in Amritsar was built during this period. First, the tank enabled emancipation from rebirth by karma, considering the number of steps – 84 – in which Rai and Singh (2003) indicate that each soul undergoes a cycle of 84,000,000 lifetimes before they become a human being again. Second, a place for congregation was demanded at the time, which met the demand for 'a sense of corporeal [collective, paraphrased by the author] identity' (Rai and Singh 2003: 35). Third, the tank was not only for the Guru but also for his devotees. Due to the installation of the *Guru Granth Sahib* into

Harmandir Sahib, the role and function of the Sikh shrine was altered from dharamsala, or the place of congregation, to gurudwara, or the doorway to the Guru, which displays the distinctive Sikh identity. With regard to Guru Hargobind, the most interesting architecture is the Guru ki Maseet, or Guru's Mosque, built for his Muslim workers, which is in fact bigger than the gurudwara for his own followers. This structure exhibits the egalitarian spirit among religions in Sikhism.

Jeevan Singh Deol's chapter, 'Illustration and Illumination in Sikh Scriptural Manuscripts', reconstructs the genre of Sikh illumination and illustration with a special focus on the *Adi Granth*, Sikh scripture, 'as cultural production or objects in themselves' (Deol 2003: 51). He addresses three kinds of manuscripts: (1) early manuscripts bearing pieces of paper with the handwriting of a Guru (*nisan*s) on their opening folios; (2) those with illumination or decoration (usually called *minakari* or *belbuta* in Punjabi); and (3) illustrated manuscripts proper. Most illustrations were produced in the nineteenth century, and some contain both Sikh and Hindu figures together. One of the most interesting aspects of his writing is the illustrated scripture used for Minas (the descendants of Priti Chand, who fought with Guru Ram Das). He suggests the possibility that this sect constantly displays its scripture in public, considering its size and sumptuousness. He regards the second quarter of the nineteenth century at the end of illuminated and illustrated manuscripts, including the *Adi Granth*. This was as the makers, such as artists and illustrators, were replaced by cheaper lithograph and type printing.

Kavita Singh's chapter, 'Allegories of Good Kingship: Wall Paintings in the Qila Mubarak at Patiala', explores the reasons why the Vaishnava theme was adopted in the murals of the Qila Mubarak in Patiala. The Qila Mubarak was built during the reign of Karam Singh and renovated by his son, Narinder Singh, the greatest patron of the arts in the state. She argues that the image of Krishna as an adult was conflated with that of a king in representations of God, good and justice. Moreover, Patiala *maharaja*s were originally descended from a Rajput family from Jaisalmer. She notes that the *Prabodhachandrodaya* was a popular text for illustration among Pahari artists working in Patiala, along with themes of Krishna's and Vishnu's *avatar*s. She

ultimately concludes that these murals played a talismanic role in the palace.

Goswamy's chapter, 'The Changing Face of Things: Little-known "Sikh" Portraits from Patiala', draws attention to portraits of the less privileged class or ordinary people owned by the descendants of Patiala artists, who originally migrated from the Alwar–Jaipur region. (It is said that the descendants of the Seu-Nainsukh family, such as Chhajju, Devi Ditta, Kehru, Kehr Chand and Saudagar, worked in Patiala beside Biba and his brother, Gohi, from another Pahari family. Likewise, Muhammad Sharif and his father, Basharat Ullah, migrated from Delhi and worked in Patiala. Similarly, Ude Ram Jaipuria, Ganda Baksh and Sheo Ram came from Rajasthan, according to oral information.) When we return to portraits of ordinary people, they are depicted in either frontal or three-quarter views, rather than the profile view that prevailed in the early modern period. They also show a sense of warmth. Goswamy suggests the possibility that these portraits were not commissioned for specific patrons but created as a gift to a neighbour or someone from whom the painter might have borrowed money.

Divia Patel's chapter, 'Symbols of Identity: Photographs of a People', claims that Sikhs reconstructed their identity through recordings and photographic documentation. Specifically, they acquired a general image of warrior/heroic solider and wealthy, exotic maharaja. The former is represented by images of the Akali, who are armed and have a distinct appearance. The typical Sikh trait of unshaven hair is considered to be in direct opposition to the Hindu ascetic, who 'proclaimed his holiness by shaving his head and renouncing society' (Patel 2003: 102). Their militant resistance to the British army enabled enlistment in it following the Anglo–Sikh wars (1845 and 1848). This recruitment was based on the fact that the Sikhs maintained their unique identity, represented by uncut hair and beards. In addition, a turban as a part of the army uniform became a standard of Sikh attire. Maharaja Dalip Singh also played a key role in creating this stereotypical image, as he was photographed with a turban manifesting his royal status. This habit was especially enhanced in the Sikh diaspora communities, which eventually gained the right to wear a turban, even in police work.

Urmi Kessar's chapter, 'Twentieth-Century Sikh Painting: The Presence of the Past', examines the loss and recovery of the pictorial tradition in Punjab in the late nineteenth to early twentieth centuries. She assumes that oils were introduced in the 1830s by Jeewan Ram and Hasn-al-din, who worked under the patronage of Lord William Bentinck. Indian artists struggled to consolidate two opposing aesthetics: the quaint and the exotic. After the annexation of Punjab into the British Raj in 1849, Sher Muhammad of Lahore gained fame for realistic portraits, while Gahia Natottam of Mandi was renowned for his inexpensive oil paintings of portraits and Hindu themes. Furthermore, some Indian artists painting in oil came from outside Punjab and their works are still in existence. The famous painter Raja Ravi Varma visited Lahore in 1887, and Bamapada Banerjee (1851–1932), who studied at the Calcutta School of Art, visited Punjab and left portraits of members of the Bengali community settled there. The Gurus were also portrayed: we know a portrait of Guru Gobind Singh painted at Lahore in 1891 bears an inscription in Gurmukhi, which states it is a copy of an authentic portrait of the Guru prepared during his lifetime. The Gurus were painted even in woodcuts, which represent Guru Nanak as a venerable father figure and Guru Gobind Singh as a valorous fighter.

Anne Murphy's 2005 article, 'Materializing Sikh Pasts', comprises a chapter in *Sikh Formations: Religion, Culture, Theory*, vol. 1, no. 2. She aims to evaluate Sikh relics or relic objects, except for the *Adi Granth*, the Sikh holy text, in accordance with pre-existing concepts such as Marcel Mauss's *The Gift*, Appadurai's terminal commodities and especially Pierre Nora's Lieux de Mémoire (sites of memory), where memory remains within the context of the modern and historical worlds. Her primary materials are the weapons and clothes, etc., with which the Sikh Gurus and historical heroes are associated. These are most likely to be housed in historical gurdwaras, exemplified by the weighing stones of Guru Nanak in Gurdwara Hatt Sahib and his cloak in Chola Sahib. Citing others' works, she challenges Nora's idea that memory and history are originally divided and argues their continuation. Like the Buddhist tradition, holy relics underpin religious practice as they enable devotees to make contact with the physical body of the

worshipped. This means that the investigation of holy relics is effective in considering religious practices.

Susan Stronge's article, 'Maharaja Ranjit Singh and Artistic Patronage at the Sikh Court', was published in 2006. Citing previous studies on the arts during the Sikh Kingdom, she reveals that Western art historians paid little attention to Sikh art and gave it a poor evaluation. This is also true of South Asian art historians, who tend to use primary sources written in their native languages rather than in English. She attributes such dismissal to the initial studies of Indian architecture, which regard Sikh architecture as a derivative of Mughal architecture. These studies focus exclusively on the Harmandir Sahib, the Golden Temple of Amritsar. Among them, some are based on classification by religion, although only Lockwood Kipling, the principal of the Lahore Museum, correctly detected their marked differences. Stronge demonstrates that Ranjit Singh renovated old buildings and gardens originally constructed by Sikhs using second-hand marble found in the ruins around Lahore.

Goswamy and Smith's 2006 catalogue, *I See No Stranger: Early Sikh Art and Devotion,* focuses on visual reflections of fundamental beliefs. Due to this concept, the volume inevitably presents many images of the Gurus in both portraiture and the *Janam-sakhi* representation. Regarding portraits of the Gurus, three examples are introduced from the written and oral information, referring to Randhawa and Macauliffe's accounts. It is pointed out that distinctive images of Guru Nanak emerged only in the late eighteenth century. In contrast, the authors insert newly published illustrations of the *Janam-sakhi*s, known as the Unbound set, from a collection of the Asian Art Museum, San Francisco. They claim that, considering the similarity in composition between the Unbound and the Guler sets, the sets were perhaps based on similar preliminary sketches. It is also valuable that this catalogue exemplifies many portraits of Sikh royalty, nobility and ordinary people.

Barbara Schmitz's 2010 volume, *Lahore: Paintings, Murals, and Calligraphy,* contains eleven essays written by art historians living in the city. In its introduction, she emphasizes two major periods of glory in Lahore, the state capital of the most advanced Punjab province in Pakistan. The first era comprises the reigns of the so-called Great

Mughals – Akbar, Jahangir, Shah Jahan and Aurangzeb (1556–1707). The second age is the rule of Maharaja Ranjit Singh and his two sons (1799–1843). The British and post-independence periods also marked significant development.

Nadhra Shahbaz Naeem's chapter, 'Fresco in Ranjit Singh's Samadhi', aims to oppose the traditional understanding that paintings from early nineteenth-century Lahore were a coarse derivative of the exquisite Pahari style. On the basis of Major Napier's letter to the British government (Naeem 2010), which does not mention the cost of completing the frescos, she argues that the frescos of Maharaja Ranjit Singh's tomb were painted between 1839 and 1849. Naeem points out three streams of art that existed in Lahore at that time: the Pahari tradition, the Westernized style of Delhi and the matter-of-fact style by European artists, a combination of which created the distinctive style of the Lahore school. According to Sohan Lal Suri's research and Syad Muhammad's 1892 note, darshan and ardas are considered to be the underlying programme or purpose for depicting Hindu deities and Sikh Gurus in the frescos. Both terms denote, in Sanskrit and Urdu, respectively, the ritual exchange of gazes between the sacred and the devotees in Hinduism and Sikhism.

Barbara Schmitz's chapter, 'Muhammad Bakhsh *Sahhaf* and the Illustrated Book in Ranjit Singh's Lahore', examines Muhammad Bakhsh, who was an employer and possibly a relative of Imam Bakhsh, a famous artist of early nineteenth-century Lahore. They seem to have belonged to a well-organized workshop rather than a group of freelancers. Muhammad Bakhsh was also the bookseller, bookbinder, painter and patron, although his first signed work, *Darbar of Nawab Muhammad Bahawal Khan*, dates back to 1846 in his later years. It is evident from his son Fazl al-Din's signature on a copy of al-Qazvini's *Aja'ib al-makhluqat va ghara'ib al-maujudat*, that Muhammad Bakhsh died no later than 1854. It is also demonstrated that his workshop underwent a radical change in style from 1819 and housed some illuminators and artists from the Kashmir district who used a Persian style and vivid colouring.

Humera Alam and Uzma Usmani's chapter, 'Ivory Paintings in the Collection of the Lahore Museum', analyses some of the 98 paintings on ivory owned by the Lahore Museum. Among these, 72

ivory pieces were acquired separately between 1864 and 1980, while the remaining pieces were donated by the Fakir Khana Museum in 1948. Their collection comprises ivory paintings by Delhi artists such as Ghulam Hussain and Lahore artists such as Elahi Bux; however, contemporary critics showed little respect for the quality of Lahore products, which were seen as mere imitations of Delhi products.

Nadhra Shahbaz Naeem's 2013 article, 'The Secular Sikh Maharaja and His Muslim Wife: Rani Gul Bahar Begum' comprises a chapter in *Indian Painting: Themes, Histories, Interpretations* (2013). In its last part, she analyses the wall paintings of Rani Gul Begum's tomb, which were commissioned by the Begum. It is demonstrated that they are among the most important murals of the period because, unlike other buildings, the tomb bears Persian inscriptions indicating construction dates of 1855-6. Moreover, the author points out that mango trees are considered a symbol of fertility, as they are used in many religions of the subcontinent, but it particularly reminds us of Ranjit Singh's tolerant policies against other religious communities.

Louis E. Fenesh's corpus, *Woven Masterpieces of Sikh Heritage: The Stylistic Development of the Kashmir Shawl under Maharaja Ranjit Singh 1780–1839,* was published in 2010. She argues that three changes occurred during the Sikh rule of Kashmir.

First, the pattern began taking over a significant portion of the shawl's surface, causing the *palla* height to be greatly enlarged. Second, freely spaced designs were mostly eliminated in favour of dense and tightly packed floral arrangements – a style that adhered to a *horror vacui* mindset. Thirdly, a particular style, based more on symbols and geometry than natural flowers, evolved (p. 155).

It is suggested that the flowery work stemming from the Kashmiri shawl evolved as decoration in Sikh manuscripts of the *Guru Granth Sahib* or the *Adi Granth* between the late seventeenth and early eighteenth centuries. Fenesh observes that Kashmiris were fond of red and other dark colours and that the vivid moon shawl proliferated in the second decade of the nineteenth century.

Nikky-Guninder Kaur Singh's 2013 article, 'Corporeal Metaphysics: Guru Nanak in Early Sikh Art', comprises a chapter in

History of Religions, vol. 53, no. 1. By examining the so-called B-40 set of the *Janam-sakhi*s illustrations painted by Alam Chand in 1733, she aims to reveal the cognitive and performative function of Guru Nanak's *body*, which should not be displayed in the presence of the Sikh scripture; this is in accordance with Gadamer's hermeneutic framework, whereby images are uniquely situated halfway between a sign (pointing-to-something) and a symbol (taking-the-place-of-something). Kaur asserts that Guru Nanak physical image allows viewers to undergo the divine, just as *Guru Granth Sahib*, the Sikh holy text, does.

Nikky-Guninder Kaur Singh's 2015 article, 'Visual Phenomenology: Seeing-in Guru Nanak at the Asian Arts Museum', comprises a chapter in *Sikh Formations: Religion, Culture, Theory*, vol. 11, nos. 1-2. Her primary focus is the so-called Unbound set of *Janam-sakhi*s illustrations, owned by Satinder Kaur Kapany, now housed in the Asian Arts Museum, San Francisco. Referring to Rochard Wollheim's and Susanne Langer's theories of the visual, she attempts to analyse some folios of the Unbound set. According to her personal conversation with the owner, Dr Kapany, Kaur attributes the Unbound set to Patna, where his great-grandfather worked as the chief custodian at the Gurdwara Sahib. She opposes Goswamy's suggestion that the artist was a Muslim, arguing that the depiction of Shivalinga at Mecca indicates the engagement of a Hindu artist. Kaur also notes that Guru Nanak is painted both with a Hindu *tilak* and in a Muslim's robe and turban. It is assumed that the Unbound set was initially installed in a Sikh home and shared at their religious gatherings.

Kristina Myrvold's 2016 article, 'Sketches of Sikhs in the 1880s: The Swedish Vanadis Expedition and Hjamar Stolpe's Ethnographical Collection from Travels in Punjab', comprises a chapter in *Sikh Formations: Religion, Culture, Theory*, vol. 12, no. 1. She focuses on Hjalmar Stolpe's expedition to Punjab. Stolpe was the founder of the Museum of Ethnography in Sweden. This article addresses the fact that Guru Nanak, Hargobind and Gobind Singh were depicted in a semi-circular wall relief above the entrance to Gurdwara Bair Sahib in Sialkot, two pillars of which were decorated with Hindu motifs of Vishnu and Krishna, etc. Stolpe was talented at drawing and sketched

a full body of Nihang Sikh, whom he met in Sialkot, where he was gifted the Sikh weapons. He also purchased 31 paintings and the Urdu calendar for the year 1885, including images of Guru Nanak.

Paul Michael Taylor and Sonia Dhami edited *Sikh Art from the Kapany Collection* in 2017, which comprises 15 essays written by US researchers and is based on the collection of Narinder and Satinder Kapany, the directors of Sikh Foundation International in San Francisco.

Nirvikar Singh's chapter, 'Portraits of the Sikh Gurus', outlines the history of portraits of the Sikh Gurus, especially Guru Nanak, from the late seventeenth century to the present; this includes the earlier documents describing them. It is remarkable that Nirvikar Singh mentions the Sikh attitude towards idolatry in comparison with Muslims and Hindus. Sikhism approves in part of the representation of the Gurus unless they are worshipped and installed inside a congregation hall, while the major tradition of Islam prohibits visual representation of the Prophet Muhammad. However, Randhawa states that the prints of Sobha Singh's 1937 portrait of Guru Nanak, *Nam Khumari Nanaka Charhi Rahe Din Raat*, are worshipped as icons in many Sikh homes. Nirvikar Singh emphasizes the importance of the visual representation of the Sikh Gurus, as well as gurbani, the words of the Gurus in the Sikh scripture.

Jyoti M. Rai's chapter, 'The Nanakshahi: The Divine Sikh Coinage', analyses the Sikh silver and copper coinage known as the Nanakshahis, rupees that came from or belonged to Guru Nanak, which were minted in Amritsar and Kashmir from the early eighteenth to the early nineteenth centuries. It is assumed that few remain because those who possessed them were persecuted by the Mughals. Another tragedy is that the British East India Company gathered them and sent them to Bombay for minting Company currency. The Nanakshahis were uniquely produced to glorify the Gurus and faith, although they are multicultural in that they describe the Hindu calendar in Persian script. During Ranjit Singh's period (1799–1839), the Nanakshahis were likely to include the motif of the leaf, which symbolizes fertility and allows the illiterate to understand the Sikh subject matter. It is remarkable that some temple tokens minted as religious medallions include depictions of the Sikh Gurus, which follow the contemporary iconography seen in *Janam-sakhi* illustrations and portraiture.

Cristin McKnight Sethi's chapter, 'Faith and Identity in Silk, Cotton, and Wool: Textiles from the Kapany Collection', examines the traditional textile with four-petalled floral forms, known as phulkaris, that were produced by Jat women in rural Punjab. Some phulkaris depict figures, peacocks and horses, perhaps from life. These are different from Pahari rumals, notably from Chamba, in the use of expensive silk and metallic-wrapped thread. Figurative phulkaris include Guru Nanak with Bala and Mardana and a darbar scene of Sher Singh, son of Maharaja Ranjit Singh and ruler of Punjab until 1843. These were certainly influenced by contemporary court painting.

Although I have previously reviewed scholarship on Sikh art with special reference to images of the Gurus, I am able to point out the drawbacks of previous studies. First, while portraiture has been regarded as a primary genre of Sikh art, the definition of portraiture depends on the researchers themselves. In a broader sense, portraiture is a synonym for figure painting and a counter-concept of narrative painting. This suggests the possibility that single portraits are the only authentic form of this genre. Second, it is most likely the case that portraiture of the Gurus, particularly Guru Nanak, is more important in Sikhism than portraiture of royalty and nobility. However, this is linked inextricably to the Sikh doctrine that idolatry is strictly prohibited in scriptures, such as the *Guru Granth Sahib*. The relationship between portraiture of the Gurus and Sikhism's doctrine of prohibition of idolatry is not fully discussed. Third, scholars have overlooked how similar or different Guru Nanak is in comparison with Krishna in Hinduism and Muhammad in Islam. It is necessary to investigate how this impacted visual images and the role their portraits played for audiences.

2. Methodology

Since my primary focus is portraits of Guru Nanak as works of art, this research applies an approach founded in art history on the basis of Erwin Panofsky's theory of iconology (Panofsky 1972, originally published in 1939). Iconography/iconology is a more textual method of investigation than stylistic analysis stemming from Kantian aesthetics. In the Introduction to *Studies in Iconology* (1939), Erwin Panofsky proposes an expanded theory of iconography, which he

designates *iconology*. Exemplified by his encounter with a gentleman, he sets three levels of meaning that constitute his new methodology: the primary/natural, the secondary/conventional and the intrinsic meaning/content. The primary/natural meaning is a synonym for formal analysis, whereas the distinction between the secondary/conventional meaning and the intrinsic meaning/content is that the former includes images, stories and allegories, while the latter indicates symbolical values stemming from a certain civilization.

Although Panofsky's theory prioritizes symbolical values above form and narrative, it is impossible to separate them in a strict sense. For example, some facial expressions, such as *smile* and *agony*, are universally common across cultures. If a person's physiognomy represents his inner qualities, we can reveal his social status, including power, wealth and class, as well as his personality and mental condition. Furthermore, we can speculate about other biological features, such as gender and age. Gender is a state of being either male or female; however, these binary opposites are often blurred in contemporary understandings of sex. In other words, gender could be, in part, a social condition. Although ageing depends on individuals, age can be a more reliable criterion than gender. Thus, it is proposed that age is the first element in analysing iconic art, particularly portraiture.

Portraiture is a controversial genre because its definition is not as obvious as that of genres such as history painting, landscape painting, still painting and narratives. Some scholars aim to clarify the boundaries of the concept of portraiture from different perspectives. For instance, Freeland understands portraiture as 'a representation or depiction of a living being as a unique individual possessing (1) a recognizable physical body along with (2) an inner life, i.e. some sort of character and/or psychological or mental states', and (3) 'an act of posing or of self-presentation' (Freeland 2010: 5, 9). In contrast, Spinicci's definition is more flexible than that of Freeland. He expands Freeland's third criterion, that the sitter must pose to the audience, to the criterion that the sitter must be viewed as if he/she were posing (Spinicci 2009: 50). In addition, Maes (2015) argues:

Some object x counts as a portrait only if x is the product of a largely successful intention to create a portrait. The maker of the object intends that x is a portrait only if (a) they have a substantive concept of the nature of portraits

that largely matches the substantive concept held by a group of prior portrait makers, if there are any, and (b) the maker intends to realise that substantive concept by imposing portrait-relevant features on the object. (p. 315)

In addition, West (2004) argues:

(1) [P]ortraits can be placed on a continuum between the specificity of likeness and the generality of type; (2) all portraits represent something about the body and face, on the one hand, and the soul, character, or virtues of the sitter, on the other; (3) all portraits involve a series of negotiations – often between artist and sitter, but sometimes there is also a patron who is not included in the portrait. (p. 41)

Similarly, Lefevre (2018) defines portraiture as follows:

[A]n 'image', either flat or in the round, is to be considered as a 'portrait' according to three criteria: intention, perception, function. By 'intention', I mean that the artist/craftsman and/or his patron have deliberately chosen to represent, in one way or another, a specific and historically attested person. By 'perception', I assume that in order not to be an anonymous image, a portrait must be acknowledged as such by the viewer; this can be obtained through a visual examination or a written statement. Incidentally, it means that what may at first have been conceived as 'portrait' may become, if it is not identified, a simple 'image'. Finally, by 'function', I imply that, technically speaking, a 'portrait' is an 'image' like any other but that its specificity relies on the way it is used. (p. 34)

The problems of previous studies on portraiture are summarized as follows. First, except Lefevre, scholars presume secular portraiture in advance. The Western concept of portraiture often represents secular people such as royalty, nobility and even ordinary people as subjects. Religious icons of Christ are not called portraiture; rather, they are considered devotional images. Second, while West partially mentions the issue, scholars tend to dismiss a social relationship regarding portraiture. The interplay between the three agents – the portrait, its maker and its audience – gives rise to a new methodology for the study of portraiture in general, as Alfred Gell (1998) predicted.

Given the above, this research scrutinizes portraiture of religious persons that blur the boundaries between portraiture and idols. This article studies portraits of Guru Nanak, who is perhaps one of the best-known subjects for portraiture in contemporary South Asia.

Portraits of the Sikh Gurus are an overlooked field in the study of portraiture in South Asia, for it is contentious to regard them as portraiture. The Sikh Gurus are basically seen as holding attributes of both the profane and the sacred. Examining them bridges the traditional distinction between portraits and devotional images. At the same time, I draw attention to the role of the audience in defining the portrait. Sikhs are/were actively involved in the use of Guru Nanak portraiture and determining its social function. It is anticipated that this research will reveal the definition and social roles of portraiture from a South Asian point of view.

3. Organization

This volume comprises five chapters following the Introduction. It is arranged both chronologically and thematically. The main chapters are followed by concluding remarks.

Chapter 1, 'History of Sikhism and the Punjab Region', explains the establishment of Sikhism and the transformation of Punjab society from the late fifteenth to the early twentieth centuries. Although fundamental characteristics of Sikhism were created during the reign of the ten Sikh Gurus (1469–1708), and the rule of Ranjit Singh (1799–1839) realized political and economic unity in the region, the most significant development of Sikh society took place during the British period (1849–1947). After the annexation of the Punjab to the British territories in 1849, a new middle class was formed through the introduction of a capitalist-dominated economy. This class received a Western education. Indigenous communities were organized for self-determination, in opposition to the propagation of Christianity. They published religious periodicals and engaged in socio-religious movements; this included the Singh Sabha Movement, which aimed for the normalization of Sikh orthodoxy.

Chapter 2, 'Early Sikh Imagery in Narrative Painting', compares and analyses *Janam-sakhi* paintings such as the B-40, the Guler, the Unbound and so on in the eighteenth century. In the B-40 set, completed in 1733, Guru Nanak was painted in a three-quarter view, which enabled audiences to distinguish him from other figures. From the early to the later folios, his figure gradually became larger than

those of others. The images of him in the set were likely used for those of the Guler set, which was painted in the late eighteenth century. This is because the Punjabi painters of the time shared similar preliminary sketches across workshops (Goswamy and Smith 2006). It is noteworthy that the Guler set was produced in the Seu-Nainsukh workshop of the district (Goswamy 2000). Thereafter, painters began encircling Guru Nanak's head with a nimbus in the Unbound set, painted at the end of the eighteenth century. It is evident that the pictorial expression stems from the emperors in Mughal painting; however, its fundamental origin lies in the Christian icons that had been imported since the sixteenth century.

Chapter 3, 'Portraiture of Guru Nanak till 1849', reveals the attempts of local painters to deify Guru Nanak in their works from the early eighteenth to the early nineteenth centuries. With regard to extant artworks, portraits of Guru Nanak, including figure painting, date back to the late seventeenth century. Its tradition is different from the images of *Janam-sakhi* painting, which are reminiscent of the narrative painting produced in the Rajput courts. In comparison, the early portraits of Guru Nanak were copies of Mughal portraiture with regard to style and iconography. Another trait is that Guru Nanak is sometimes represented as a Hindu ascetic, apart from the fact that he is rendered exclusively as a Muslim saint in *Janam-sakhi* paintings. In terms of formal and stylistic analysis, it can be argued that only Hindu painters at the Mankot court, a Rajput native state in the Pahari hills, depicted Guru Nanak as a representative of their faith. Other Hindu and Muslim painters were likely to exhibit him as a Muslim saint. Finally, Guru Nanak came to be depicted at a Hindu-like frontal angle in a single portrait, which implies the pre-existing custom of Sikh idolization of him prior to the colonial period.

Chapter 4, 'Portraiture of Later Gurus up to 1849', describes the images of nine Sikh Gurus, including Guru Angad, Guru Amar Das, Guru Ram Das, Guru Arjan, Guru Hargobind, Guru Har Rai, Guru Har Krishan, Guru Tegh Bahadur and Guru Gobind Singh. Guru Angad is painted with a black beard in portraiture, in which he succeeded in the guruship from Guru Nanak. Guru Amar Das is painted as an old man, like Guru Nanak. Guru Ram Das is painted with both black and white beards. Guru Arjan is painted with a black

beard like Guru Angad. Guru Hargobind is painted as a warrior; he frequently rides a horse, holds a falcon and wears a sword. Guru Har Rai is painted with a black beard. Guru Har Krishan is one of the most recognizable because he is painted as a child. Guru Tegh Bahadur is painted as a warrior, like Guru Hargobind. Guru Gobind Singh is the most frequently painted in portraiture among nine Sikh Gurus; his military episodes reflect on his image, like those of Guru Hargobind and Guru Tegh Bahadur.

Chapter 5, 'Colonial Portraiture of the Sikh Gurus', demonstrates that Guru Nanak portraiture became a ground for Sikh identity in the colonial period. *Guru Nanak Dressed in an Inscribed Robe* is perhaps the most renowned portrait of him and is frequently used in catalogues. At a glance, this portrait is influenced by European painting while traditional patterns are applied as well. Considering the inscription written in the local script, the author argues that the patron of this painting was the newly-formed urban middle class. Since the portrait is a double-size traditional miniature painting, it was likely hung on the wall. Remarkably, portraiture of Guru Nanak was painted in both a full face and a three-quarter face; the former implies Hindu gods, while the latter manifests the uniqueness of the Sikh identity stemming from his iconography of *Janam-sakhi* painting. It is assumed that the portraiture of Guru Nanak is a cultural device that includes the ideas of different factions in Sikh society.

Some elements of the chapters of this book have already been published in the listed journals as follows.

Chapter 1

Ikeda, Atsushi, 2019a, 'The European Influence on Sikh Portraiture: Representations of Maharaja Ranjit Singh, Sher-e-Punjab (the Lion of the Punjab)', *Chitrolekha Journal on Art and Design*, Murshidabad: Aesthetics Media Services, 3(1): 1-16.

Chapter 2

Ikeda, Atsushi, 2019c, 'Early Sikh Imagery in Janam-sakhi Painting: A Comparison of the B-40, the Guler and the Unbound Set', *Sikh Formations: Religion, Culture, Theory*, 16(3): 244–68.

Chapters 3 and 4

Ikeda, Atsushi, 2019b, 'Cultural Negotiation in Early Sikh Imagery: Portraiture of the Sikh Gurus to 1849', *Sikh Research Journal*, 4(1): 21-44, Palo Alto; The Sikh Foundation International.

Chapter 5

池田篤史、2021年、「スィック教創始者グルー・ナーナクの肖像画の成立と展開―植民地期における変容とその社会的役割」、『南アジア研究』、日本南アジア学会

Ikeda, Atsushi. 2022. 'Portraiture of Guru Nanak, the Founder of Sikhism: Colonial Transformation and the Social Role', *Sikh Formations: Religion, Culture, Theory* (https://doi.org/10.1080/17448727.2022.2090793).

Ikeda, Atsushi. 2023. 'Portraiture of Guru Nanak, the Founder of Sikhism: Colonial Transformation and the Social Role', *Sikh Formations: Religion, Culture, Theory*, vol. 19, Issue 2.

CHAPTER 1

History of Sikhism and the Punjab Region

The Operation Blue Star by the Indian army in 1984 drew worldwide attention to Sikhism. During this operation, Sikh fundamentalists gained control of Darbar Sahib in Amritsar to demand the establishment of an independent Sikh state, the so-called Khalistan. They were keen on the revival of the Sikh golden age under Ranjit Singh's reign in the early nineteenth century. Indira Gandhi, the prime minister at the time, instructed the army to attack them. This resulted in her assassination by her Sikh bodyguards. Following this, Hindus committed genocide against Sikhs across the state.

Among the cities in Punjab, Chandigarh is the most developed because it was planned to be the new capital of the province. Jawaharlal Nehru was frightened not only about the potential threat of Pakistan but also about the Sikh independence movement. Amritsar, despite having the largest population in the province, still lagged behind Chandigarh in terms of infrastructure and public hygiene. Ochi (1992) points out that the Indian government invested less in Punjab despite its huge contribution to the national economy as a cornerstone of the food supply. Likewise, he indicates that almost all peasants in the province were Sikhs. Furthermore, the Sikh proportion of the Indian army was gradually reduced (33 per cent in 1947 to 12 per cent in 1981), according to a new policy of the central government to recruit soldiers in fair proportion across India. These policies increased the Sikhs' discontent with central Indian authority (Ochi 1992).

As the Khalistan movement took place between the 1980s and 1990s, Sikhs struggled to promote their tradition and culture in both Punjab and diaspora communities rather than continuing to promote their political claims for independence. The Shiromani Gurdwara

Parbandhak Committee (SGPC) played a central role in publishing works such as standard versions of the Recht Maryada (rules regarding Sikh belief and custom) and the Guru Granth (Sikh sacred text), and for this they spent 400,000,000 US dollars from the 1950s to 2003. Similarly, the SGPC established the Historical Research Board, the Sikh Reference Library and the Sikh Central Museum. In addition, they raised Sikh temples and sacred spaces, such as Damdama Sahib and Talwandi Sabo, to the status of takht (a throne or seat of authority) in 1966 and promoted celebration of the birthdays of Guru Gobind Singh and Guru Nanak in 1969 and Tegh Bahadur in 1975 (Mann 2004). 1999 was an important year for Sikhs because it was the 300th anniversary of the union of the Khalsa (faithful Sikhs), according to Guru Gobind Singh's teaching. Accordingly, the largest events ever planned for cultural, artistic and educational purposes were held; among these, several important exhibitions on Sikhism were held around the world.

In 500 years of Sikhism, the year 1849 was the milestone in which the Sikh kingdom (Khalsa Raj) came to an end after its fifty-year sovereignty, when the British East India Company gained control of Punjab. After the failure of the Indian Rebellion of 1857, the region was officially incorporated into the British Empire; which replaced the Mughal Empire (1526–1858), a Turco-Mongol Islamic dynasty. The subcontinent came under direct British jurisdiction; colonial rule had a huge impact on the politics, economy, society and culture of Punjab. Thus, this chapter explains the establishment of Sikhism and the transformation of Punjab society from the late fifteenth century to the early twentieth century. It comprises two sections: (1) Overview of Sikhism; and (2) British Colonialism in the Punjab Region.

1. Overview of Sikhism

(a) Guru Nanak, Founder of Sikhism

According to the hagiographic text, the *Janam-sakhis* (composed by later theorists), Guru Nanak was born in the village of Talwandi, located west of Lahore, in 1469. He received a revelation of divine will while working as a merchant in the town of Sultanpur. In the late 1490s, he travelled to hold dialogues with various people, accompanied

by only Mardana, a Muslim attendant. After his pilgrimage through various districts, Nanak settled along the river Ravi and established the town of Kartarpur (literally meaning a town in which God resides).

At the end of the fifteenth century, Nanak established Sikhism in the Punjab region. This region overlapped the modern territories of northwest India and eastern Pakistan. It is known that Nanak was influenced by Islamic mysticism, or Sufism, and the Hindu bhakti movement spread by *sant*s in north India, which highlighted devotion to Vishnu (Cole and Sambhi 1978). Nanak presumed a more abstract entity by using the vocabulary favoured by both Hinduism and Islam for the designation of the divine. In Sikhism, the absolute entity is ideally defined as Nirankar (invisible, formless). That is to say, Sikhism is a rigid monism that prohibits idolatry. However, Nanak approved the authority of the sacred texts, such as the Quran and the Veda, with criticism against the deterioration of both Islam and Hinduism. Thus, *Adi Granth* (the Sikh sacred text) contains works by Hindu and Muslim poets. Among them, Kabir (1440–1518?) occupies the major part, but there is no evidence to prove his personal teacher–pupil relationship with Nanak (Cole and Sambhi 1978).

The Sikh panth (community) in Nanak's era was called sangat (congregation) (Cole and Sambhi 1978). The community comprised four groups: peasants in nearby Kartarpur, lower-caste converts to Islam (this was probably the smallest group due to the ban by Muslim administrators [Mann 2004]), the merchant class of Khatri, to which Nanak belonged, and Jats. Jats were most likely from Central Asia and comprise two-thirds of contemporary Sikhs. They are considered descendants of Rajputs (son of a king) who were classified as aristocrats and warriors Kshatriya. Jats and Rajputs had different marriage customs, in that Jats allowed widows to remarry. It is noted that Hindus basically prohibited such practices. Nanak stated, 'There is no distinction in status between the rich/poor, the sacred/profane, the strong/weak and male/female distinctions, for we have only one God' (Mann 2004: 23).

In Sikhism, the term 'Guru' is the name of divinity as well as the designation of 'the person who removes ignorance and darkness, and who exhibits a revelation' (Cole and Sambhi 1978). Nanak is the only Guru of the ten Sikh Gurus to receive a revelation (Cole and Sambhi 1978). This led the later Gurus to use the inscription of Nanak to

insert their own verses into the sacred manuscript (Mann 2004). According to *Janam-sakhi*, Nanak nominated Lahina as his successor to Guru status. Lahina was the most educated disciple and was named Angad (follower, limbs, incarnation) (Mann 2004). In the early nineteenth century within the Sikh Kingdom, the Sikh coins illustrated Nanak and Gobind Singh as the most powerful (Mann 2004). Considering this evidence, Nanak is not only the founder of the sect and the first Guru, but he also underpins the fundamental Sikh thoughts and creates a spiritual relationship with his successors.

(b) The Establishment and Transformation of the Sikh Community

For its religious power, the Sikh community relied only on Nanak, the founder and first Guru of the religion. Kartarpur, where Nanak started a new community, was located along a pilgrimage route and was self-sufficient (Mann 2004). When the community (*sangat*) was established, candidates were required to pass a rite in which the tips of their toes were baptised with water, which was then drunk by other Sikhs (Mann 2004). Nanak recommended customs of belief and practice, such as morning bathing and thrice-daily prayers, which were conducted by Sikhs of that period. In addition to these individual doctrines, collective practices were implemented: eating in the common dining hall (*langar*) and singing with instruments (*kirtan*) (Mann 2004). In the community, the contribution to group benefits was praised over a guarantee of fair distribution. In this initial stage of Sikhism (around the end of the fifteenth century), Kartarpur had already established accommodations and a prayer hall (*dharamsala*) for visitors. These culminated in the construction of a Sikh temple, called the *gurdwara*.

Amar Das (1470–1574), the third Guru, introduced the administrative organization called Manji and split the sect into 22 branches (Mann 2004). He recommended eating in a common dining hall as an egalitarian notion to control Muslims and Hindus from different castes (Mann 2004). After that, Ram Das (1534-84), the fourth Guru, established the position of masand (the 'dignified position', or the native ruler). As a result, masands began to manage the local divine service. During the reign of Arjan (1563-1606), the fifth Guru, Sikh propagation caused conversion of many Jats (Mann

2004: 34-5). Moreover, *dasvandh* (taxation by 10 per cent) was institutionalised and apportioned to the budget for the common dining hall (Mann 2004). Emperor Jahangir executed Guru Arjan in 1606. After his martyrdom, the militant Khalsa replaced pacifist reformers in the Sikh community. Guru Hargobind (1606-44) started this process by constructing a fortress at Amritsar and the Akal Takht (seat of temporal authority) (Singh 2006). His decision to wear two swords representing *miri* (warrior) and *piri* (saint) further promoted it. Sikhs faced persecution, their institutions were attacked and guruship was challenged by heretic schism.

Modern Sikh identity is founded on two major innovations introduced by Guru Gobind (1658–1707). The Khalsa (the pure) were baptised by him on Baisakhi (New Year) in 1699. They devoted themselves to fearless defence of the community. External symbols of identity were established with the five Ks (*kesh* [unshorn hair], *kangha* [a wooden comb], *kara* [an iron bracelet], *kachera* [a white undergarment] and *kirpan* [a dagger]). Sikhs also started to designate themselves as Singh (male) or Kaur (female). The purpose of the Khalsa Declaration was to relish the status of masand and unify the administrative organizations fragmented across the Punjab district (Mann 2004). There were many factions during the time of Tegh Bahadur, the ninth Guru, and it is said that a masand shut the gate when the Guru visited Amritsar. Gobind Singh encouraged other leaders to renounce their authority by absorbing themselves into the Khalsa and undermining the authority of the Guru. Within the Panth, a pre-eminent position was enjoyed by the Singhs of Guru Gobind (Mann 2004).

Another purpose of the Khalsa was to challenge Mughal rule, which continued throughout the eighteenth century. The establishment of the Sikh Kingdom (Khalsa Raj) that Gobind Singh proposed was maintained even after the death of the Guru. In 1738, Nadir Shah invaded the Punjab district from Afghanistan, which promoted the militarization of the Sikhs (Mann 2004). By 1765, Lahore was controlled by the Sikhs, and their influence covered most of the Punjab district. The reason for this remarkable rise to power in the face of adversity, persecution and minority status was the collapse of Mughal rule rather than Sikh state formation. In particular, 'revolt of the common people', such as *rakhi* (protection), *misl* (militia) and *dal*

Khalsa (combined militias) was promoted by Sikh institutions against landlords, local, state and centralized authority. But if this revolution came after the revolt of peasant tribes, it was supported by the collective vision of Gobind's Khalsa which guaranteed 'the right of every Singh to fight, to conquer and to rule' (Grewal 1990, as cited in Singh 2000, 81).

Next, Gobind Singh relinquished the status of human Guru and elevated the sacred text *Adi Granth* to the status of Guru, namely, *Guru Granth Sahib*, which was enshrined in Darbar Sahib. The reason why the *Guru Granth Sahib* successfully replaced human Guru is because the most important mission of later Gurus was to propagate Nanak's words (*bani*). Sikh identity was demarcated much more distinctly and clearly by these two changes (Singh 2000).

(c) Sikh Kingdom: The Rule of Maharaja Ranjit Singh

The evolution of Sikh power is the most remarkable occurrence in the political history of the Punjab region in the eighteenth and nineteenth centuries. After Guru Gobind Singh died in 1708, Banda Singh (1670–1716) started an initiative for Sikh self-governance. The Khalsa, Gobind's followers, came to be classified into twelve divisions, or Misls. Their succession was basically a republic, but sometimes hereditary (Cole and Sambhi 1978). Among them, the Sukerchakia misl inaugurated 18-year-old Ranjit Singh as their head. He was to become most renowned as Sher-e-Punjab, or the Maharaja of the Punjab.

In 1799, Ranjit Singh unified the twelve misls into one state, or Sarkar-i-Khalsa, and gained control of Lahore, the second capital of the Mughal Empire. Ranjit Singh proclaimed the Court of Lahore and designated himself Maharaja in 1801. Therefore, his kingdom is also known as the Sikh Empire or the Empire of the Sikhs. In almost forty years, Ranjit Singh conquered Afghan territories to the west, Kashmir to the north and Lhasa and Tibet to the east. Following the 1830s, he reorganized the Sikh military in the Western manner by recruiting Napoleon's subordinates, such as Jean-François Allard and Jean-Baptiste Ventura. Partly because of the 1809 Sikh–British treaty that set the Sutlej as the military border between them, Ranjit's modernized army defended their land from the East India Company until the Maharaja died in 1839.

Ranjit Singh appointed governors (nazims) to rule his territories and developed centralized administrative power, which included the entire record of income and expenditure of the state (Grewal 1990). He introduced cash salaries for his court ministers and army generals. However, *jagir*s, or feudal land grants, often free from taxation, were still the most important mode of payment in the state. Some jagirs were bequeathed to descendants if they made an outstanding contribution to the state. This was particularly the case in religious lands. Another economic trait of Ranjit Singh's reign was the revival of cultivation and trade, which were supported in part by the grant of revenue-free lands. Ranjit Singh launched state loans to dig new wells. Such a state policy underpinned the cultivation and irrigation of land. This was followed by an increase in manufacturing based on family businesses such as the Kashmir shawl industry; the exception was salt production, which was monopolized by the state. Trade of agricultural, manufactured and natural products flourished under strong public security and the development of a traffic network (Grewal 1990).

In the Sikh Kingdom, all ethnicities, such as Hindu, Muslim and Sikh, were treated as equal. For instance, Ranjit Singh promoted people on the basis of their abilities, not their religion. Moreover, Persian was adapted as an administrative language and was also as important in scholarship as Sanskrit, whereas the Punjabi language and Gurmukhi script became more widely accepted as common ground. As a result, the regional identity of the people was gradually formed (Grewal 1990).

Nevertheless, the Sikhs comprised more than 50 per cent of the ruling class. The royal family were exclusively Sikh and all commanders of the army were the Khalsa. It is evident that a distinction between the Keshdharis and the Sehajdharis existed in the early nineteenth century, apart from minor sects such as the Akalis and the Nihangs. Although there was enough social differentiation in the community, it is certain that they were now governed by their own people. In many ways, the ideas of equality, the need for mobility, and the requirements of guerrilla warfare allowed the Khalsa creeds to match the milieux of the eighteenth and nineteenth centuries (Singh 2000).

Ranjit Singh's kingdom came to its end due to weak successors, royal rivalry and British intrigue. After Ranjit Singh died in 1839, the

Sikh Kingdom fell into succession conflicts among the royalty and nobility at the Lahore Court. Only three were enthroned: Kharak Singh, Nao Nihal Singh and Duleep Singh. Other important characters were the Hindu Dogra brothers, the Attariwala and Sandanwalia families and Maharani Jindan, who acted as guardian of young Kharak Singh. Afghan Muslim rulers also played a pivotal role during the last period, as they fought with the British, even after the Sikhs were defeated. The Treaty of Lahore (1846) and the subsequent annexation of Punjab by the British (1849) brought about the de facto end of the Sikh state (Singh 2000).

2. British Colonialism in the Punjab Region

(a) *The Rise of the Middle Class*

In the late nineteenth century, a huge change came about in the socio-economic structure of the subcontinent through the British colonial administration and the introduction of a capitalism-dominated economy. Under these circumstances, there was a surge in the wealthy class that had not existed in Punjab society before. The wealthy class was employed as the sector that required Western knowledge and techniques. A majority worked for the state government as civil servants. Others occupied vocations, such as lawyer, teacher, doctor, journalist, photographer and engineer (Sukhdev 2008).

However, Oberoi raises a question about the term 'middle class', or the wealthy class in the Indian context in the nineteenth century. He points out that 'petty bureaucrats and urban professionals could at best only dream of industrialization; thus this non-productive class could not appropriately be named middle class' (1994: 260). For Oberoi, all words like 'professional Western-educated elements', 'intelligentsia' or 'lower-middle class' (petit bourgeoisie) do not fit them (Oberoi 1994: 261). Finally, he advocates the use of 'new elites' who gained access to 'Anglo-vernacular education and print culture', although he concedes such literate people to have been only about 7 per cent of the population. 'In 1891 only 19,274 out of an approximate population of twenty-three million Punjabis could speak and write English' and '[i]n 1886 there were 292 Punjabis belonging to the Subordinate Executive Service (Oberoi 1994: 262).

The new wealthy class received a Western education, including such subjects as critical thinking, science and Christianity, which were offered in English and Urdu by the state government. Due to the high expense, this education was in fact monopolized by the wealthy class. For example, Dyal Singh Majithia (1849-98), who was renowned as a Sikh modernist and studied in the Christian missionary school in Amritsar, maintained that Western thought should replace indigenous thought (Mann 2004).

With regard to vernacular education, the government school was established at Amritsar in central Punjab for the first time (Mehta 1929, as cited in Oberoi 1994). In 1856, there were 35 such institutions, which were located at Rawalpindi, Gujarat, Shahpur, Multan, Jhelum and Jalandhar. The establishment of a new educational department produced 107 schools in cities and 456 schools in villages, including two schools to train teachers at Rawalpindi and Lahore (Oberoi 1994). In addition, a medical school was opened in Lahore in 1860. In 1868, the Anjuman-i-Punjab launched a law school in Lahore and its examination system in 1874 (Oberoi 1994). Moreover, Gottlieb Wilhelm Leitner, its chairman, built a university college in 1870. This college comprised three schools: the Oriental College, the Government College and the Medical School. The college was quickly upgraded to be the Oriental University (Oberoi 1994).

The primary subject at the schools was language. Earlier, in 1855, Urdu became the official language in local government instead of Persian; this occurred during the reign of the Sikh Kingdom (Ashok 1974, as cited in Oberoi 1994). The Oriental College, which originated as a Sanskrit school in 1863, began Arabic and Persian education under the management of the Anjuman-i-Punjab. After 1870, it became a part of University College (Oberoi 1994). In 1877 Gurmukhi Singh succeeded in introducing the Punjabi language as a subject at Oriental College, Lahore, through an official petition from the Amritsar Singh Sabha (Ashok 1974, as cited in Oberoi 1994). Gurmukhi Singh found 389 books and manuscripts in Gurmukhi characters in the Avtar Singh collection. This collection enabled teaching Punjabi in Gurmukhi script at Punjab University College in the Gurmukhi Department that was established in 1877 (Oberoi 1994). In 1879, Bhai Harsa Singh organized a Sikh congregation at Gurdwara Janam Asthan in Lahore to celebrate the birthday of the

fourth master, where he argued that Gurumukhi script should be taught in the Oriental College (Oberoi 1994).

In due course, the Sikhs began to teach Western culture and scholarship in the Punjabi language and Gurmukhi script. In addition, the Mayo School of Art was established in Lahore in 1875, which offered Sikh art students a curriculum in the Western technique of oil painting (Gurinder 2004; Nadeem 2003). Khalsa College was established in 1892, which held a *gurdwara* on campus and provided the wealthy class with a national education in such subjects as the history and beliefs of Sikhism (Gurinder 2004). In due course, the Sikh wealthy class by itself came to produce intellectuals and eventually promoted a redefinition of traditional thoughts, including idol worship and an enhancement of nationalism.

(b) Propagation of Christianity and Indigenous Communities

We have looked at the arrival of Western people and culture in Punjab in the nineteenth century. We will now explore the transformation of Punjab society through the propagation of Christianity and modern laws. Among religious groups in the Punjab, Hindus were the most radical and active because reform movements had already taken place in Bengal, where the colonial government was located. Muslims and Sikhs followed the actions of the Hindus.

In the nineteenth century, a new spirit of opposition was fostered on the Indian subcontinent against the propagation of Christianity and the British colonial administration. Christian missionaries arrived in Punjab in the early nineteenth century after the British Parliament revised the British East India Company's contract and licence in 1813 and then liberated travel to India (Sukhdev 2008). In 1835, American Presbyterian missionaries established a base in Ludhiana. After Punjab's annexation in 1849, they expanded their activities into densely populated areas such as Marwa and Maja (Khushwant 2008). In 1862, the Punjab Missionary Conference was held at Lahore (Oberoi 1994). Another example of the propagation of Christianity is Anjuman-i-Punjab, or the Society for the Diffusion of Useful Knowledge. It was established in 1865 by Gottlieb Wilhelm Leitner, president of Government College Lahore. The Anjuman acquired 300 members in 1877, including many potential Sikh leaders (Perrill, as cited in Oberoi 1994).

Christian missionaries expanded their activities in 1850, when the colonial government approved Christian converts to inherit land (Khushwant 2008). In the 1868 census, the second conducted under British rule, Sikhs numbered 1,144,090, or 6.5 per cent, Muslims comprised 55 per cent and Hindus comprised 22 per cent of the total of over 17 million (Oberoi 1994). In 1881, Punjab was the only state in which all ethnicities resided: Muslims at 50 per cent, Hindus at less than 40 per cent, Sikhs under 10 per cent (of 1,716,114) and a few Jains and Christians. In the census of the same year, there were 3,912 Christians; ten years later, there were 19,750 – 'an increase of 410 per cent' (Oberoi 1994: 222). This number subsequently soared to 37,980 in 1901 and 300,000 in 1921 (Grewal 1990; Jones 1989).

For Sikhs, the Indian army was an important sector in which to find employment after the Punjab annexation in 1849 and the Indian rebellion in 1857. In the former incident, it had threatened and resisted the British army for a long time. In the latter event, Sikhs supported the East India Company because the rebel army of 1857 took aim at the Mughal emperor on the throne, who persecuted them and killed several Sikh Gurus over the course of two hundred years. After 1857, Sikhs were regarded as the 'martial race' and were allotted military posts with priority by the British administration, which marginally raised the quota of Sikhs that could join the army (Singh 2000).

Indigenous communities, especially Hindus, were quite sensitive to Christian propagation throughout the subcontinent. For instance, Ram Mohan Roy (1772–1833) set up the Brahmo Samaj in Bengal in 1828. He stressed reform and enlightenment as well as ancient Hindu texts that guaranteed the authority of Hinduism. For him, idolatry and sati (widow martyrdom) were not innate characteristics of Hinduism; rather, they were acquired. The Brahmo Samaj was rebuilt by Debendranath Tagore (1817–1905) after Roy passed away (Metcalf 2001). In Punjab, Navina Chandra Rai, an accountant with the North Western Railway, established the Brahmo Samaj at Lahore in 1862-3 (Oberoi 1994; Jones 1989). The Samaj basically aimed to 'fulfill the need of Bangali officials who had followed the trail of the empire into Punjab' (Oberoi 1994: 223). It expanded into Bunnoo, Multan, Rawalpindi, Amritsar, Ropar, Shimla and Dera Ghazi Khan (Oberoi 1994). In 1866, the Lahore Sat Sabha (Society of Truth) was built by Lala Behari Lal, Pandit Bhannu Datta, Basant Ram, Navina

Chandra Rai and S.P. Bhattacharje. Their activities in Punjab culminated in the time of Dyal Singh Majithia (1848-98), the Sikh millionaire. Majithia graduated from the mission school founded in 1853 in Amritsar, in which classes were conducted both in local and international languages such as his native language Urdu, Persian and English (Oberoi 1994). He invited a Brahmin from Ferozepore and asked for his help in studying the Bhagawad Gita (Anand 1986, as cited in Oberoi 1994). In 1880, when Dyal Singh visited Calcutta and contacted many Bengali intellectuals and leaders, he participated in 'the inner circle of Brahmo leaders' (Oberoi 1994: 225).

In the same vein, the Arya Samaj was the place where Hinduism was deritualized/rationalized and minorities such as the Sikhs were absorbed (Singh 2006; Mandair 2014; Jones 1989). It was built by Dayananda in 1875, and its membership increased by 300 per cent per month due to the establishment of a library and a Sanskrit school. The samaj became a model for eleven other samajs he founded across the Punjab in places such as Rawalpindi and Jalandhar. Oberoi maintains, 'it envisioned a Hinduism free of polytheism, superstition, idolatry, child marriage, evil priests and social decadence' (Oberoi 1994: 279-80). The Samaj included some future Sikh leaders, such as Ditt Singh, Jawahir Singh and Maya Singh (Oberoi 1994), who encouraged the Singh Sabha movements in the 1880s (Singh 2006; Mandair 2014).

To propagate their beliefs, every sect distributed journals written in their own vernacular, although some were written in English. As a result, total publications increased from 6 per year in the 1870s to 160 per year in the 1890s. According to the 1911 census, there were approximately 600 publications in Urdu, nearly 450 in Punjabi and about 80 in English and Hindi. Half of them were published in Lahore, where printing technology was initially introduced (Sukhdev 2008). Oberoi points out three salient aspects of the printing press in India. First, it facilitated access to information stored in another community. Second, it standardized letters, vocabulary and grammar, which somewhat systematized a community. Third, Indian print culture was closer to an oral culture in that the names of authors were often omitted because the oral mode was still powerful in both rural and urban communities (Oberoi 1994).

In 1836, American Presbyterian missionaries began to publish

journals, tracts and pamphlets, which were written in Punjabi, Hindi, Urdu, Persian and Kashmiri. The sum of their publications amounted to 68,000 volumes over three years. Following this, they 'annually released six to ten million pages of vernacular literature'. In 1851, a Punjabi Grammar was published by the American Presbyterian John Newton. He and his cousin Levi Janvier produced the first English–Punjabi dictionary together. 'The Ludhiana Mission Press was the only corporation dealing with "the only Gurmukhi typefaces"' (Oberoi 1994: 220). Oberoi claims, 'The communication skills of missionaries helped not only in the interaction with potential converts but also played a creative role in the development and standardisation of north Indian languages like Punjabi' (Oberoi 1994: 220).

Vernacular presses were built at Lahore, Bhera and Kapurthala in the early 1850s The *Lahore Chronicle*, Lahore's first English-language newspaper, was launched by Muhammad Azim, the 'father of the press in the Punjab'. The *Kohi-i-Nur*, the first Urdu newspaper in Punjab, was also established by Harsukh Rai, a Kayastha from the North-Western Provinces (Oberoi 1994). As for publications by Punjabis, *Anwar-ul-Shams*, the first law journal of the province in Persian, Urdu and Gurumukhi, was launched by Buta Singh in 1866. The *Aftab-i-Punjab*, an Urdu weekly, and *Khalsa Prakas*, a Punjabi weekly, were started immediately afterward (Barrier and Wallace 1970, as cited in Oberoi 1994). Singh established a press branch at Peshawar, and then the *Rajputana Government Gazette* was established at Ajmer. A Kuka account indicates that Diwan Buta Singh first produced a printed edition of the *Adi Granth*, although 'at most approximately 3000 handwritten copies' were seen then (Nahar 1955, as cited in Oberoi 1994, 275).

The Brahmo Samaj began to translate its tracts into Hindi, Punjabi and Urdu in 1876, as well as a monthly magazine, *Hari Hakikat*, in 1877 (Oberoi 1994). Dyal Singh Majithia, a graduate of a Christian missionary school at Amritsar, published *The Tribune*, a 12-page weekly paper in English. Moreover, he translated the English lectures of Keshub Chander Sen into Urdu for the public (Oberoi 1994).

Similarly, the Anjuman-i-Punjab established a free public library in Lahore that comprised 1,431 volumes donated by British officials. The vernacular titles were limited to poetry and grammar, although the English titles included history and science (Oberoi 1994).

In 1881, the Arya Samaj requested that the local government approve Hindi in Devanagari script as an official language instead of Urdu in Shahmukhi or Arabic, although these were identical in grammar and almost all vocabulary. Muslims and Sikhs also followed suit and developed Urdu and Punjabi, in Gurmukhi script, as an official language. The government's decision to maintain Urdu as the official language intensified a sense of rivalry and competition among sects, particularly in job hunting, under the capitalist-dominated economy and the elections under democratic governance (Grewal 1990). In addition, the central government enacted legislation to establish local governments and required all provinces to follow the principle of 'communal recruitment', or a proportional number of representatives according to the population of communities. It escalated competition between the sects for a governmental post, the biggest share in the job market for modern occupations. Similar to Hindus, Muslims attempted to advocate for their own rights against the government. An example is Anjuman-i-Islamia, which Muslims organized with Anjuman-i-Himayat-i-Islam in Lahore in the 1870s to oppose the propagation of Christianity (Grewal 1990). The former requested the introduction of the reserved quota for Muslims in a governmental post in 1877. In 1896, the Central National Mohammadan Association, Punjab, objected to Hindu dominancy in the primary posts; this was a direct opposition to another community.

(c) The Sikh Socio-Religious Movement

The Singh Sabhas, a social and religious association, aimed to unify Sikhs in each city to confront Christian and Western powers, as well as Hinduism and Islam. The Singh Sabha was based on the Joint Stock Companies Law of 1860 (Mann 2004). The first Singh Sabha was established in Amritsar in 1873, the second in Lahore in 1879 and the third in Bhasaur in 1893 (Mann 2004). Afterwards, they established Khalsa Diwans in Amritsar in 1893 and in Lahore in 1896, which were responsible for Sikh cultural and public activities. These were absorbed into the Chief Khalsa Diwan in 1902 (Jones 1989: 114).

The Amritsar Singh Sabha, namely the Sri Guru Singh Sabha, was founded by Thakur Singh with the financial aid of Raja Bikram

Singh, the ruler of Faridkot. Thakur Singh is known for convening a famous meeting with Sikh leaders and scholars (Oberoi 1994). Bikram Singh was appointed Fellow of Punjab University in 1882 (Oberoi 1994). In the same year, he organized Khalsa Diwan, which was affiliated with 36 Sabhas. He strived to establish a Singh Sabha at Jalandhar and was in charge until his death in 1887. It is interesting that he introduced electric lights on the surface of the Golden Temple, which were switched on for the first time during Queen Victoria's Jubilee celebrations (Oberoi 1994).

We find no evidence to prove a specific manifesto written by the leaders of the Amritsar Singh Sabha, although Oberoi states that

it [Amritsar Singh Sabha] aimed at securing the future of the community, recording its customs, acting as a channel for transmitting traditions and representing the Sikh cause before the colonial state' referring to Avtar Singh's observation that 'at that time it was deeply felt that efforts must be made to safeguard the ancient customs, rites and ritual of the Sikh community.

Their meeting was often held 'at Manji Sahib, a Sikh shrine on the periphery of the Golden Temple' (Oberoi 1994: 236, 244), which was fixed in 1890.

Another prominent figure is Baba Khem Singh Bedi, who was a descendant of historical Sikh Gurus (Oberoi 1994; Mandair 2014; Jones 1989). He was employed by the colonial government in 1857, the year of the Indian rebellion. In 1879, he was selected for 'the honour of Companionship in Order of the Indian Empire' as well as 'Knight Commander of the Indian Empire' (Nahar 1933, as cited in Oberoi 1994: 249) in 1898. Khem Singh Bedi was promoted to be a 'charter member of the Senate established in 1869 to run Punjab University College' and contributed to female education in Rawalpindi, Jhelum and Gujarat. He was a founding member of the Anjuman-i-Punjab and was then appointed president of the Khalsa Diwan in 1882.

The conservative attitude of the Amritsar Singh Sabha towards religious subjects promoted the foundation of the Lahore Singh Sabha (Mandair 2014), on 2 November 1879. It planned for the regular issue of proceedings on Sundays and later organized the annual conference, or Jalsa (Oberoi 1994). Oberoi assumes that Sunday was available for members of the newly wealthy class (Oberoi 1994). The

Sabha was managed under the cooperation of the Amritsar Singh Sabha. For example, Khem Singh Bedi was a member and Thakur Singh Sandhanwalia was engaged in proceedings. The Lahore Singh Sabha acquired 268 members in the early 1880s (Oberoi 1994).

Thereafter, Attar Singh supported the foundation of a Singh Sabha at Ludhiana in 1884 and became its president (Oberoi 1994). Likewise, Baba Khem Singh built a Singh Sabha in his hometown, Rawalpindi. Raja Bikram Singh founded a Sabha in his region, Faridkot. Kanwar Bikram Singh started a Sabha in his native city of Kapurthala (Oberoi 1994). Ram Singh, who belonged to the Singh Sabha at Dera Khalsa, launched a new Sabha at Ghila. In 1893, Panjkora gained a Sabha under the auspices of the Ambala Cantonment. In addition to hometown and distance, migration was also an opportunity to create a new Singh Sabha. For instance, Sant Singh, who belonged to the Ferozepore Sabha, moved to Delhi and established a Sabha in 1896. The Agra Singh Sabha was an exception, as it was set up by Sikh students at the local medical college (Oberoi 1994). In total, 115 Sabhas were organized in Punjab, Malaysia and Hong Kong (Oberoi 1994; Ballantyne 2006).

In 1883, the Amritsar Singh Sabha also published the biographies of Sikh Gurus, entitled *Sri Gurpurab Prakas*. Written in Gurmukhi script, the volume comprised 80 pages (Oberoi 1994). In 1887, Ernest Trump wrote an exegesis of the *Adi Granth* in Gurmukhi script (Macauliffe 1958, as cited in Oberoi 1994). The complete edition was published as *Sri Guru Granth Satik* in 1905-6 (Oberoi 1994). H.T. Colebrooke donated it to the Library of East India House in 1815 or 1816 (Oberoi 1994). In addition, Hazara Singh, a member of the Amritsar Singh Sabha, released a commentary on the *Adi Granth*, mainly Kabir's part, and the glossary in 1899. He added commentary on the writing of Bhai Gurdas. Hazara Singh contributed to the hymns from the *Adi Granth* in Max Macauliffe's monograph on Sikhs in 1893 (Macauliffe 1909, as cited in Oberoi 1994). Khem Singh Bedi established a monthly magazine, *Sri Gurumat Prakasak*, in 1885 (Oberoi 1994).

As for the Lahore Singh Sabha, Gurmukhi Singh launched a weekly paper, the *Gurmukhi Akhbar*, in Punjabi in 1880 and a monthly journal, *Vidyarak*, a year later. After the Khalsa Press was started in Lahore in 1883, an Urdu weekly magazine, the *Khalsa Gazette*, and a

Punjabi weekly magazine, the *Khalsa Akhbar*, were started in 1884 and 1886, respectively. These were followed by a monthly magazine, *Sudharak*, in 1886, under the control of Gurmukhi Singh (Jagjit [no year], as cited in Oberoi 1994). However, the Khalsa Press and the *Khalsa Akhbar* were closed due to friction between the Amritsar and Lahore Singh Sabhas (Oberoi 1994).

In 1880, the Amritsar and Lahore Sabhas merged. At the same time, the Sri Guru Singh Sabha General was established; it was seen as the representative of all the Sabhas. The Khalsa Diwan at Amritsar replaced it in April 1883 to unite Sikhs of different ideologies (Oberoi 1994; Jones 1989). The official positions were taken over by the pre-existing leaders: Bikram Singh and Attar Singh as patrons, Baba Khem Singh as president, Man Singh (manager of the Golden Temple) as vice president, and Gurmukh Singh and Ganesha Singh as secretaries (Oberoi 1994; Jones 1989). It was followed by the foundation of another Khalsa Diwan at Lahore in 1886 by Gurmukh Singh, comprising of at least 30 *sabha*s (Oberoi 1994; Jones 1989).

In addition, the Sikh community was undergoing a so-called 'identity crisis' in the late nineteenth century. The Singh Sabhas monitored the participation of Sikhs in the Arya Samaj, but did not forbid it on the grounds that the Samaj initially produced both Hindu and Sikh leaders. However, Bhai Jawahar Singh and Bhai Dir Singh Giani withdrew from the Samaj and affiliated themselves with a Singh Sabha in 1888 when an Arya leader offered the criticism that Sikh Gurus imitated Hindu Gurus. Moreover, the Lahore Khalsa Diwan stated to the Governor General that Sikhs should not be identified as Hindus. Likewise, Bhagat Lakshman Singh opposed Bawa Chajju Singh's idea that Sikhism is a reformation of Hinduism and Sikh sacred texts were copies of Hindu texts. For him, Sikhism was a characteristic system rather than a secondary body of Hindu philosophy. However, Sikh hostility moved from Hinduism to Christianity in 1900 when the Arya Samaj held a ceremony to reconvert a Sikh by cutting his hair in public (Grewal 1990). Apart from these, we can see the conflict between Sikhs and Muslims, which is less serious than that between Sikhs and Hindus. In 1890, Mirza Ghulam Ahmad launched the movement to justify Islam based on the Quran and propagate the second advent of the prophet Muhammad. The Ahmadi movement generated a religious body in 1901 and argued that Guru Nanak,

founder of Sikhism, was a sort of Muslim, which provoked Hindus and Christians beside Sikhs due to the fear of Muslims increasing under democracy (Grewal 1990).

In 1901, the local government implemented the Punjab Land Alienation Act to stabilize the rural area supplying the imperial army (Singh 2000). It incurred political opposition from lawyers and bankers for the Arya Samaj because the Act protected traditional landowners, or *zamindar*, comprising conservative Hindus. At the same time, the construction of the Canal Colonies in the western Punjab made the barren land 'fertile and cultivable plots by canal irrigation' and produced 'patriotic' and 'loyal' cultivators (Singh 2000, 83). The Land Alienation Act was chronologically followed by the setup of the Chief Khalsa Diwan in 1902, the Punjab Singh Sabha in 1907 and the Punjab Hindu Sabha in 1909; all three sabhas integrated into a national party, the Hindu Maha Sabha, in 1913.

In the meantime, the concept of private property, introduced by Britain, raised an important question about the management of Sikh temples, the *gurdwara*. As British officers registered the temples under the individual name of the *mahant* (traditional custodian), the Udasi sect declared their right of ownership regardless of Sikh rule. The Udasi were the followers of Sri Chand, who was the son of Guru Nanak. They emerged following the conflict of succession of the second Guru Angad. The Udasis were initially engaged in Hindu rituals, although they seemed to follow Sikh customs at that time due to their self-consciousness as successors; however, it is possible that they were not seen as Sikhs (Mann 2004).

The dispute over the management of the gurudwara incurred lawsuits and riots. In the end, 4,000 were killed, 2,000 were injured and 30,000 people were jailed. The fines owed by participants reached 5,000,000 rupees; it was in this mess that the Akali Dal emerged, which later developed into a religious party. After the implementation of the Gurdwara Act in 1925, the SGPC was created to manage and control the Sikh *gurdwara*, whose headquarters were located in Darbar Sahib. The SGPC functioned as a parliament and was seen by Sikhs as the modern version of the *guru panth*, which Gobind Singh created as the decision-making body (Mann 2004). Sikhs regarded the Shiromani Akali Dal (SAD), which had led the movement, as the 'political wing of the SGPC'. The SGPC and the SAD created a self-

governing religious community compared to the Sikh political system. Thereafter, religion and politics became inextricably linked in Sikhism (Singh 2006).

Conclusion

To conclude this chapter, I would like to suggest two reasons that portraits of Guru Nanak began to be hung on walls, considering the social circumstances of colonial Punjab. First, Christian icons might have been brought into the Punjab region in the late nineteenth century. Christian missionaries of that time propagated their beliefs under the auspices of colonial bureaucracy, and the Bible was disseminated among the Punjabis (Grewal 1990; Singh 2005). I believe that the icons were used for propagation apart from the Bible. The Sikhs might have hung portraits of the venerated Guru Nanak on the wall, in the manner of the Christian icons that the devotees worshipped. However, it was not merely imitation; the Sikhs likely intended to oppose Christians by hanging portraits of Guru Nanak on walls.

Second, disputes about idolatry in Sikhism might affect the behaviour of hanging a portrait of Guru Nanak. The Amritsar Singh Sabha, which played a pivotal role in the Singh Sabha Movement, along with the Lahore Singh Sabha, claimed that the icons and idols of the ten Gurus were the manifestations of inclusive religious practice and the medium for worship (Fenech and McLeod 2014). It is pointed out that members of the Amritsar Singh Sabha had some sympathy for Hindu sacred texts and the practice of idolatry (Ballantyne 2006). As such, there was an atmosphere among the Sikhs in which idolatry was tolerated despite the Sikh doctrines. This likely allowed the Sikhs to approve of the act of hanging portraits of Guru Nanak on walls. However, this differed remarkably from the idolatry performed by Hindus. In Hinduism, *darshan*, the act of exchanging gazes between devotees and divine statues, is regarded as important. In contrast, it seems that such behaviour does not exist between portraits of Guru Nanak and the Sikhs. This is because Guru Nanak is not a God, but, I dare say, merely a prophet, bridge between God and His devotees, which generated the distinction between Hindu idols and portraits of the Sikh Guru.

CHAPTER 2

Early Sikh Imagery in Narrative Painting

Painters in the early stages of the development of Sikh art attempted to create a distinct artistic form for the depiction of the Sikh Gurus, particularly Guru Nanak, in *Janam-sakhi* painting. McLeod (1991) points out that Sikh art stems from illustrations of the *Janam-sakhi*s. In his opinion, paintings of the *Janam-sakhi*s are the most important in the study of early Sikh art. Furthermore, *Janam-sakhi* painting is considered the richest source of representations of Guru Nanak. In addition to *Janam-sakhi* painting, the Sikh Gurus were depicted with attendants in portraiture as well. Guru Nanak was rendered in both narrative painting and portraiture, whereas later Gurus were painted predominantly in portraiture. The exception is Guru Angad, the second Guru, who was described several times in the texts of the *Janam-sakhi*s. Similarly, paintings of an assembly of the ten Gurus were a popular form in their representations. In addition, the Gurus were represented in murals in temples and palaces; some of these are still in existence, while others are merely described in various accounts.

The most important study of the *Janam-sakhi*s was conducted by McLeod (1980b). People often believe that the *Janam-sakhi*s translate to a 'biography' of Guru Nanak. Although they are related to the character of Guru Nanak and some elements certainly originate in his life, the *Janam-sakhi*s are not exactly a biography. In fact, they are better defined as a hagiographic account of his life. The difference between biography and hagiography is blurred, but we must understand the difference to have a deep understanding of the *Janam-sakhi*s. The *Janam-sakhi*s were not composed by later writers; rather, they constitute the early history of Sikh literature. The wonderful legends are not the

actual events of the Guru's life; instead, they offer us 'an interpretation of that life' or 'interpretation springing from the piety and commitment of later generations' (McLeod 1980).

With regard to terminology, authors of the *Janam-sakhi*s frequently used the word *sakhi* to indicate 'testimony', which was the belief that became the so-called 'myth of Nanak' in its specific form. In fact, they describe actual episodes from Nanak's life. They are considered to authenticate the soteriological status of Nanak and produce an essential myth. Thus, the earliest collections were merely called *sakhian* or 'testimonies'. However, the word *sakhi* changed its meaning slightly over time. The *janam-patri* is used for one of the earlier collections, which means 'horoscope', or more precisely, 'the piece of paper on which a person's horoscope is recorded'. Among the stories and episodes, only the opening anecdote about the birth of Nanak is suitable for the term *janam-patri*. It is certain, however, that the term refers to the collection as a whole. Eventually, the term merged with the previously used term *sakhi*, and *Janam-sakhi* was coined as a new compound. This compound has been in use ever since. The term 'biography' is used for translation into English. Although we sometimes encounter an old usage of *sakhi*, or testimony, its present meaning is an 'episode' or 'chapter' from the biography of Nanak. McLeod states, 'Individual incidents are recorded separately or in integrated series, and each incident or series is called a *sakhi*. The individual *sakhi*s have been gathered into collections, some random and some ordered. These collections constitute the *Janam-sakhi*s' (1980: 11). Although the *Janam-sakhi*s of other religious figures such as Kabir and Namdev exist, the term is exclusively used for Guru Nanak today. In other words, the *Janam-sakhi*s are generally translated not as a biography, but as the biography of Guru Nanak.

It is assumed that authentic memories concerning actual incidents from Nanak's life were the oldest parts of the *Janam-sakhi*s. Perhaps these anecdotes were disseminated in his lifetime when the legendary aspects could not have developed because of his actual presence. However, it is certain that the majority of *Janam-sakhi* literature in existence emerged after Nanak died in 1539 (McLeod 1980). McLeod (1980) points out three components of the *Janam-sakhi*s. The first is the received tradition prevalent in the Punjab region in the seventeenth

century. These received traditions comprise the Epics and Puranas, the Nath *yogi*s and the episodes from the Sufi tradition. The second important component was an ascetic tradition. Nanak rejected extreme asceticism, but its influence was deeply rooted in Indian tradition that was difficult to eliminate.

The primary component is Nanak's own poetic works, which were originally composed for the benefit of his followers. When the *Janam-sakhi*s were planned, the narrator likely inserted his hymns into it, which gradually prompted the making of anecdotes. These hymns were either Nanak's answer to an interlocutor or his own annotation to the content of the *sakhi*s. Although Nanak's own works are important, they are not a primary origin of the anecdotes. Most hymns of the *Janam-sakhi*s were added by later writers because they seemed to fit those anecdotes. Another source is the narrator's commentary on doctrinal issues in a dispute with the later community. Most hymns quoted in the *Janam-sakhi*s were written by Nanak himself and are contained in the *Adi Granth*. This also means that the *Janam-sakhi*s grew from the standard *Adi Granth* text. Nanak's hymns of the *Janam-sakhi*s were added to the *Adi Granth*, while others' works have not been detected in the holy text. It is possible that original works might not be mentioned in the *Adi Granth* but are maintained in an oral tradition.

Several scholars have studied *Janam-sakhi* painting. The earliest study focuses on the so-called B-40 set, which is housed in the British Library. The manuscript has been the most carefully studied because it contains the name of the artist and the date of execution. In addition, it has been well preserved and is in good condition. Hans (1987) published exquisite renderings of this B-40 set in 1987, with an introduction and brief captions in both Punjabi and English. Thereafter, McLeod (1991) discovered the earlier sets of *Janam-sakhi* painting. According to him, the first extant set is the Bala set, dating to 1658 (Samvat 1715) and owned by P.N. Kapoor of Delhi, which numbers 29 folios. The second set is the Bagharian manuscript dating to 1724 (S. 1781), which contains 42 illustrations. The third set is the B-40 manuscript, which was completed in 1733 (S. 1790) and comprises 57 illustrations. Although there are a few sets in the period of the Sikh kingdom, it is assumed that the production of painted *Janam-sakhi*s

declined with the introduction of printing presses to Lahore in the 1870s. Later, Goswamy (2000; 2006) discusses the Guler set of *Janam-sakhi* paintings that were created in the last quarter of the eighteenth century. Similarly, he introduced the Unbound set, owned by Sarinder Kapany and the Asian Art Museum, San Francisco. Recently, Kaur wrote an article on the B-40 and Unbound sets that discussed them in terms of religious studies (Kaur 2013; 2017).

The drawback of previous studies is that their methods are limited to the historical, philological and conceptual aspects of the works. Although this book attempts to explore the social and religious aspects of the formation and development of Sikh art, it seems to me that classical methodologies, such as formal analysis and iconography, are demanded for the study of *Janam-sakhi* painting at this stage. Thus, I begin by examining the early imagery of Guru Nanak in *Janam-sakhi* painting, including the B-40 set, the Guler set, and the Unbound set that were all painted before 1849, the year of British annexation of the Punjab. The materials discussed here are housed in the British Library (London), the Government Museum and Art Gallery (Chandigarh), the Asian Art Museum (San Francisco) and other public and private collections. This chapter comprises three sections: (1) The B-40 set of *Janam-sakhi* Painting; (2) The Guler set of *Janam-sakhi* Painting; and (3) The Unbound set of *Janam-sakhi* Painting.

1. The B-40 Set of *Janam-sakhi* Painting

The B-40 set is the most important among *Janam-sakhi* painting because its condition is very good and the set includes a large number, a total of 57 illustrations. In addition, the painter's name is inscribed, along with the date of production and the compiler's name. This information is described in folios 85a and 230b of the B-40 set.

- 85a: 'Bhai Sangu had this volume written by Dasvandhi's son, servant of the sangat. It was written by Daja, the son of Khatri in obedience to the sangat's wishes. The illustrations were executed by Alam Chand, Raj, servant of the sangat' (McLeod 1980b: 90-1).
- 230b: '[This Janam-]sakhi was completed on Friday, the third day of the light half of [the month of] Bhandon, Samvat

1790. It was written by one who is humble, contemptible, degraded, the slave and servant of the *sangat*; and it offers testimony to the humble submission of Daia Ram Abrol' (McLeod 1980b: 241).

The word *sangat* generally refers to a congregation of Sikhs. Hans claims that both Alam Chand and his patron, Bhai Sangu, were Sikhs (Hans 1987). We, however, must assess his argument for the reasons described below.

First, neither Alam Chand nor Bhai Sangu are named Singh, which is common and almost mandatory among contemporary Sikh males. The custom officially began during the period of Guru Gobind Singh in 1699, when he declared the union of Khalsa, represented by five devotees. Although Sikh males use the last name of Singh and Sikh females use Kaur, it is possible the origins of this custom date back even further than Gobind Singh, for Gobind Singh's reform of the community was no more than a prescription of the prevailing custom and fashion of that time.

Second, the B-40 set is painted not in Mughal style but in Rajput style, which features stylistic figures, bold backgrounds and vivid colouring, although the distinction between these styles was blurred at that time (Aitkin 2010). This suggests the possibility that the painter, Alam Chand, was employed by a Hindu patron and he himself was a Hindu; this explains the use of the Rajput style. If Alam Chand were a Sikh artist, he would have been trained by Hindu painters in their family workshop. Considering that the B-40 set is a manuscript, the patron could be a Sikh, and Hans's argument, 'by a Sikh for a Sikh', would be justified.

Moreover, the B-40 set was discovered in Lahore in the nineteenth century and obtained by the India Office Library in 1907 (McLeod 1991). Kaur insists that it was originally produced in Lahore or Gujranwala, or more likely Kapurthala, based on external evidence, although she did not mention any reference (Stronge 1999; Kaur 2013). Likewise, Kaur maintains that Alam Chand Raj belonged to the artisan caste known as Raj Mistris (masons and bricklayers), who contributed to Sikh art and architecture, along with the subcaste of Tarkhans (carpenters) (Kaur 2013).

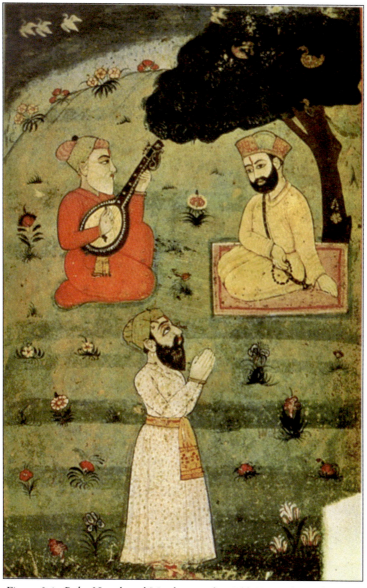

Figure 2.1: *Baba Nanak and Mardana with a Sikh.* From the B-40 set of *Janam-sakhi* paintings. By Alam Chand. Punjab. 1733. Gouache on paper. Hans (1987), plate 11

There is another issue that we should revisit. Hans argues that Guru Nanak is always painted larger than others, while Kaur asserts that his size is the same as others (Hans 1987; Kaur 2013). My research suggests that Guru Nanak's figure grows larger than others from the beginning to the end of the folios. In Baba Nanak and Mardana with a Sikh (Figure 2.1), Guru Nanak, who has a black beard and faces left in three-quarter view, takes a seat on the pink carpet on the grass. He is wearing red headgear with a green hat. A *tilaka* (a blessed mark for Hindus) is shown on his forehead. He is clothed in a yellow robe that is tied around his waist. A black cord is hung diagonally from his right shoulder. He is holding a rosary in his right hand and dropping his left hand onto the carpet. Above his head is a tree with green leaves that contains two birds. More birds are flying in the sky, which is painted dark green. Mardana, who has a white beard and faces in profile to Guru Nanak on the right, is sitting on the grass to the left. He is playing a string instrument, which is painted black and yellow. He is wearing a pink turban tied with a green sash. His robe is coloured orange and tied with a yellow sash around his waist. A Sikh with a black beard stands at the bottom. He faces right, in profile, looking up to Guru Nanak. He is wearing a green turban and holds his hands together to pay homage to the Guru. His robe is coloured white and tied with a gold sash around his waist. The grass and several kinds of flowers flourish on the ground; there is a curve at the top of the painting under the white layer. The colour of the grass is stronger at the bottom and weaker at the top. It is evident that Guru Nanak is not painted larger than the others, which suggests that the painter had a realistic attitude towards the depiction of Guru Nanak.

In contrast, Baba Nanak and Mardana, three Jogeshwaras with Kamla (Figure 2.2), depicts Guru Nanak and Mardana as much larger than other minor figures. Guru Nanak, who has a white beard and faces left in three-quarter view, is sitting on the grass on the right side at the top. He is wearing orange headgear with a green hat. He puts his right elbow on his raised right knee and drops his left hand to the ground. His robe is yellow and tied with a black cord around his waist. He is holding a white flower with his right hand and a black cord is hung diagonally from the right shoulder. Above his head is a tree with green leaves that contains several birds. Mardana, who has a white

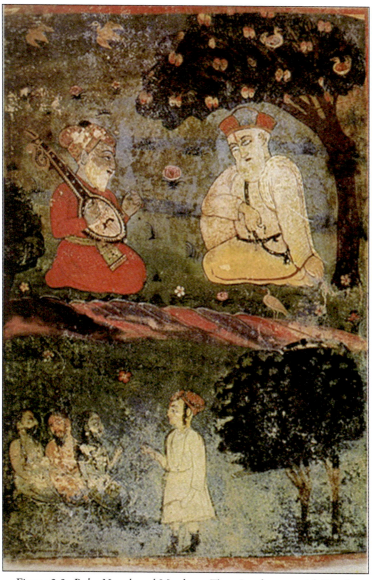

Figure 2.2: *Baba Nanak and Mardana, Three Jogeshwaras with Kamla*. From the B-40 set of *Janam-sakhi* paintings. By Alam Chand. Punjab. 1733. Gouache on paper. Hans (1987), plate 57

beard and faces right in profile, is sitting on the grass and holding a black and yellow string instrument with his right hand. He is wearing an orange turban and a red robe tied with a green sash around his waist. He is holding a flower with his left hand. A green bush is shown behind him. In the lower area, Kamla, who has no beard and faces left in profile, stands on the grass at the bottom. He is wearing a red turban and his braided sidelocks hang low. He is wearing a white robe and black shoes. His right hand is reaching ahead or to the left. Three naked ascetics are shown sitting opposite. Two of them have black beards and face right in profile; their bodies are painted green. The one who sits between them is depicted in three-quarter view, as if he is turning his head to look back. His body is painted differently, in flesh tones.

I would argue that Alam Chand initially followed the text of the *Janam-sakhi*s commonly written above the illustrations, but he gradually changed his attitude and came to emphasize the visual effect of the works. This is perhaps because earlier folios tended to have more complex compositions than later ones, which would represent his faithful attitude to the text. Later, he draws attention to Guru Nanak and his work becomes symbolic rather than realistic. This indicates that Guru Nanak was becoming more revered than other figures. From the feminist point of view, Kaur points out that Nanaki and Daulan, Nanak's sisters, are not painted in the B-40 set. This is because the text does not mention them. Their absence means that Alam Chand was faithful to the textual description (Kaur 2013).

Intriguingly, Bhai Mardana is painted on the same scale as Guru Nanak in almost all folios. It is remarkable that Mardana is painted even when the text does not narrate him. This is because his presence reinforces the authenticity of Guru Nanak's representation. In other words, his presence makes us identify the figure as Guru Nanak without relying on the text. Hence, based on my examination of the B-40, Alam Chand is contributing significantly to the development of iconography around the *Janam-sakhi*'s personification of Nanak, as he likely created Guru Nanak's common iconography.

Apart from Guru Nanak and Mardana, the B-40 set renders a tree behind Nanak that seems to be a substitute for a canopy, as both are frequently depicted in later works. Kaur lists other attributes of

Guru Nanak: halo, fly whisk, water pot, armrest and book (Kaur 2013). There is an iconography or symbology beyond the representation of Nanak being developed through the *Janam-sakhi* paintings.

It is evident that Alam Chand tends to fill the sky with birds (Hans 1987). I suggest three possible reasons for his depiction. First, he aimed for decorative effects to illuminate the manuscript. In Baba Nanak, Abdul Rehman, Mian Mitha and Mardana (Figure 2.3), some

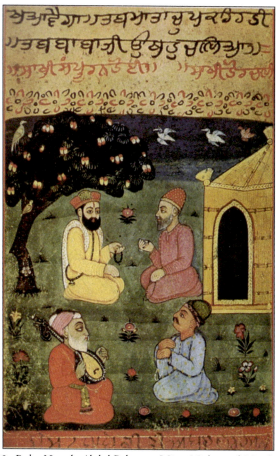

Figure 2.3: *Baba Nanak, Abdul Rehman, Mian Mitha and Mardana*. From the B-40 set of *Janam-sakhi* paintings. By Alam Chand. Punjab. 1733. Gouache on paper. Hans (1987), plate 7

letters are written in red in the inscribed text, following two-tone flowers. Trees are stylistic and their blossoms are vivid. The grass is covered by many flowers. For the painter, the rendering of the environment might be design and decoration rather than pictorial expression. In addition, Guru Nanak, who has a black beard and faces right in three-quarter view, is sitting on the grass under the tree; the tree contains several blossoms and a bird. He is wearing red headgear with a green hat and a yellow robe. A white shawl hangs on his shoulders and a black cord runs diagonally across his body. He is holding a rosary in his left hand and appears to be talking to Abdul Rehman. Abdul Rehman has a grey beard and faces left in profile; he is sitting on the grass. He is wearing a red skullcap with white edging and a pink robe. He is raising his right hand while speaking to Guru Nanak. His wooden hut stands behind him; the entrance is painted black. In the lower area, Mian Mitta, who has a small black moustache and is looking up to the left at Guru Nanak, is sitting with his legs folded on the grass. He is wearing a green skullcap and a blue robe. He is holding his right knee with his hands. On the left side, Mardana, who has a white beard and faces right in profile, is sitting on the grass while playing a string instrument. He is wearing a white turban tied with a wide pink sash and a red robe tied with a gold sash.

Second, birds might symbolize the concept of time; that is, they imply daytime, even when the background is painted black. Alam Chand attempts to grasp the concept of time in his illustration of revelation. In Baba Nanak in the Presence of God (Figure 2.4), Guru Nanak, who has a grey beard and faces up in three-quarter view, is standing on the grass. He is wearing red headgear with a green hat and a yellow robe tied at the waist over red trousers. A white shawl hangs from his shoulders and a black cord crosses diagonally from his right shoulder. He is holding up a white rosary in his hands. His eyes are closed and his expression seems enchanted. In the lower area, Mardana, who has a white beard and faces left in profile, is sitting and playing a string instrument painted black and yellow. He is wearing a white turban and a red robe tied with a yellow sash. On the left side is a slim tree with green leaves in which a white bird sits. A few flowers are painted on the grass, which is curved at the top of the painting and surrounded by trees. The sky is basically dark, but some clouds

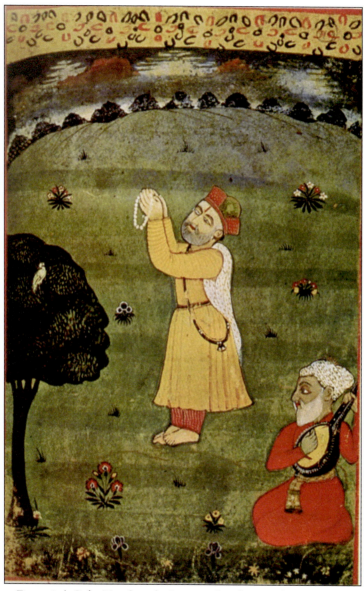

Figure 2.4: *Baba Nanak in the Presence of God*. From the B-40 set of *Janam-sakhi* paintings. By Alam Chand. Punjab. 1733. Gouache on paper. Hans (1987), plate 28

and twilight are shown. In this scene, Nanak's beard changes colour from black to grey, before and after the revelation. This means that he grew from a young man to a venerated sage. This might be the reason why the painter displayed so many birds in the sky.

Third, the depiction of birds might derive from preliminary sketches that were commonly used among painters of eighteenth-century north India (Figure 2.5). The rough drawings would have been larger than his completed paintings, as the folios are approximately 25 cm (height) by 14 cm (width), which is too small to draw in detail. Moreover, his illustrations indicate a high degree of perfectionism. When Alam Chand began painting each folio, he would have found it too small to pictorialize everything in the sketches that he had drawn in preparation for painting. However, he did his best; as a result, the area of the sky was filled with superfluous objects or birds. In addition, the scene of revelation has illustration number 28, which is the exact middle of the total of 57 illustrations. In short, the earlier phase is

Figure 2.5: *Janam-sakhi*. Artist unknown. Punjab. Eighteenth century. 50.8 × 63.5 cm. Black ink on paper. The Samrai Collection, London. Goswamy (2006), plate 1.29

Early Sikh Imagery in Narrative Painting 91

used for Nanak's youth, whereas the later phase is spent on his old age. The planned division allows us to imagine the presence of preliminary drawings.

Subsequently, it raises another question about the number of painters involved in the production of the B-40 *Janam-sakhi*. The stylistic similarities throughout the set suggest that the set was painted by a single person, namely, Alam Chand. It is not impossible to imagine that he completed the total number of 57 illustrations by himself. But I do not discount the possibility that some younger artists in his workshop painted the environment surrounding Nanak and Mardana, such as trees, sky, birds, grasses, flowers, mountains, animals, buildings and minor castes. Since painters normally belonged to private or family workshops and were commissioned by royal patrons, the system of dividing labour specialization was, and still is, common in the local tradition. This suggests that preliminary sketches preserved by the family were used in the production of the B-40 set.

In the meantime, it is evident that many folios share similar compositions. For instance, Guru Nanak and Mardana are painted in the upper area in folios 16 (Figure 2.6), 30 (Figure 2.7) and 57 (Figure 1.2), while the lower area includes minor characters described in the original text. Guru Nanak is always depicted to the right of Mardana, under the tree. Similarly, illustrations 26 and 54 are almost identical because Nanak is located on the left side under the tree and Mardana sits at the right, at the bottom. Another figure appears on the right side at the top, that is, opposite Guru Nanak. The same composition was used repeatedly because the spaces for illustration are limited in a folio. At the same time, perspective is not clearly shown in all illustrations. The shallow depth does not allow a painter to compose complex settings and forces him to use the same format over and over. This is chiefly because painters of the time did not have a high standard technique of shortening or perspective, although Mardana's instrument often shows this effect. Thus, almost all compositions adopted structural settings that represent geographical positions and sometimes different times and places.

Apart from these, Hans points out that there is a blank area or a place left unpainted in plate 25, and it seems like an incomplete folio (Figure 2.8). However, I would disagree with Hans' statement because

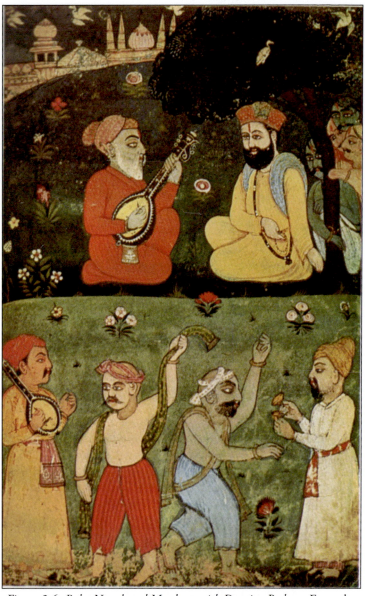

Figure 2.6: *Baba Nanak and Mardana with Dancing Pathans.* From the B-40 set of *Janam-sakhi* paintings. By Alam Chand. Punjab. 1733. Gouache on paper. Hans (1987), plate 16

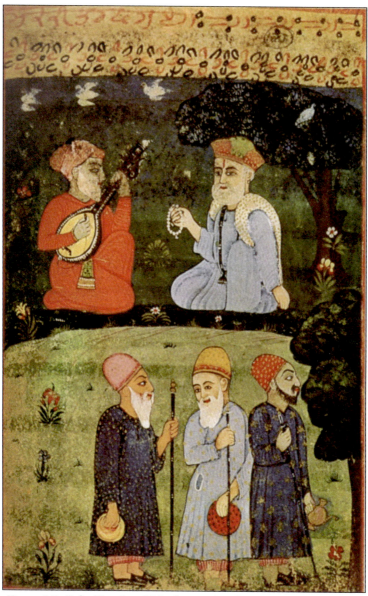

Figure 2.7: *Baba Nanak and Mardana with Fakirs on their way to Mecca.* From the B-40 set of *Janam-sakhi* paintings. By Alam Chand. Punjab. 1733. Gouache on paper. Hans (1987), plate 30

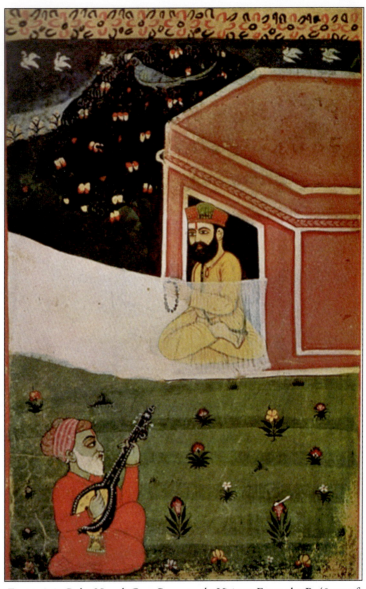

Figure 2.8: *Baba Nanak Gave Boons to the Visitors*. From the B-40 set of *Janam-sakhi* paintings. By Alam Chand. Punjab. 1733. Gouache on paper. Hans (1987), plate 25

the text says 'Baba Nanak would spread a cloth' (McLeod 1980: 116). This means that the white part of the illustration would be a cloth rather than a place left unpainted.

In illustration 37 (Figure 2.9), the faces of Nanak and Mardana lose the colouring of their noses, eyes and mouths. Their beards have a few black hairs. As no other illustration has similar features, this indicates that a later artist added the line of the nose, eyes and mouth, but did not paint them. Therefore, it is argued that only illustration number 25 is a sort of incomplete picture.

Regarding the issue of the three-quarter view of the face, Hans states:

Alam Chand Raj has recourse to a number of technical devices to portray the spiritual sovereignty of Guru Nanak. Guru Nanak's portrayal is divinized by painting his face three-fourth. All the other major characters are painted in profile. Alternatively a three-fourth face is shown only in the case of minor figures like school children (1), the prisoners of a demon (8) the Pathan revellers, (16) the temptresses (19, 34), a traveller to Durga temple (21), a pilgrim to Mecca (30), an ordinary man (36, 41, 42). The device of portraying the face three-fourth is at times cancelled by another one of a different kind. The demon's symbolic face (8) is cancelled by its animality; those of *siddhas* (20, 27, 44) by the smallness of their size; and those of the traveller to Mecca (30), Death (53), *jogeshwaras* (57) by their being in the lower plane. Only Kabir (31) is painted like Guru Nanak. His face is only slightly smaller in size; he is just a little on the lower plane. These little difference have a theological meaning. The affinity of Kabir and Guru Nanak had already been pointed out in relation to the device of white dress. (Hans 1987: 8)

In contrast, Kaur claims that a three-quarter view was used 'perhaps to create an artistic variation within the group?' (Kaur 2013: 36). Similarly, she explains, 'Without overpowering us with the Guru's frontality, he [Alam] produces a unique perspective of Guru Nanak as a three-dimensional figure' (Kaur 2013: 36). Although I agree with her former argument, I would oppose her latter opinion, for a three-quarter face is likely not a three-dimensional expression, but a sign of secondary divinity or for religious figures in early modern painting. For further discussion on this, see Ikeda (2017), where I classify a frontal, a profile and a three-quarter view depending on religious connotations in Hinduism and Islam.

Figure 2.9: *Baba Nanak and Mardana in the Country.* From the B-40 set of *Janam-sakhi* paintings. By Alam Chand. Punjab. 1733. Gouache on paper. Hans (1987), plate 37

In addition, Kaur asserts that Alam Chand's depiction of Guru Nanak tends to be a Muslim rather than a Hindu protagonist (Kaur 2013). She also claims that Nanak's turban, starting with his adolescence, is the roundish headgear of Sufi sages (Kaur 2013). McLeod (1992) argues that the iconography of Guru Nanak and Sikh was established in the B-40 set. He states, 'It is possible to identify a distinctively Sikh art and to affirm that tradition was well established before the middle of the 18th century.' However, he points out that the style is not 'uniquely Sikh', for the dependence on Sufi tradition is too apparent. He concludes that Sikh art depends on 'content rather than style', although it stimulated the surge in distinctiveness of Sikh style in the later period (McLeod 1991: 6-7).

2. The Guler Set of *Janam-sakhi* Painting

The Guler set is owned by the Government Museum and Art Gallery, Chandigarh, where B.N. Goswamy was the curator after he taught at Panjab University. From what I surveyed in the museum, the Guler set comprises ten paintings and 67 (brush) drawings, among which Goswamy published seven paintings and thirteen drawings in his catalogues, entitled *The Piety and Splendour: Sikh Heritage in Art* (Goswamy 2000), and *I See No Stranger: Early Sikh Art and Devotion* (Goswamy 2006). These volumes were published to celebrate the tercentenary of the union of the Khalsa in 1699. Furthermore, some paintings and drawings are reproduced in *Guru Nanak: His Life & Teaching*, written by Roopinder Singh (2004). The grand total of paintings and drawings of the Guler set outnumber the B-40 set of 57 paintings, although most folios of the Guler set overlap in painting and drawing. The complete paintings of the Guler set are very sophisticated in style and can be considered masterpieces of Pahari painting. It is evident from the stylistic analysis that the Guler set was produced at the Seu-Nainsukh workshop of Guler, whose works include, but are not limited to, highly esteemed paintings of Gita Govinda, Bhagabata Purana, Sat Sai, Nala Damayanti and Barahmasa.

The Guler set was produced at the Seu-Nainsukh workshop, but the painters did not necessarily live in Guler. Seu, Manaku, Nainsukh and their sons were born in Guler. They were commissioned by both

domestic and foreign patrons across the Punjab hills, which suggests that some of the descendants were born in their working cities. These circumstances make it difficult to identify where the Guler set was executed. Sansar Chand of Kangra was one of the most powerful rajas in the hills of that time. Garhwal was also an important site in the production of Guler–Kangra painting. Although we do not know where the Guler set was painted, it is probable that the set was prepared for a Sikh patron. The power of the Sikh was threatening to the Punjab hills in the late eighteenth century. Some hill states were conquered by Sikh armies. These incidents urged Pahari painters to work for Sikh patrons and some artists visited the Sikh ruling cities in the plain. Devi Ditta is one such case; he worked in Patiala for several years (Goswamy 1968; Paul 1998). It is noticeable that some Hindu patrons seemed to be interested in Sikh subjects, as some paintings of that time include both Hindu and Sikh subjects. B.N. Goswamy attributes these Guler–Kangra paintings to the last quarter of the eighteenth century (Goswamy 1992). This suggests the possibility that the Guler set of *Janam-sakhi* painting was produced in the same period (Goswamy 2000; 2006). Our interest here is not to identify the date and place of production but to examine the illustrations of the Guler set as best as possible. Thus, we will analyse its formal and stylistic features below.

First, it can be demonstrated that several painters, not a single painter, were engaged in the production of the Guler set. It was a common custom at the Seu-Nainsukh workshop, and other masterpieces were also painted on the assembly line. The presence of brush drawings supports this view. The master or senior painter drew the brush drawings and the apprentice or junior painters coloured them according to the instructions of their master or senior. For example, the Guler set showcases two different styles. One displays the rounded forehead of Guru Nanak, and the other exhibits the less rounded forehead for him. These observations suggest that multiple painters engaged in the production of the Guler set of *Janam-sakhi*s. It is assumed that the Guler set basically comprised more than 100 pictures when it was completed in the last quarter of the eighteenth century, because other sets of paintings from the workshop normally outnumber the figure. The famous *Gita Govinda* painting of 1730, which was depicted at the Seu-Nainsukh workshop, was executed by

at least three painters (Ikeda 2012). It is argued that the Guler *Janamsakhi*, with over 100 folios, required the involvement of at least two or three junior artists and one master. If we had more extant examples of the Guler set, we would be able to identify more people involved in creating its pictures. Unfortunately, we have only 10 paintings and 67 drawings now; however, it is possible to discover one master who probably drew sketches and two junior painters who depicted Guru Nanak in a different style.

In A King Pays Homage to Guru Nanak (Figure 2.10), the sentence below is inscribed both in Devanagari and Gurmukhi characters on verso: sakhi raje Madhurbain nal hoi (An encounter with Raja Madhurban took place). On the right side, Guru Nanak, who has a black beard and faces left in three-quarter view, is sitting cross-legged on an orange carpet under a tree with green leaves in which two birds sit. He is wearing orange headgear over a white bandana and a pink robe tied with a sash. A *tilak* is shown on his forehead. He is holding a stick under his arm and a rosary in his right hand. A manuscript lays on the carpet. On the left side, a king who has a black beard and faces right in profile is astride a horse. He is wearing a white turban and an orange robe tied with a white sash. A scarf hangs on his right shoulder. He is also holding the reins with his hands. The saddle is beautifully decorated and ornamented. Two attendants are sitting on the right side at the bottom. Bala, who has a grey beard and faces left in profile, is sitting with one bent knee. He is wearing a white turban and a red robe tied with a white sash. Mardana, who has a black beard and looks up to the king in profile, is sitting on his knees on the grass while playing a string instrument. He is wearing a white turban tied with a yellow sash and a white robe tied with a yellow sash.

In Guru Nanak in Conversation with Two Muslim Holy Men (Figure 2.11), the sentence below is inscribed in both Devanagari and Gurmukhi characters on verso: Babaji Yuch gaye [Babaji went to Yuch (Uccha?)]. On the right side, Guru Nanak, who has a black beard and faces left in three-quarter view, is sitting with Bala and Mardana. He is wearing a pink turban and robe. A white scarf hangs on his left shoulder and a black cord is crossed diagonally from his shoulder. He is gesturing with both hands. Bala, who has a black beard and faces

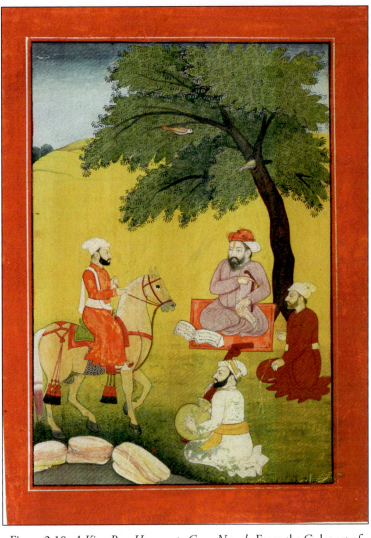

Figure 2.10: *A King Pays Homage to Guru Nanak*. From the Guler set of *Janam-sakhi* paintings. Attributed to the Seu-Nainsukh workshop. Pahari. Last quarter of the eighteenth century. 22.6 × 16.5 cm. Opaque watercolour on paper. Acc. no. 4072(3), Government Museum and Art Gallery, Chandigarh. Goswamy (2006), plate 1.7

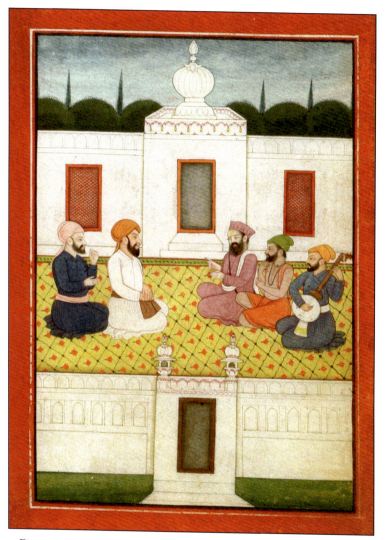

Figure 2.11: *Guru Nanak in Conversation with Two Muslim Holy Men.* From the Guler set of *Janam-sakhi* paintings. Attributed to the Seu-Nainsukh workshop. Pahari. Last quarter of the eighteenth century. 22.6 × 16.5 cm. Opaque watercolour on paper. Acc. no. 4072(6), Government Museum and Art Gallery, Chandigarh. Goswamy (2006), plate 1.9

left in profile, is sitting with his legs folded under him on the terrace. He is wearing a green turban and an orange half-pant. His upper body is bare, but an orange scarf hangs on his left shoulder. A black necklace hangs from his neck. He is also making some gestures about conversation. Mardana, who has a black beard and faces left in profile, is sitting upright while playing a string instrument. He is wearing a yellow turban and a blue robe tied with a white sash. On the left side, Ibrahim or Shekh Brahm and Kamal, his associate, are sitting upright on the terrace. Ibrahim, who has a black beard and faces right in profile, is sitting upright with his hands folded. He is wearing an orange turban, shaped differently from that of Sikhs, and a white robe tied with a brown sash. Kamal, who has a black beard and faces right in profile, is sitting while gesturing about the conversation. He is wearing a pink Muslim turban and a navy blue robe tied with a pink sash. The carpet on the floor is decorated with red flowers on yellow square tiles. At the bottom, there are painted walls with a door and gateway. Beyond the white building, including a door and windows, conifers and leafy trees are depicted at regular intervals.

An important feature of the Guler set is its complicated compositions. Unlike the B-40 set, the Guler set has a relatively better-organized perspective. Deep depth enables a painter to allow for more complex settings and compositions. This is perhaps because of the well-organized assembly line of the Seu-Nainsukh workshop. The master artist focused exclusively on the creation of distinctive compositions, and the junior artists concentrated on the completion of colouring. Although the master artist was also involved in the completion of colouring, his primary job was to produce preliminary drawings for mass production by later generations. Complex compositions were worthy of conservation and preservation because later painters would be able to reuse them. Thus, descendants of the Seu-Nainsukh workshop were likely to inherit these legacies. As far as *Janam-sakhi* painting is concerned, Goswamy proposes that workshops from a wide area used the same compositions because he found thumbnail images that depict the narratives of the *Janam-sakhi*s (Figure 2.5). The sketch would be used for the conservation of compositions across the workshops rather than generations. We can know how popular illustrations of the *Janam-sakhi*s were in the

Early Sikh Imagery in Narrative Painting

eighteenth century. According to McLeod (1980b), this was due to the political situation of the eighteenth-century Punjab, when Nadir Shah, Iranian general and king, invaded the subcontinent through the Khyber Pass in 1739. At the time, the Punjab also experienced Afghan invasions. The political instability seemed to have stirred up

Figure 2.12: *A Scene of Revelation*. From the Guler set of *Janam-sakhi* paintings. Attributed to the Seu-Nainsukh workshop. Pahari. Last quarter of the eighteenth century. 22.6 × 16.5 cm. Opaque watercolour on paper. Acc. no. 2369, Government Museum and Art Gallery, Chandigarh. Copied from the museum album in 2016

anxiety, which also made the *Janam-sakhi*s popular among Sikhs in both literature and paintings throughout the eighteenth century.

These thumbnail images offer another important clue for understanding *Janam-sakhi* painting. We can see similarities in composition between the Guler set and the B-40 set (Figures 2.4 and 2.12). The Chandigarh museum wrote 'unidentified' for the subject in the Guler set; yet this iconography is apparently reminiscent of the scene of revelation. Apart from the illustration of the B-40 set, that of the Guler set does not show Mardana and only Guru Nanak is depicted in the picture. Intriguingly, this composition is found in the thumbnail images that Goswamy introduces (Figure 2.5). In this thumbnail image, Mardana sits on the right at the bottom. It seems that the Guler painters deliberately omit the figure of Mardana from the illustration to draw the audience's attention to the figure of Guru Nanak.

There are two possible reasons for this. First, the text that Guler painters referred to did not include the description of Mardana in the very scene of revelation. This assumes that Guler painters produced the Guler set of *Janam-sakhi* paintings according to a reading of the text. The rectos, however, show only a short caption and folio number. They do not include any original episodes. Considering that Alam Chand, the painter of the B-40 set, painted Mardana with Guru Nanak in the scene of revelation, he might refer to the thumbnail images since the B-40 *Janam-sakhi* does not mention Mardana in the scene of revelation. It is perhaps not the case that these thumbnail images were created after the B-40 set. I believe that these thumbnail images were drawn prior to the production of the B-40 set. Second, the Guler set does not rely on the text, but Guler painters refer to other artworks as their model. It is assumed that the omission of Mardana from the scene of revelation is purely the creation of Guler painters and their attempt to emphasize a pictorial impression rather than the pre-existing canon of the thumbnail images. Furthermore, they reverse the direction of Guru Nanak. In the B-40 set and thumbnail images, Guru Nanak faces left. In the Guler set, however, he faces right. This leads to the conclusion that thumbnail images were created at least before the Guler set was produced in the late eighteenth century.

In addition, other compositional elements are shared between the

Early Sikh Imagery in Narrative Painting 105

thumbnail images and the B-40 set. For instance, the scenes of *A Demon with Boiling Cauldron* and *Baba Nanak and Mardana* are reproduced in both. Likewise, *Baba Nanak Practices Austerities* is found in both sets of images. Similarly, *Baba Nanak and Mardana with Dancing Pathans* are found in both sets of images. *Baba Nanak and Mardana with Mendicants at Mula Khatri's* are also identified. If we carefully observe the thumbnail images, the B-40 set and even the Guler set, it is evident that more images shared compositional elements with these images. It is remarkable that the thumbnail images include both young Nanak with black hair and old Nanak with grey hair. It may be argued that most of the creations of Alam Chand are derived from the thumbnail images or painted illustrations based on them. The Guler set is more independent from the thumbnail images than the B-40 set, so the production year of the thumbnail images may be closer to that of the B-40 set, 1733, than that of the Guler set, the last quarter of the eighteenth century.

Finally, considering that both the Guler set and the thumbnail sketches do not include Bala, the Guler set is not likely to have a textual source. In other words, the Guler set is purely an artistic production rather than a visualization of the text. Likewise, the thumbnail sketches probably originate in illustrations whose text does not have a description of Bala, such as the B-40 *Janam-sakhi*, the *Puratan Janam-sakhi*, the Adi Sakhi and the Miharban tradition (McLeod 1980b).

3. The Unbound Set of *Janam-sakhi* Painting

The Unbound set includes 41 paintings that may have one of two borders: red or black. It is the most controversial set among *Janam-sakhi* paintings, for the set is likely a combination of multiple sets. The Unbound set is currently housed by the Asian Art Museum, San Francisco, but earlier it was owned by Surinder Kapany and Sikh Foundation International. The Asian Art Museum attributes its production year to the late eighteenth to the early nineteenth century, its location from Lahore to somewhere in India. In his exhibition catalogue, *I See No Stranger: Early Sikh Art and Devotion*, Goswamy (2006) ascribes some folios of the Unbound set to 'probably

Murshidabad, West Bengal' from 1755 to 1770. It seems that the Asian Art Museum referred to his view in dating and locating it. However, Goswamy reproduced only seven pictures of the Unbound set, so most folios are still uncertainly attributed. Thus, the purpose of this small section is to examine the Unbound set and classify it appropriately.

The easiest way to classify the set is to depend on the border colours. I have already mentioned that the set includes both red and black borders. Following the idea of the Asian Art Museum with regard to date and place, it can be argued that the red border is used for images stemming from India, while the black border is used for images deriving from Lahore. The images from India are attributed to the late eighteenth century, whereas those from Lahore are ascribed to the early nineteenth century. The Lahore images showcase a stronger perspective and the use of neutral tints. The Indian images comprise 32 pictures, nine of which have a black border. Almost all illustrations that Goswamy reproduced in exhibition catalogues bear a red border; only one picture has a black border. Intriguingly, Goswamy argues that the black-bordered illustration is a replacement folio of a red-bordered illustration (Goswamy 2006). This suggests that all black-bordered folios are a sort of replacement.

Moreover, we encounter the issue of thumbnail sketches again. Goswamy points out that a folio on Nanak's visit to Mecca is identical in the Guler and the Unbound sets. He claims that thumbnail sketches were circulated across north India, which facilitated the identical composition of both sets (Goswamy 2006). We see, then, that some folios of the Unbound set share a similar composition with the B-40 and Guler sets. For instance, the first folio of the B-40 set resembles one of the red-bordered groups of the Unbound set (Figure 2.13). This is a scene in which Father Kalu takes Nanak to school. The composition is divided vertically, such that Nanak and Kalu are depicted on the right side of the upper area. A teacher sits in front of them in the school building, and other students are portrayed in the lower area. Likewise, *Guru Nanak and the Cobra's Shade* and *Guru Nanak and Cannibal Khauda* share compositional elements between the B-40 set and the red-bordered group of the Unbound set. Between the Guler set and the black-bordered group of the Unbound set, illustrations of *Guru Nanak's Discourse with Datatre on Mount Byar*

Early Sikh Imagery in Narrative Painting 107

Figure 2.13: *Guru Nanak at School.* From the Unbound set of *Janam-sakhi* paintings. Artist unknown. Last quarter of the eighteenth century. Punjab. Acc. no. 1998.58.2, Asian Art Museum, San Francisco. Downloaded by the author in 2016 (http://searchcollection.asianart.org/)

are almost identical in composition. *Guru Nanak and Monster Fish* is equivalent between the Guler set and the red-bordered group.

In what way do these findings help in understanding the Unbound set? I am afraid that the replacement of a folio, which Goswamy asserts, is wrong because the red-bordered group and the B-40 set perhaps

originate in the same thumbnail sketch. If the black-bordered group were a replacement for the red-bordered group, the painter would have used a red border across the folios. The proximity between the folios of both *Janam-sakhi*s does not stem from the attempt at replacement, but rather from the same origin. I somewhat agree with Goswamy in that no scene overlaps and the sizes are almost identical between the red-bordered and the black-bordered groups. In addition, the same compositions in the black-bordered group and the Guler set suggest the possibility that they are based on another format of thumbnail sketch. In short, it is demonstrated that there were several versions of thumbnail sketches in the eighteenth century.

Next, the red-bordered group has an opening folio entitled Bhai Bala Recites the Life Story of Guru Nanak to Guru Angad and Onlookers (Figure 2.14). It is evident that the red-bordered group refers to the Bala tradition rather than to the B-40 *Janam-sakhi* and the text of the Guler set. The Bala *Janam-sakhi* became popular in the nineteenth century (McLeod 1980); this means the red-bordered group may include Bala for the first time. This leads to the conclusion that the production years of the red-bordered group, 1755-70, could extend through the last quarter of the eighteenth century. We can make use of another clue to justify this view. In the folio, cows are depicted at the top of the earth. This composition and its images are reminiscent of the example of the Guler–Kangra paintings in the last quarter of the eighteenth century. The picture is perhaps one of the best paintings among Guler painters' works, namely *Hide and Seek*. This suggests the possibility that the place in which the red-bordered group was produced may not be Murshidabad in West Bengal, but rather somewhere in the Punjab.

In representations of Guru Nanak, he frequently has a halo, as if he were a Mughal emperor, especially in the black-bordered group (Figure 2.15). It seems to me that the halo represents his secular quality rather than the religious aspect of his life. It is noted that not all folios endow Nanak with a halo, perhaps because several painters were involved in the production of the Unbound set. Regarding the red-bordered group, two painters have been identified by hand. One depicts Guru Nanak as a venerated sage, while the other portrays him at a slightly younger age. In the initial folios of the red-bordered group,

Early Sikh Imagery in Narrative Painting 109

Figure 2.14: *Bhai Bala Recites the Life Story of Guru Nanak to Guru Angad and Onlookers.* From the Unbound set of *Janam-sakhi* painting. Artist unknown. Last quarter of the eighteenth century. Punjab. Acc.no. 1998.58.1, Asian Art Museum, San Francisco. Downloaded by the author in 2016 (http://searchcollection.asianart.org/)

only the latter painter uses a halo for the figure of Nanak; however, the former painter also uses a halo in later folios. Furthermore, the former artist tends to rely on pre-existing compositions from a thumbnail sketch; the latter is more creative and creates a relatively

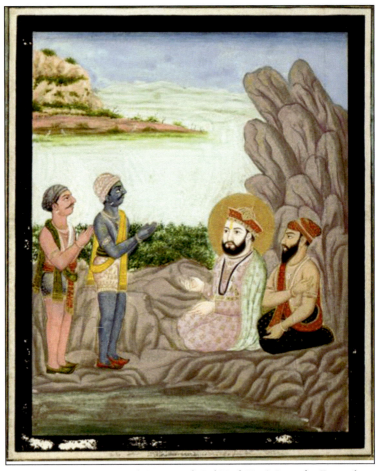

Figure 2.15: *Guru Nanak Meets with Bal Nath Yogi's Disciples.* From the Unbound set of *Janam-sakhi* paintings. Artist unknown. Last quarter of the eighteenth century. Punjab. Acc. no. 1998.58.36, Asian Art Museum, San Francisco. Downloaded by the author in 2016 (http://searchcollection.asianart.org/)

stronger perspective. In contrast, the black-bordered group shows only one painter involved, and all figures of Nanak have a halo. Considering that two painters engaged in the production of the red-bordered group, the group numbered approximately 100 folios. As a result, the curators

of the Asian Art Museum, San Francisco, attribute the Unbound set widely, ranging from the eighteenth to the nineteenth centuries and from India to Lahore.

So, why did painters use a halo to depict Guru Nanak? First, we can identify the impact of Mughal painting on the depiction of Guru Nanak. In the eighteenth century and earlier, Rajput painters learned the technique and expression of Mughal painting. In Mughal painting, a halo was used to depict secular figures, especially an emperor. Thus, Guru Nanak's power is indicated by a halo, or the halo indicates his position was elevated above that of other figures. Second, on a practical level, audiences are able to identify Nanak more easily. In the B-40 and Guler sets, viewers may identify him only by the three-quarter view of his face and the presence of Mardana. A three-quarter face, however, was applied not only to Baba Nanak, but also to demons, Hindu ascetics, Muslim saints, Kabir and some minor castes of a group. The use of a halo allows audiences to recognize Nanak in the group and provides an opportunity for darshan, the exchange of gazes, with them in a clear way.

Conclusion

I have investigated a typical series of *Janam-sakhi* paintings. It is common among the three sets that Guru Nanak is painted in three-quarter face. This allows us to identify Guru Nanak from the figures in the compositions and, more importantly, it may reflect the desire of the viewers to worship Guru Nanak's face. Many paintings from the eighteenth to the nineteenth centuries follow the tradition of *Janam-sakhi* paintings. For example, *Guru Nanak with Bala and Mardana* (Figure 5.11) shows Guru Nanak in the middle, in three-quarter face, holding a nimbus and wearing yellow headgear and a garment underneath a brown shawl. Bala and Mardana are depicted on the sides; on the back, a tree serves the role of a canopy, which tells us that traditional images and compositions succeed in this work. The tradition in which Guru Nanak is painted in three-quarter face was formed in narrative painting.

CHAPTER 3

Portraiture of Guru Nanak till 1849

In the study of South Asian art, portraiture is a topic of growing interest among art historians. One of the earliest pieces of scholarship was done by Coomaraswamy in 1939, who classified portraiture of South Asia into two categories: realistic and idealistic. This idea underpins the common genres of Mughal and Rajput painting. Goswamy surveyed depictions of portraiture in ancient literature and historical accounts in 1986. He noted that the Sanskrit word *lakshana* means 'characteristic and cognitive attributes' (Goswamy 1986: 193), the Indian thought that which portraiture is expected to bear. Desai (1989; 1994; 1996) claimed that in South Asia, the concept of portraiture or the realistic depiction of individuals derives from Western art. Its use in Mughal painting began in the late sixteenth century. In contrast, Lefevre (2011) emphasizes Spinicci's definition of portraiture, which does not require likeness. He argues that portraiture in South Asia originated in the ancient sculpture and relief of Shiva and Buddha. For him, portraiture is not an artistic category but a social one (Spinicci 2009).

In South Asia, sculpture originally occupied a central place in the arts over painting, a relationship that changed after Islamic conquests in the twelfth century. The Islamic artistic tradition was introduced, which, it is often thought, strongly forbade rendering an image of the Prophet Muhammad and Ali; that is to say, it more or less deterred idolatry, although the new artistic style created a strong demand across the Middle East for precious, brightly coloured minerals that could be ground into paint. It is remarkable that things were different in Persia, where theologians argued that figures in pictures, or *tasvir*, had no shadow of their own and that pictorial representation of individuals such as Muhammad could therefore be accepted as long as the faces

were veiled (Dehesia 1997). Persian portraiture, which flourished in the late fifteenth and early sixteenth centuries, is a direct antecedent to Mughal portraiture. Their depictions of human faces are very similar, although their format and posture are often different (Desai and Leidy 1989). The issue of profile *vs.* three-quarter view for portraits in Indian painting has been discussed by the following: Losty (1990), Koch (1997), Necipoglu (2000), Wright (2008), Aitkin (2010) and Gonzales (2015).

Goswamy (2000) claims that there were only a few portraits of Guru Nanak, for the Sikh doctrine of prohibition against idolatry affected the representation of Guru Nanak, the founder and the first Guru of Sikhism, who was the closest to the Sikh absolute entity among the Gurus. However, we know of some examples of portraits produced in the seventeenth century. Randhawa (1971: 20) states, 'A 19th-century text mentions that "Guru Har Gobind, the Sixth Guru", had his portrait drawn by an artist at village Sur Singh near Kitarpur on the request of his relations' (as cited in Goswamy 2006: 30). Again, when the Ninth Guru, Tegh Bahadur (1621-75), visited Dhaka (now the capital of Bangladesh), it is said that the people welcomed him with great reverence; this was especially true of Bulaki, the mother of a local deputy. Since she respected the Guru, she asked him to stay there much longer than he had planned to. The Guru, however, said he had other things to attend to. Then, the old lady 'sent for a painter, and had a picture of the Guru made. She hung it over the couch on which he had sat. Thus she was able to behold the Guru whenever her secular avocations admitted' (Macauliffe 1963: 353). However, nothing was later heard of that portrait.

Goswamy (2006) continues:

Again, one comes upon a reference to a portrait of Guru Gobind Singh, having possibly been made by a Pahari painter, for it is said that the ruler of the hill state of Bilaspur, with whom the Guru had to deal on many occasions in the course of his tumultuous career, once dispatched a painter from his court to bring back a likeness of the Guru. Whether the painter did indeed make such a portrait is not recorded. All that one knows is that no such portrait has survived. A somewhat coarsely made portrait, in the style that obtained toward the end of the 17th century at the hill court of Mandi – a town that Guru Gobind Singh did certainly visit – is sometimes said to be that of the great Guru. But certainly eludes one even here. (30)

It is demonstrated that single images of Guru Nanak were produced and consumed earlier than the British colonial period. Moreover, I address the topic by examining paintings about the assembly of ten Gurus as an independent subject. These materials were produced in the Punjab region from the late seventeenth century to the early nineteenth century. This chapter comprises four sections: (1) Portraiture of Guru Nanak in the Seventeenth and Eighteenth Centuries; (2) Portraiture of Guru Nanak in the Early Nineteenth Century; (3) Group Portraiture of the Ten Sikh Gurus up to 1849; and (4) Single Portraits of Guru Nanak till 1849.

1. Portraiture of Guru Nanak in the Seventeenth and Eighteenth Centuries

Portraiture of Guru Nanak dates back to the late seventeenth century. The tradition of such portraiture differs from images of him in *Janam-sakhi* paintings, which is reminiscent of the narrative painting produced in Rajput courts (for example, the Ramayana, the *Gita Govinda* and the *Bhagavata Purana*). In comparison, the earliest portraits of him copied Mughal portraiture in style and iconography. Another characteristic is that Guru Nanak is represented as either a Muslim saint (Sufi) or a Hindu ascetic, although he is rendered exclusively as a Muslim saint in *Janam-sakhi* paintings. On the basis of formal and stylistic analysis, it is argued that only Hindu painters at the Mankot court, a Rajput native state in the Pahari hills, depicted Guru Nanak as the representative of their faith. Other Hindu and Muslim painters were likely to depict him as a Muslim saint. This section examines portraits of Guru Nanak that were produced in the late seventeenth and eighteenth centuries.

It seems that the earliest extant image of Guru Nanak is *Guru Nanak and Har Rai Listening to Music* (Figure 3.1). According to Randhawa (1971), this painting was executed at the Mughal atelier in the late seventeenth century. In this painting, Guru Nanak and Har Rai, depicted in the centre of the composition, are sitting on the well-decorated carpet. Guru Nanak, with a white beard, is wearing white attire, including a white coat and a white headgear. He faces

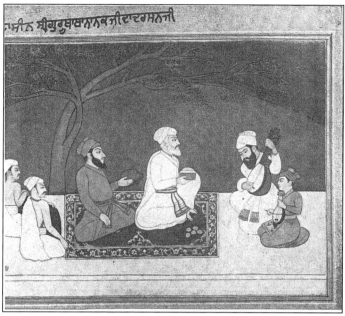

Figure 3.1: *Guru Nanak and Har Rai Listening to Music.* Randhawa (1971)

right in profile and is raising his left knee. He holds an unidentifiable object in his right hand. Behind Guru Nanak, Har Rai is rendered as if he were Guru Nanak at a younger age. The shape of his black beard reminds us of that of Guru Nanak's white beard. His cloth and headgear are similar to those of Guru Nanak, although their colour is different. He reaches his left hand out and puts his right hand down. He faces right in profile and sits cross-legged. Two attendants are depicted on the left-hand side. Both are sitting on the floor with their upper bodies bare, although they are wearing coats. All of their attire is painted in white. The shape of turban is completely the same as that of Guru Nanak. Both face right in profile, but they have no beard. They each appear to have a black shield. In addition, two musicians are rendered on the right-hand side. Both have string instruments in their left hands. One on the upper level faces left in three-quarter view, while the other at the lower level faces left in profile. The one on the upper level has a black beard and wears white attire and a white

headgear. The other at the lower level has no beard or moustache and wears a coloured cloth. Considering the smallest size of this figure, as well as his appearance, he looks the youngest among the figures in this painting. In the background, a tree grows as if it covered Guru Nanak and Har Rai. A rounded horizon is rendered.

There is another painting that has a similar composition to the previous painting (Figure 3.2). However, this painting lacks the presence of Har Rai. Randhawa insists that Har Rai was dead when this painting was executed. We can see other small changes between these paintings. First, the scene changes from the terrace to the forest. Second, the carpet becomes simple. Third, the centre of the composition is not Guru Nanak, but the space between him and musicians. Although the colour of the background is different between them, we cannot identify it clearly from these monochrome images.

Guru Nanak is often depicted with a musician (Figure 3.3). The next painting shows him on the right-hand side. A tree is rendered as if it covers his head. He looks like an old sage by his rich white beard. A red hat tied with a white cloth indicates his Muslim status. His

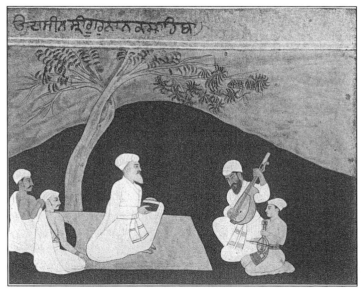

Figure 3.2: *Guru Nanak Listening to Music*. Randhawa (1971)

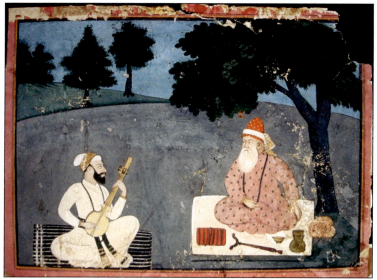

Figure 3.3: *Guru Nanak Listening to Music.* Acc. no. 1685. Possibly the Government Museum and Art Gallery, Chandigarh. Photographed by the author at Vijay Sharma's house in 2010

beltless robe is coloured white with black dots. He wears a long necklace and faces left in three-quarter view. He is sitting cross-legged and touches his left knee with his left hand. His right hand rests on his feet. Five objects are put on the white carpet on which Guru Nanak sits. A vase, a cup and a stick are depicted; two other objects are unidentifiable. On the left-hand side, the musician, probably Bhai Mardana, is shown; he has a black beard and is dressed in white. His white turban is tied with a yellow bandana. He holds a string instrument. A patterned black cloth is tied at his waist. His appearance evokes the feeling that he is a courtly figure. The carpet on which the musician sits is painted with a black and white border. The earth is painted in grey and shows a rounded horizon. Some trees on the grass field are seen in a distant view on the left-hand side.

 A similar composition is seen in the following painting (Figure 3.4). The setting changes from the forest to a terrace. On the right-hand side, Guru Nanak is sitting and leaning on a red cushion. He has a long white beard and faces left in three-quarter view. The

118 *Portraying the Guru*

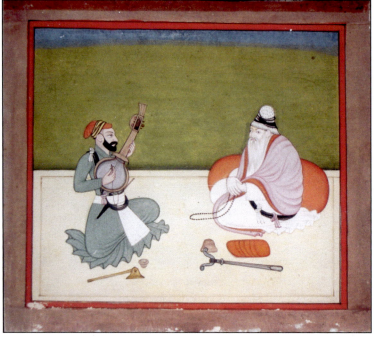

Figure 3.4: *Guru Nanak Listening to Music*. Acc. no. 2135. Possibly the Government Museum and Art Gallery, Chandigarh. Photographed by the author at Vijay Sharma's house in 2010

headgear, tied by black threads, is coloured in white with black dots. He is wearing a pink coat with red borders and a black belt. He clasps his hands on his knees. Three objects are rendered on the white floor. A stick and a cup are identified, but another is not clear. On the left-hand side, the musician, probably Bhai Mardana, is shown. He has a black beard and faces right in profile. He wears red headgear tied with a yellow and black cloth. He wears a blue-tone robe tied with a white cloth near his waist. These colourful accessories show his courtly status. He holds a string instrument with both hands; the instrument's body is blue and neck is beige. Two objects are depicted below him. One is a cup; the other is perhaps a stand for the instrument. The background is painted in bold green and the blue sky is shown at the top, although the border between the field and the sky is blurred.

The next painting is a bit contentious because we do not know

Portraiture of Guru Nanak till 1849 119

whether the handwritten inscriptions (added later) on the heads of the figures are correct or incorrect (Figure 3.5). In this painting, the right figure, inscribed as Guru Nanak in Persian, has a black beard and is standing barefoot. He is holding a cane in his right hand and a peacock feather fan in his left. He is wearing a white skullcap with dots and the same patterned one-piece robe. The figure in the centre, described as Guru Arjan in Takri, is paying homage to Guru Nanak by stroking a hawk that is sitting on his hand. His turban is heavily decorated in purple and red and is tied with a golden cloth. His robe is white but with gradations of gold at the top. His waist is bound by a gorgeous belt with floral patterns, and he is equipped with a dagger. He wears red trousers and shoes. Behind this royal figure stands a courtly attendant, inscribed as Guru Hari Rae in Takri. He has a black beard and stands holding a sword as if it were a cane. He is wearing

Figure 3.5: *Guru Nanak (?) Approached by Guru Gobind Singh (?)*. Opaque watercolour on paper. Pahari. Possibly from a Bilaspur workshop. Second quarter of the eighteenth century. 21 × 26.7 cm. Acc. no. 1843. Government Museum and Art Gallery, Chandigarh. Goswamy (2000), plate 15

a white robe under a coat decorated in floral patterns. His belt is similar to that of his superior, but is of a slightly different colour. He is also wearing a kind of scarf. He wears vertical striped trousers and red shoes. Goswamy (2006) gives a detailed analytical description for this painting, attributing it to Bilaspur, a state in the Pahari area. He insists that the inscriptions of Guru Arjan and Guru Hari Rae are probably wrong. He also indicates that if the figure on the right-hand side is Guru Nanak, this painting is the oldest extant example of his representation. However, his argument may be incorrect, for we have already seen at least three earlier paintings related to Guru Nanak.

The next painting shows Guru Nanak as a Muslim saint, but with different iconography (Figure 3.6). Guru Nanak, who has a white beard, is listening to Mardana in a courtly setting. He is sitting cross-legged on a yellow carpet with floral patterns. He faces left in three-quarter view and slightly tilts his head. He is resting his elbow on his right knee and holding a rosary. His right hand drops to the floor. His robe is coloured purple. He wears two necklaces in black and white. The headgear he wears has a feather attached and is shaped like a crown; it is coloured gold. On the left-hand side, Mardana, who has a white beard and a black moustache, faces right in profile. He holds a string instrument coloured red and yellow. He wears a white robe tied around his waist. The golden cloths are wound around the turban, shoulder and chest. He also wears a necklace with a stone. The floor is coloured green and decorated with patterns. The terrace is surrounded by fine latticework. A white building with a purple roof and yellow decorations is depicted behind Nanak. The entrance is painted green with red borders. The background is painted green and the sky blue. A stylized tree is rendered as if Nanak is underneath the leaves. Nanak's iconography in this painting is very similar to later representations. The owner attributes this to the early eighteenth century, but it seems to me that the production is approximately mid-eighteenth century, since Guru Nanak is depicted differently from earlier Sufi-like images and the setting has become more formal.

Another example from the Pahari region shows Guru Nanak in a larger size than Mardana (Figure 3.7). On the right-hand side, Nanak, who has a grey beard and faces left in three-quarter view, is sitting cross-legged on the pedestal, which has four red legs and is covered

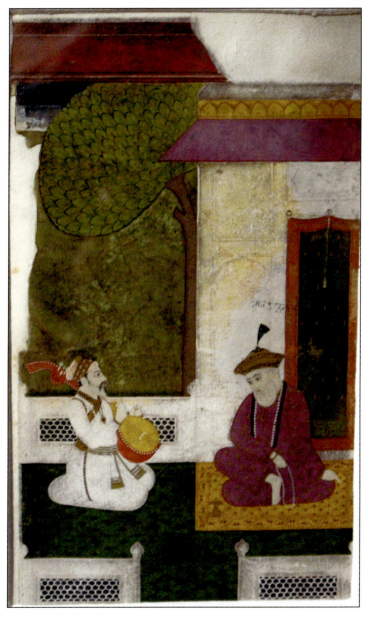

Figure 3.6: *Guru Nanak Listening to Music*. Himachal State Museum, Shimla. Photographed by the author in 2017

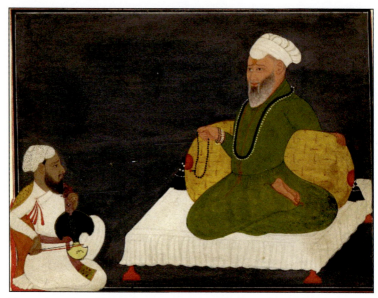

Figure 3.7: *Guru Nanak Listening to Music*. Early nineteenth century. 18.5 × 13.8 cm. Acc. no. 1922,1214,0.2, British Museum. Downloaded by the author in 2017. (https://www.britishmuseum.org/collection)

by a white sheet. He is wearing a white turban and a green robe. He is leaning on a yellow cushion with red edges and black tassels. A black thread and a long white rosary hang from his neck. It seems that a long orange necklace was originally to be depicted. He is holding a black rosary in his right hand, which has two black rosaries and two white rosaries at the wrist. He seems to be looking at Mardana with a wrinkled brow. Mardana, who has a black beard and faces right in profile, is sitting with one knee up. His body overlaps the right border, as some figures in Pahari painting do. He is wearing a white turban with colourful dots and a white robe tied with a purple cloth, including green edges decorated with flowers under the yellow shawl, the underside of which is orange. He is using a bow to play a black and yellow string instrument whose shape is unusual. His robe is fastened with a red clasp, and he is wearing a white ring on his left hand. The owner attributes this painting to the early nineteenth century, but I believe it was produced half a century before.

Portraiture of Guru Nanak till 1849

Guru Nanak was depicted as a Muslim saint during the eighteenth century (Figure 3.8). He has a white beard and faces left in three-quarter view. He is sitting with a woman, possibly his sister, Nanaki, on a blue carpet with green edges on a quadruped pedestal. He is wearing a pink hood and a white robe under a brown shawl. His attire is decorated with red and blue polka dots. A red mark is painted on his forehead. Nanaki, who is paying homage to Nanak and faces left in profile, is wearing a black shawl with white flowers and a red skirt with green edges. Nanaki is also wearing a lot of jewellery, such as a necklace, a bracelet, an armlet, earrings and a nose ring. A black thread hangs around her neck. On the right-hand side, Bala, who has no beard and faces left in profile, is standing on the black and white floor. He is holding a peacock feather fan in his right hand and a white cloth in his left hand. He is wearing a white triangular hat and robe decorated with black polka dots. A red mark is shown on his forehead as well. He is also wearing a golden necklace, a bracelet and an earring. A black thread is hung from his right shoulder to his left hip. On the

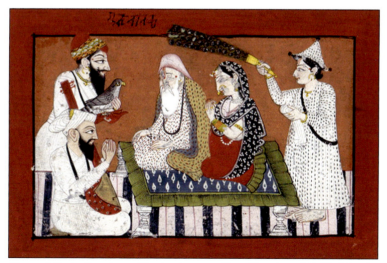

Figure 3.8: *An Imaginary Meeting between Guru Nanak and Gobind Singh*. Mandi, *c.*1780. Opaque water, silver and ink on paper. Sheet: 5 × 7⅝ in. (12.7 × 19.37 cm); Image: 4⅛ × 6⅜ in. (10.48 × 16.19 cm). Acc. no. M.75.114.2, The Los Angeles County Museum of Art. Downloaded by the author from the museum website in 2017

left-hand side, Mardana and one princely figure are rendered. The owner identifies him as Gobind Singh, the tenth Sikh Guru. Mardana, who has a black beard and faces right in profile, is paying homage to Nanak. He is wearing a white turban and robe tied around his waist. He is carrying a red and brown string instrument. A black string hangs from his neck. Gobind Singh, who has a black beard and faces right in profile, is slightly bowing towards Nanak. His red turban is tied with a heavily decorated bandana. He is wearing a white robe tied around his waist. A hawk is sitting atop a red cloth that he is holding. The name Nanak is inscribed on the top border. The owner attributes this painting to a Mandi workshop in *c.*1780.

In the late eighteenth century, Guru Nanak was depicted with Bhai Bala beside Bhai Mardana. The first painting shows the three of them on a terrace (Figure 3.9). The inscriptions seem to have been written in a later hand in Persian. Guru Nanak, who has a white beard and faces left in three-quarter view, is sitting cross-legged on a pedestal, which is decorated in gold and colourful stones. He is holding a manuscript that says, 'Ek Omkar'. He is wearing a pink robe tied around his waist and a red skull cap with a pink bandana. The cap is also equipped with a precious stone on the forehead. He is leaning on a yellow cushion with vertical stripes and wearing a white necklace with a stone. A white rosary is held in his right hand. He is wearing a black thread from his right shoulder to his chest. Bala, who has a black beard and faces left in profile, looks similar to Guru Nanak. He is standing on the right-hand side, holding a peacock feather fan in his right hand. He is wearing a pink robe and cap tied with a white cloth. An orange cloth is held in his left hand. He is wearing a white necklace with a stone and a black thread. On the left-hand side, Mardana, who has a black beard and faces right in profile, eagerly plays a string instrument. He is wearing an orange robe tied around the waist with a grey cloth and a white turban. A white ring with a stone is depicted in his ear. A banana tree with blossoms is growing above his head. A red floral carpet with green borders is spread on the floor, on which lie a plate with fruits and a vase with a yellow cloth. An orange canopy with green folds is built on the terrace, and there is nothing in the background. Goswamy attributes this painting to

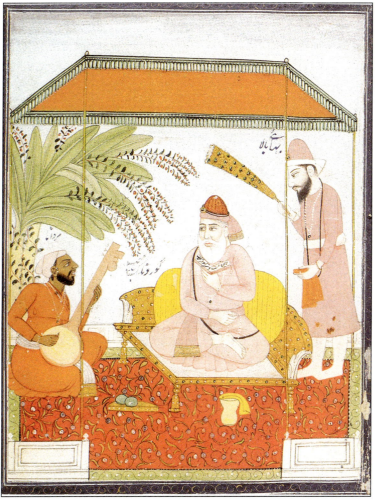

Figure 3.9: *Guru Nanak with Bhai Mardana Singing*. Punjab plains, possibly Patiala. Last quarter of the nineteenth century. Opaque watercolour on paper. 43 × 32 cm. The collection of Sardarini Kanwal Ajit Singh, Chandigarh. Goswamy (2000), plate 18. Some editions have a different picture on plate 18

late nineteenth-century Patiala, but dating seems to be an error. It should be the late eighteenth century.

The second painting has no inscription, but it is obvious that its composition is based on the first painting (Figure 3.10). The primary difference is the use of colour. Nanak's robe has become dark orange and his skull cap is illustrated with vertical stripes in red and white.

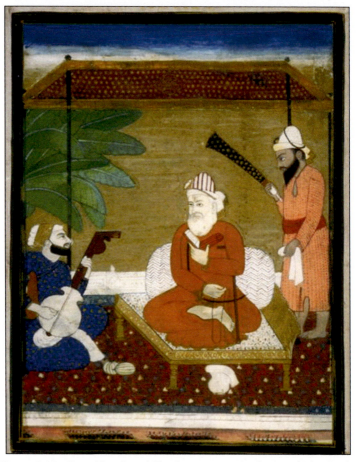

Figure 3.10: *Guru Nanak and His Companions Mardana and Bhai Mala*. Punjab. *c*.1700–1800. Opaque watercolour on paper. 21.6 × 17.8 cm. Acc. no. 1998.93, Asian Art Museum, San Francisco. Downloaded by the author in 2017 (http://searchcollection.asianart.org/)

Portraiture of Guru Nanak till 1849 127

The text in the manuscript is unreadable. There is the absence of white necklace but still keeps the black thread. Bala's cap has changed from pink to white and the cloth tied around his waist has become red. His skin has become tan. There is the absence of the white necklace and the black thread. Mardana is wearing a blue robe with golden dots. The body of his instrument is painted white and the handle is brown. A carpet and a canopy are coloured almost brown. The background is clearly divided into brown earth and blue/white sky. A banana tree has lost its blossoms. The plate of fruits has become an unidentifiable object.

The next painting is a variation of the previous two paintings (Figure 3.11). Guru Nanak, centred in the composition, is sitting cross-legged on the light purple carpet and is surrounded by Bala, Mardana and a courtly figure. He has a white beard and a grey moustache and faces right in three-quarter view. He holds a manuscript in his left hand and points to the courtly figure with his right hand. He may be leaning on an orange cushion with dots whose edges are coloured green. His orange skull cap is tied with a white bandana and two black threads. The decoration, including a stone, is attached to the cap. A vertical yellow mark is painted on his forehead. His robe, which is tied with a white cloth around his waist, has a pattern of vertical stripes in yellow and white. A black thread is hung diagonally from the right shoulder. Bala is standing behind Nanak on the right-hand side. He is holding a feather fan in his right hand and a white cloth in his left hand. He has a short black beard and faces right in profile. A yellow mark is painted on his forehead. He is wearing a white skull cap with black dots, which is tied with two black threads. His robe is coloured light purple and tied with a white cloth around the waist. Mardana is depicted below Bala on the left-hand side. He has a black beard and faces right in profile. He is playing a string instrument and sitting cross-legged. His turban, which is tied with a yellow cloth and two black threads, is coloured blue. An earring with two white stones is in his right ear. His knit robe has vertical stripes in yellow and blue and is possibly tied around the waist. A light purple cloth is held under his right arm. On the right-hand side, a courtly figure, perhaps a patron who commissioned this painting, is sitting on the floor and paying homage to Guru Nanak. He has a black beard

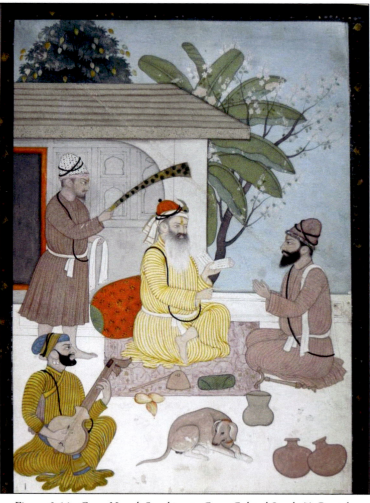

Figure 3.11: *Guru Nanak Speaking to Guru Gobind Singh (?)*. Punjab. Early nineteenth century. By the Seu-Nainsukh workshop of Guler. Acc. no. F-39, Lahore Museum. Courtesy of the Lahore Museum in 2017

Portraiture of Guru Nanak till 1849 129

and faces left in profile with a yellow mark on the forehead. His skullcap and robe are coloured light purple. Two black threads are tired around his cap, and another one hangs diagonally from his right shoulder. A white cloth drops from his left shoulder and is tied around his waist. Many objects are placed on the floor. On the light purple carpet, which has a floral pattern, there are three lotuses, a green wrap and something like a religious stick. Another stick is rendered below the courtly figure. Three vases are depicted and a dog is crouching. In the background on the left stands a white building whose entrance has red borders. A tree and banana leaves and blossoms are depicted around the building. The sky and space are painted light blue. The owner attributes this painting to Guler in *c.*1815–20.

This late eighteenth-century piece is an interesting brush drawing (Figure 3.12). The drawing shows ten people, including Guru Nanak, who is sitting cross-legged on the pedestal. He has a grey moustache

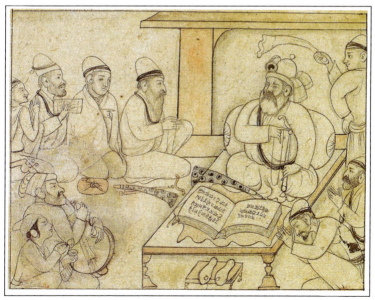

Figure 3.12: *Guru Nana with Followers.* Pahari, from the family workshop of Nainsukh of Guler. Last quarter of the eighteenth century. Lightly tinted brush drawing on paper. 11.5 × 14.9 cm. Acc. no. F-38, Government Museum and Art Gallery, Chandigarh

and a white beard. He faces left in three-quarter or nearly full view. His skullcap is equipped with a large stone on his forehead and is tied with a cloth. A stick is tucked under his arm. He holds a rosary in his right hand in front of his chest. Black threads hang from his right shoulder. He is leaning on a cushion the edges of which are painted in different colours. A large book, which says in Takri '*Gyan anjan gur diya...* [It is the Guru who gave me the collection of knowledge with which to see]' (Goswamy 2000: 33) is open on the cloth spread on the pedestal. A feather fan is placed between Nanak and the book. Three people are depicted on the right-hand side. One, who is standing, is holding a fly whisk above Nanak's head; the other two, who are seated below, are paying homage to him. All three are facing left in profile. On the left-hand side, four people are rendered in the upper area, whereas two people are portrayed in the lower area. Among the four, only one faces left in three-quarter view, while the others face left in profile. Another holds a manuscript in his right hand. Three objects, a stick, a feather fan and something like a package, are placed on the terrace. Below them, two musicians are rendered. Perhaps one, who has a string instrument, is Mardana. A younger figure holds an instrument like castanets. Goswamy attributes this painting to the Seu-Nainsukh workshop in the Pahari region.

There is a painting outside the mainstream due to its production location of Lucknow or Patna (Figure 3.13). It is one of the folios about *Shahnama*, according to Goswamy (2000). He attributes this painting to *c.*1780. This painting depicts Guru Nanak and Mardana in the top border of the painting. In the border, Guru Nanak is sitting cross-legged on a floral-patterned carpet in the forest. His left hand is dropping to the earth and his right elbow is on his right knee. He faces left in profile. His headgear is not a skullcap, but something like a crown. Black threads are rendered around his neck, diagonally from the right. He is leaning on a cushion with vertical stripes. A tree grows behind Nanak on the right-hand side, its leaves extending above his head. On the side borders, only vegetation is painted in green and brown. Opposite Nanak, Mardana is sitting on the grass and playing a string instrument. He faces right in profile, and his turban is tied with a cloth. The image of Guru Nanak and the setting of the forest remind me of the illustrations from the *Janam-sakhi*s. It seems that

Figure 3.13: *Rustam Slaying a Dragon; On the Borders Diverse Scenes, Including One of Guru Nanak Seated with Mardana.* Folio, possibly from a dispersed Shahnama manuscript, mounted as an album page. Lucknow or Patna. *c.*1780. Opaque watercolour and gold on paper. 40.64 × 29.21 cm. The Samrai Collection, London. Goswamy (2006), plate 2.8

this painting was executed before 1780. Otherwise, it is assumed that the painter referred to early eighteenth-century works.

2. Portraiture of Guru Nanak in the Early Nineteenth Century

This section examines portraits of Guru Nanak that were produced in the early nineteenth century.

This painting again shows Nanak as a Muslim saint (Figure 3.14). Although the name Angad, the second Guru, is written on the top border, Goswamy correctly identifies the figure as Guru Nanak. He is depicted in the centre in a larger size than the other figures. He has a white beard and a red spot on his forehead; he is facing left in three-quarter view. His skull cap is painted in white and his head is encircled by a golden halo. He is wearing a pink robe under a white coat. Both are decorated with floral patterns such as the yellow-bordered carpet on which Nanak sits cross-legged. He is leaning on an orange cushion, in which both edges are painted in red. A tree with unusual colourful leaves grows over Nanak. On the right-hand side, Bala, who has a

Figure 3.14: *Guru Nanak with Disciples and Attendant.* Painted leaf from a manuscript. Kashmir/Punjab. First quarter of the nineteenth century. Opaque watercolour on paper. 11.3 × 17.8 cm. Acc. no. 3507, Government Museum and Art Gallery, Chandigarh

black beard and wears a white skullcap like Nanak, is holding a peacock feather fan for the Guru. He is standing and wearing an orange robe and a long pink scarf. On the left-hand side, two princely figures with white beards, facing right in profile, are paying homage to Guru Nanak. Both of them are sitting on the red floor. One wears an orange shirt and a yellow lower garment, and the other wears a pink shirt and a blue lower garment; he has an armlet on his right arm. Their turbans are characteristic in form. One is coloured gold, and the other is orange. In the background, a white building with blue entryways is depicted with an orange roof equipped with pink edges on the right-hand side. On the left-hand side, a green hill and orange earth can be seen. Beyond the blue river, stylized pink mountains are shown above the top borders. This painting has several borders, including the inner blue ones with floral patterns and the outer red ones. Goswamy attributes this painting to Kashmir or Punjab in the first half of the nineteenth century. It is possible that the rich colouring here is of Kashmiri origin. He also insists that this work was one of the leaves of a prayer book of some religious manuscript. The two princely figures are seen as patrons of the work. Mardana is not depicted partly because he is usually rendered on the left-hand side of the painting, which is occupied by two men here.

In *Guru Nanak and Bhai Mardana* (Figure 3.15), Guru Nanak, who has a white beard and faces the lower left in three-quarter view, is sitting cross-legged on a carpet covering a terrace; a book and a peacock feather fan are placed on the carpet. He is wearing a red turban tied with a white cloth and a yellow robe under a colourfully patch-worked shawl. He is holding a red rosary in his left hand and pointing somewhere to the right with his right hand. Behind him, there is a hermitage, the walls of which are painted pink and the roofs yellow. A tree with green leaves flourishes outside the terrace. On the left-hand side, Mardana, who has a black beard and faces the upper right in profile, is sitting on his knees. His white turban is tied with a yellow bandana, and his green robe is tied around the waist with a purple cloth. He is playing a string instrument painted yellow and brown. The sky is painted light blue. The pink edge of the terrace is shown at the bottom.

In the early nineteenth century, the unique iconography of Guru

Figure 3.15: *Guru Nanak and Bhai Mardana*. Pahari. *c.*1800. Paper, 20.2 × 15 cm. Acc. no.76.35, National Museum, New Delhi. Daljeet (2009)

Nanak, which differed from that of previous centuries, was developed. In this painting (Figure 3.16), Guru Nanak and Guru Gobind Singh are depicted among an assembly of gods. Nanak faces right in three-quarter or almost frontal view. He has a white beard and wears crown-like headgear painted red. His head is encircled by a golden halo. He is sitting cross-legged on the pink carpet. His coat is distinctively painted in white with colourful polka dots. His grey robe is tied with a golden cloth around his waist. His right elbow is resting on his right knee and his left hand is dropping to the floor. Guru Gobind Singh is sitting next to Guru Nanak. He has a black beard and faces right in profile. His head is encircled by a golden halo. He is wearing a

Portraiture of Guru Nanak till 1849 135

yellow robe tied around the waist and a yellow turban with a black feather. He is armed with a black shield on his back, a red sheath at his waist, a golden bow on his right shoulder and a red quiver of arrows at his waist. He holds an arrow with both hands. All the figures and

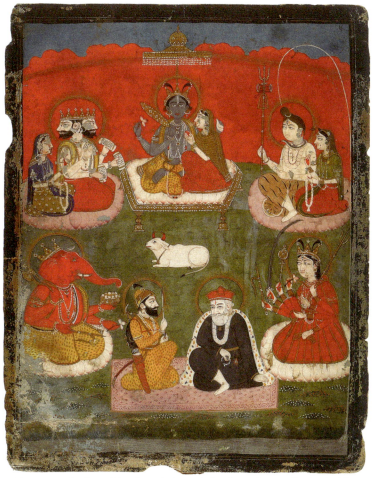

Figure 3.16: *Guru Nanak and Guru Gobind Singh Seated, Flanked by Brahma, Vishnu, Shiva, Ganesh and Devi.* Punjab Plains. First half of the nineteenth century. Opaque watercolour on paper. 23 × 18.7 cm. Acc. no. 974, Government Museum and Art Gallery, Chandigarh. Singh, Kavita (2003), plate 1

gods surround a crouching cow in the centre, which faces left in profile and has red horns. The god on the top is seen as Vishnu according to his blue-black skin and multiple arms. He faces front and holds four common objects, one in each hand. His wife, Lakshmi, who faces left in profile, sits beside him on the pedestal. On the upper left-hand side, Brahma, who has multiple heads, is sitting on the lotus-like carpet with his wife. His hands are full of manuscripts. On the upper right-hand side, Shiva, who faces left in three-quarter view, is sitting with his wife, Parvati. His lower garment is made of tiger skin, as usual. On the lower right-hand side, Ganesh, elephant god, whose skin is red, is sitting on the lotus-like carpet. He faces right in profile and holds typical objects with his four hands. Opposite Ganesh, the goddess Durga, who faces left in three-quarter view, is sitting on the lotus-like carpet. She holds devotional objects in her eight hands. Every God and Goddess has a golden halo. In this painting, Guru Nanak and Guru Gobind Singh are depicted as deities. Considering the unrealistic bold colouring of the background in red, this painting seems to have been used for devotional purposes.

There is another painting stemming from the Kashmir region (Figure 3.17). Like the former painting from the same district, this painting shows Guru Nanak in the centre position in a much larger size than other religious characters. His iconography is based on the pre-existing images that we have seen. He has a white beard and faces left in three-quarter view. His crown-like headgear is coloured orange. His head has a light background instead of a golden halo. This form seems to originate in the Kashmir or Persian traditions. Unlike other paintings, a tree with stylistic leaves is depicted right behind Nanak. He wears a yellow robe and a colourful coat. He is sitting cross-legged on the geometric patterned carpet, whose margins are decorated in floral patterns. He is leaning on an orange cushion, resting his right elbow on his right knee and holding a rosary in his left hand. An armlet encircles his right arm. Typical attendants, such as Bala and Mardana, are rendered in a relatively larger size than other characters. Bala is standing on the right-hand side and holding a fly whisk over Nanak. Bala, who has a white beard, wears an orange skull cap and yellow attire. On the left-hand side, Mardana, who has a black beard, is sitting on the terrace and playing a string instrument. His turban

Portraiture of Guru Nanak till 1849 137

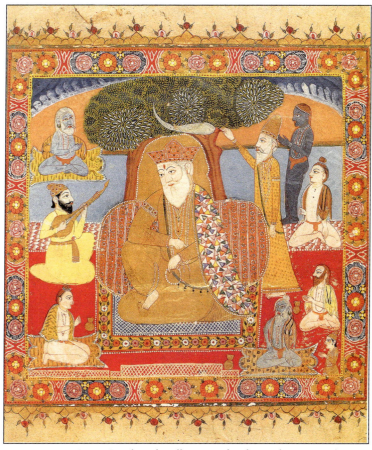

Figure 3.17: *Guru Nanak with Followers and Other Holy Men*. Kashmir/Punjab. First quarter of the nineteenth century. Opaque watercolour and gold on paper. 28.1 × 24.6 cm. Acc. no. 75.246. Himachal State Museum, Shimla. Goswamy (2000), plate 20

is painted in gold, as is a cloth tied around his waist. His robe is coloured in saffron yellow. Seven more figures are shown in this painting. Most are almost naked and some sit on a tiger skin. Some have blue skin, which indicates the ashes of the dead. A red carpet is spread on the floor. The middle distance, painted in blue, seems to represent a river. The far distance shows orange earth and blue sky

with a rounded horizon, including tinted white clouds. The borders are finely decorated with floral patterns.

The following painting shows Guru Nanak with similar iconography on the right-hand side (Figure 3.18). He faces right in three-quarter view and has a white beard; he is sitting cross-legged on the carpet. He is wearing red crown-like headgear. His head is encircled by a golden halo with many rays. He wears a colourful coat over a light blue robe tied with a golden cloth around his waist. A white

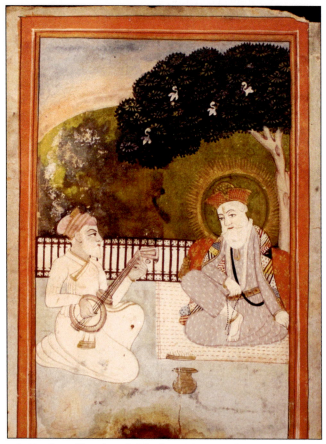

Figure 3.18: *Guru Nanak with Mardana.* Nineteenth century. Watercolour on paper. 18.9 × 14.5 cm. Acc. no. 3661, Government Museum and Art Gallery, Chandigarh. Photographed by the author in 2016

Portraiture of Guru Nanak till 1849 139

necklace and a black thread are hung around his neck and from the right shoulder, respectively. The cushion on which Nanak is leaning is painted in orange with floral patterns. On the left-hand side, Mardana, who has a white beard and faces right in profile, is playing a string instrument. He is sitting cross-legged on the terrace. His turban is tinted light pink and he is wearing white attire that is tied at his waist. A vase and an unidentifiable object are placed on the terrace. The landscape spreads beyond fine latticework. A tree with green leaves, inhabited by four birds, grows over Nanak on the right-hand side. vegetation is shown on the left-hand side. Green grass and a white sky are rendered with the curved horizon.

The next painting shows a common composition in an unusual style (Figure 3.19). Lafont and Schmitz (2002) attribute this painting to the Imam Baksh workshop active in early nineteenth-century Lahore. Nanak, who has a white beard, faces front and looks at the

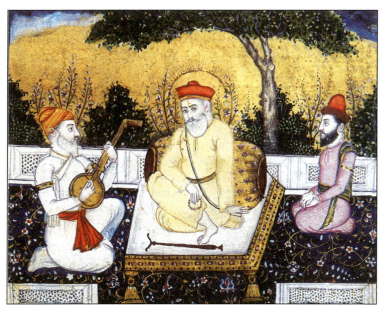

Figure 3.19: *Guru Nanak. From Military Manual of Maharaja Ranjit Singh.* Probably the workshop of Imam Bakhsh Lahori. 1822-30. Acc. no. 1035, Maharaja Ranjit Singh Museum, Amritsar. Lafont (2002), plate 110

audience. He is wearing red crown-like headgear and a yellow mark is shown on his forehead. A light halo encircles his head. As usual, he is sitting cross-legged on a pedestal and wearing yellow attire tied with a golden cloth around his waist. He is resting his right elbow on his right knee and is holding a rosary with the same hand. His left hand is dropping onto the pedestal, the margins of which are gorgeously decorated in gold. The gold cushion on which he is leaning is well decorated with pink flowers. Each edge is coloured brown. Another figure, who has a black beard and faces left in profile, seems to be Bala, although he does not have a feather fan or a fly whisk. He sits on the floor on the right-hand side and is wearing a red skullcap and pink attire. A black and gold cloth is tied around his waist. A stole of the same colour drops from his left shoulder. A golden armlet with stones encircles his left arm. On the left-hand side, Mardana is depicted relatively larger than Bala who has a white beard and faces right in profile, and playing a string instrument. He wears an orange turban and white attire tied with a red cloth around the waist. The armlet is painted in gold, as is the instrument. The black carpet, finely decorated with floral patterns, is spread on the terrace. Fine latticework is shown on both the upper and lower sides. In the background, a realistic tree grows above Nanak and some bushes are rendered alongside the upper latticework. However, most of the background is occupied by a flat golden colouring. The blue sky is rendered with a rounded horizon.

One of the last paintings of the early nineteenth century shows Guru Nanak as a Muslim saint (Figure 3.20). My first impression of this painting is that linear perspective is applied to the composition. Guru Nanak, who has a white beard, faces left in three-quarter view. His orange skullcap is tied with a white bandana. His head is encircled by an obvious golden halo. He is sitting cross-legged on the well-decorated carpet. He holds a rosary in his right hand while his left hand is resting on his leg. He is wearing a yellow robe and a colourful coat. A couple of white necklaces are hanging around his neck. The cushion on which the Guru is leaning is painted white. Bala is standing on the right-hand side; he has a black beard and faces left in profile. He holds a feather fan in his right hand and a cloth in his left hand. He is wearing a pink skullcap and attire with two black threads hanging diagonally across his neck. A white necklace is hanging around his

Portraiture of Guru Nanak till 1849 141

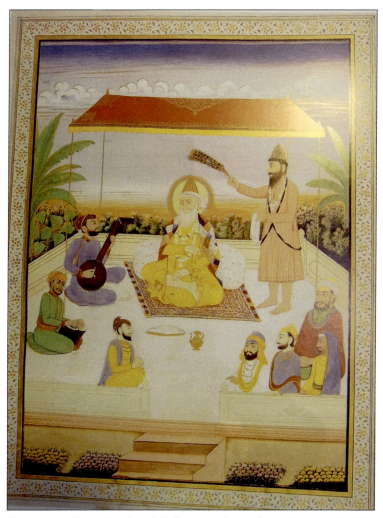

Figure 3.20: *Guru Nanak with Followers and Attendants.* Goswamy (2000), plate 18. Some editions include another image

neck as well. On the left-hand side, Mardana, who has a black beard and faces right in profile, is playing a string instrument while sitting on the floor. His turban is painted brown. He is wearing blue attire and holding a brown instrument. These three figures are covered by a red canopy. Six more people are depicted in the lower area of the

terrace. One figure, who is playing a percussion instrument below Mardana, seems to be a non-elite attendant. Others are perhaps nobility judging from their colourful and characteristic attire. The further back the terrace goes, the narrower its width. Beyond the terrace, banana trees grow on both sides. Realistic blossoms are rendered in the background. The rays from the setting sun are shown on the lower area, behind which white space spreads. White clouds and blue sky are seen in the upper zone. At the bottom of the painting, artificial flower beds are depicted on both sides of the stairs. This painting was perhaps produced in Delhi.

3. Group Portraiture of the Ten Sikh Gurus up to 1849

This section examines the group portraiture of ten Gurus that were produced from the late seventeenth century to the early nineteenth century.

One Deccani painting shows an imaginary meeting of Guru Nanak, Mardana, other Sikh Gurus and so on. In this vertical painting (Figure 3.21), Guru Nanak, who has a white beard and faces left in three-quarter view, is sitting on his heels on the grass at the top of the circle. He is wearing a white skullcap and a colourful robe decorated with triangular patterns and tied with a black belt around his waist. He is holding a stick in his right hand and makes a symbolic sign with his left fingers. A thin brown tree with stylized leaves grows to his right. Some objects, including a vase, are placed in front of Nanak. On the left-hand side, Mardana, who has a white beard and faces right in three-quarter view, is sitting on his heels on the grass outside the circle. He is slightly nodding and playing a brown string instrument. His purple and white turban is tied with a golden cloth. He is wearing a pink robe decorated with floral patterns and tied with a white cloth with golden edges around his waist. At the bottom, two princely figures and an ascetic are depicted. An ascetic who has a white beard and faces left in three-quarter view is sitting cross-legged on the grass on the right-hand side. His uncut hair is tied with a black bandana. He has no attire except a white loincloth. He folds his arms on a stick that stands on the grass. He is staring at two princely figures who are standing on the left-hand side and paying homage to the ascetic. The

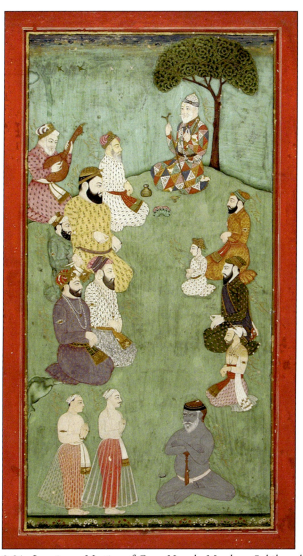

Figure 3.21: *Imaginary Meeting of Guru Nanak, Mardana Sahib and Other Sikh Gurus.* Hyderabad. *c.*1780. Opaque watercolour and gold on paper. 44.13 (38.1) × 25.4 (19.69) cm. Acc. no. M.74.88.3. Downloaded by the author in 2017. The Los Angeles County Museum of Art. Downloaded by the author from the museum website in 2017 (https://collections.lacma.org/)

man, who has a black moustache and white hair, faces right in profile. He is wearing a white turban decorated with black polka dots and tied with a golden cloth. His trousers are painted red. His transparent robe, tied with a white cloth with golden edges, seems to represent a white one. A golden ring is shown on his right hand. Behind him, another figure, who appears to be of a lesser position, is standing in the same posture. His attire is also identical to that of the first man. The only difference is that the attendant has no moustache and his hair is black, which makes him appear younger. Moreover, a golden armlet encircles his right arm. The owner attributes this painting to Hyderabad *c.*1780. It is assumed that these princely figures represent patrons of this work.

The painting (Figure 3.22) shows Guru Nanak in the same iconography as a previous work. This painting is a scene of Sodhi Bhan Singh offering prayers. Twelve lotus spaces surround the circle where Sodhi Bhan Singh is depicted. Each lotus represents a Sikh Guru and so on. Guru Nanak is shown on the left-hand side. His representation is almost identical to the representation of Angad, the second Guru. Two lotus leaves have almost the same composition, where the Gurus on the left-hand side are paid homage by one lady and two attendants on the right-hand side. The attendants, who have white beards and are facing right in three-quarter view, are sitting on the floor. Three colourful trees grow from the green space behind Nanak, which appears to represent a landscape. He is wearing a white skullcap and has a red mark on his forehead. Nanak, who is situated in the upper portion, is wearing a white coat as in the previous Kashmiri painting. Angad, in the lower portion, is wearing a green coat. Their robes are painted red in both renderings. A lady and two attendants are depicted in the same way in both renderings, but a pink canopy and a blue space are added in Angad's folio. The edges of the terrace in Nanak's folio are painted white, whereas they are in yellow in Angad's folio. It is important for us to be able to identify the year of creation of this painting. This painting is seen as one of the folios from the illuminated manuscript of the *Guru Granth Sahib*, the colophon of which says that it was produced in 1839 and took four years to complete, and that it was commissioned by Sodhi Bhan Singh of Haranpur in

Portraiture of Guru Nanak till 1849

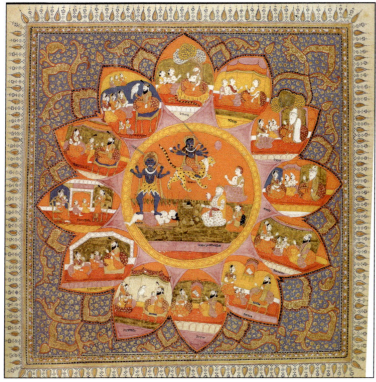

Figure 3.22: *Sodhi Bhan Singh Offering Prayers.* Leaf, possibly formerly appended to a manuscript of the *Guru Granth Sahib*. Kashmir/Punjab. *c.*1840. 52 × 47 cm. Acc. no. 59.525, National Museum, New Delhi. Photographed by the author in 2016

Kashmir. Interestingly, we know that Guru Nanak and Guru Angad are seen as one in representation at this point.

The major renovation of early nineteenth-century Sikh portraits is the establishment of portraits of other Gurus. The painting comprises portraits of the ten Gurus (Figure 3.23). Guru Nanak's image, inscribed below in Gurmukhi, is placed in a prominent position in the upper middle. In this panel, Guru Nanak, who has a white beard, is sitting cross-legged on the floral-patterned carpet. He is looking at the audience in three-quarter view. It is interesting that his head is encircled by a natural halo. His skullcap is painted red and tied with a white

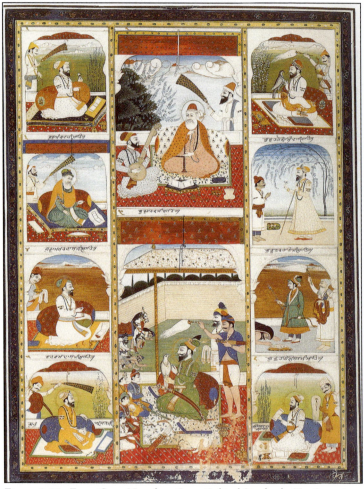

Figure 3.23: *From Guru Nanak to Guru Gobind Singh, the Ten Sovereigns.* From the workshop of Purkhu of Kangra. Pahari. Early nineteenth century. Opaque watercolour on paper. 42 × 42 cm. Collection of Satinder and Narinder Kapany. Goswamy (2006), plate 3.1

bandana. He is wearing a pink robe under an orange dotted coat. He is holding a rosary in his right hand and a stick in his left. He has a black thread around his neck. He is leaning on a white cushion with

floral patterns, each edge of which is painted red. A book is open on the luxurious cloth. On the left-hand side, Mardana who faces right in profile, is sitting and playing a string instrument. He has a black beard and his red turban is tied with an orange bandana. His robe is coloured light grey and tied around his waist. He wears a necklace and a black thread around his neck and an armlet around his right arm. There are a few objects, including a vase, on the geometrically patterned red carpet. In the background, Bala is holding a feather fan above Nanak's head on the right-hand side. He has a black beard and faces left in profile. His red skullcap is tied with a white bandana. A grey cloth is hanging from his left shoulder under the white attire. On the left-hand side, a tree is flourishing with leaves and a blossom. White clouds are drifting across the top with red rays from the setting sun. A red curtain is rolled up with a white thread. Decorated white supports are painted on both sides. Goswamy attributes this painting to the workshop led by Purkhu of Kangra.

The next assembly painting shows the ten Sikh Gurus meetings beyond spacetime (Figure 3.24). It is interesting that the border decorations are the same as those in Ranjit Singh's paintings, which were produced in *c.*1840. This is also the first example of an assembly of the Gurus. Guru Nanak, who has a white beard and faces left in three-quarter view, is sitting cross-legged on the blue carpet with orange borders. He is staring at empty space. His head is encircled by an orange halo. He is wearing golden headgear and a yellow robe under a colourful shawl with square patterns. He is holding a stick in his right hand and dropping his left hand to the floor. A long, black necklace is hanging around his neck. He is leaning on a pink cushion with green edges. To his right stands Bala, who has a grey beard and faces left in profile. He is holding a white fly whisk in his right hand. His skullcap is painted red. He is wearing a light pink robe under a pink shawl. At the bottom, Mardana, who has a white beard, is looking up at Nanak in profile and sitting with one knee propped up. He is stretching out his right hand, as if speaking to Nanak. A brown and yellow string instrument rests on his left shoulder. He is wearing a light pink turban and robe. An orange stole is hung from his right shoulder.

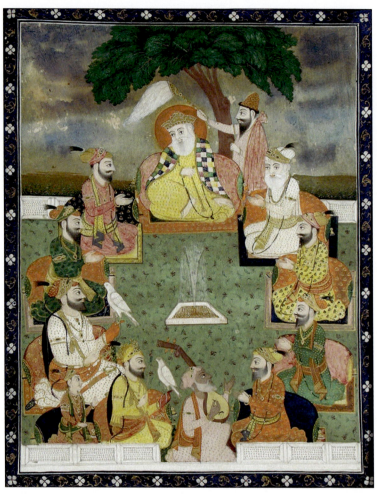

Figure 3.24: *The Nine Sikh Gurus Seated in a Circle under a Tree*. Punjab. *c.*1840. Opaque watercolour and gold on paper. 28.8 × 23.6 cm. Acc. no. 1990.1347, The San Diego Museum of Art. Downloaded by the author in 2017 (https://collection.sdmart.org/kiosk/search.htm).

4. Single Portraits of Guru Nanak till 1849

Some paintings show Guru Nanak as a Hindu ascetic or siddha (Figure 3.25). The first painting portrays Guru Nanak, inscribed on verse in Devanagari, in frontal view. He is sitting cross-legged and placing his

Portraiture of Guru Nanak till 1849

Figure 3.25: *Guru Nanak Seated in Meditation.* Opaque watercolour on paper. Pahari, possibly from a Mankot workshop. Second quarter of the eighteenth century. 18 × 11.2 cm. Acc. no. 248. Government Museum and Art Gallery, Chandigarh. Goswamy (2000), plate 16

left hand on his left knee. His right hand is holding a manuscript that says 'with the Grace of the True Guru' in Takri. He has a white beard and moustache. His red cap is wound with a white bandana. His body is thin and bare except for the transparent white shawl wrapped around it and a short length orange lower garment. Both hands are encircled by bracelets, but a rosary is rendered only in his right hand. Two necklaces in white and black are hanging around his neck. The earring in his left ear proves his status as Master, according to Goswamy. A vessel is depicted on a pink carpet. The background is painted flat in grass colour, which is typical of Pahari painting. Goswamy attributes this painting to a Mankot workshop in the second quarter of the

eighteenth century and indicates the proximity to the representation of Kabir, presumably Nanak's teacher.

The second painting displays Guru Nanak with similar iconography to the first painting, although we find some small changes (Figure 3.26). The biggest difference is the depiction of the background. Guru Nanak is portrayed as if he is living in the hermitage, which is constructed in a traditional manner. The green building is shaped in a rough triangle behind the flat grey space. Two unidentifiable objects are depicted in the house. At the bottom is perhaps the river. His face is altered from a meditative expression to a somewhat insane expression with unfocused eyes. The yellow colour on his forehead becomes more obvious. In addition to the beard and moustache, his eyebrows have

Figure 3.26: *Guru Nanak Seated in Meditation.* Pahari, possibly from a Mankot workshop. Second quarter of the eighteenth century. In Diamond (eds.), 2013

Portraiture of Guru Nanak till 1849 151

turned white. The earring and two necklaces have disappeared. Instead, he is holding a rosary in his right hand. The colour of the lower garment has changed from orange to white. The shawl now has decorated edging. Although this painting is exhibited as a Sikh ascetic, it is evident that the painter aims to represent Guru Nanak, considering its similarity to the first painting.

One of the best examples of Guru Nanak as a Muslim Sufi is the above painting (Figure 3.27). This painting portrays Guru Nanak, inscribed above in Persian, alone in a vertical format. He faces right

Figure 3.27: *Guru Nanak Reading from a Text*. Folio, possibly from a series of portraits of religious men. Late Mughal. Last quarter of the eighteenth century. Opaque watercolour on paper. 16.7 × 15.5 cm. Collection of Satinder and Narinder Kapany. In Goswamy (2006), plate 3.7

in three-quarter view and has a white beard. He is wearing a red skullcap tied with a white bandana. He is holding a red book in his left hand and has marks on his right hand. He is leaning on a pink cushion and wearing a white robe with black polka dots. A long white stole draped from his neck to the floor is impressive. He seems to stay on the terrace. The background shows a landscape that has depth. Lands are shown in the distance, beyond the lake in the middle view. The blue borders are heavily decorated with golden flowers. Goswamy points out that this painting is one of a series of religious figures. Nanak's realistic face is unusual in the history of his representation. Perhaps the artist was trained at the Mughal atelier.

There is a painting that lies outside the mainstream due to its production location of the Deccani states (Figure 3.28). It portrays Guru Nanak in an extraordinarily large size. He faces left in three-quarter view and has a white beard. A white mark is shown on his forehead. His skullcap is painted in white, pink and blue. His head is encircled by a golden halo in which the inner area is painted green. A nimbus is spreading stylized rays. He is wearing a pink robe. One large black thread and another small black thread are hanging from his shoulder and neck, respectively. A golden armlet is encircling his right arm. He is sitting cross-legged on the decorated pedestal and leaning on a red cushion with floral patterns. Many objects are drawn on the terrace in an extremely small size. Mardana, who has a string instrument, is standing on the left-hand side and is quite small in size. He has a white beard and is wearing a red turban tied with a golden cloth. His robe is painted pink and tied around the waist with a red and gold cloth. The owner attributes this painting to Hyderabad, c.1730-40.

Ultimately, Guru Nanak was likely painted shortly before the colonial period or in the 1840s. It portrays him in frontal view, which is easier to use for the purpose of worship. In this painting (Figure 3.29), Guru Nanak faces front and has a white beard and moustache. He is staring straightforwardly at the viewers, with heavy eyes, sitting cross-legged and alone. His head is encircled by a golden halo. He is wearing a yellow turban and robe beneath a navy shawl, which includes shaded draping. He is also wearing a beaded necklace and is holding a rosary in his right hand. He is putting his left hand to the ground.

Portraiture of Guru Nanak till 1849 153

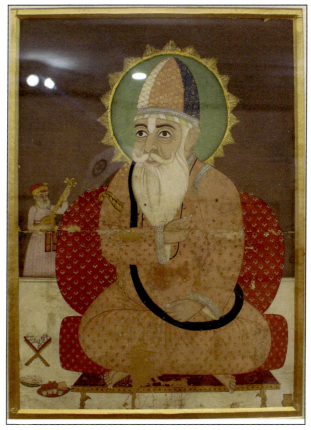

Figure 3.28: *Guru Nanak, the First Guru of the Sikhs.* Hyderabad, Deccan. *c.*1730-40. Paper. 35.5 × 24.5 cm. Acc. no. 59.314, National Museum, New Delhi. Photographed by the author in 2016

A tree, the trunk of which is brown and includes highlighting, is rendered on the right side; its leaves are drooping towards Nanak's head. Green mountains are seen in the distance across a blue river. A bit of sky appears at the top left edge. The textures are unusual, and the brush is likely different from a traditional one. The model for this portrait is unknown; however, it could have been a Sikh teacher. The painting could, in fact, be a rendering of Guru Nanak's statue, located in a Sikh temple. Moreover, his likeness may be modelled after a Hindu god or ascetic through Jodh Singh's imagination.

Figure 3.29: *Guru Nanak*. By artist Jodh Singh. 1848. Shreesh pigment on canvas. Sonia Dhami Collection. Courtesy of its owners

The last painting is new material that I discovered in 2010 (Figure 3.30). This brush drawing is probably a preliminary sketch for a complete painting. Guru Nanak, who has a black beard and faces left in three-quarter view, is sitting cross-legged inside the oval frame. Although the image is not clear, it is assumed that he is wearing a colourful shawl over his robe. His headgear is shaped like a crown. He is resting his right elbow on his right knee and his left hand appears to be dropping to the floor. He is leaning on a cushion, perhaps on

Portraiture of Guru Nanak till 1849 155

Figure 3.30: *Guru Nanak with Ganesh and Soldiers.* Lahore. Second quarter of the nineteenth century. Possibly from the workshop of Imam Bakhsh Lahori. Fakir Khana Museum, Lahore. Photographed by the author in 2010

the terrace. A small image of Ganesh is depicted inside the same frame, which is decorated like a pendant. Well-arranged leaves flourish around the oval frame. Two warriors who have black beards are symmetrically rendered in profile on both sides of the leaves. They are armoured and hold a sword and a shield. The hats are certainly from outside the subcontinent, i.e. Europe. At the top, four attendants are depicted on both sides of a vase. They are armed-like two warriors, but two of them are portrayed in three-quarter view. At the bottom, two tigers

are crouching and carrying the oval frame on their backs. It is certain that this drawing is attributed to the Imam Bakhsh workshop in Lahore, for they are influenced by Western art under the patronage of French generals.

Conclusion

Considering the above analysis and examination, we can see the trial and error of artists around the depiction of Guru Nanak in portraiture produced before the colonial period. I will argue that since Sikhism was a young religion founded at the end of the fifteenth century, it did not have the original tradition of painting that Hinduism and Islam have. Although Guru Nanak is considered one of the saints (*sant*s) active in medieval north India, it is intriguing that the formal features of Guru Nanak's image are those of Islamic saints (Sufis).

CHAPTER 4

Portraiture of Later Gurus up to 1849

While portraiture of Guru Nanak is a manifestation of religious quality, portraiture of the later Gurus is endowed with secular connotations and derives from Mughal and Rajput portraiture. According to the episode in the Akbarnama, the third Mughal emperor Akbar instructed his men to sit for portraits and stated, 'so that those who have passed away have received new life, and those who are still alive have immortality promised them' (Desai and Leidy 1989: 21). Early Mughal portraiture was normally compiled into an album. Most of these portraits are single images of emperors, courtiers and visiting dignitaries; among these, Akbar is depicted differently from others (Desai and Leidy 1989; Stronge 2002; Wright 2008).

In comparison with Akbar's reign, in which Mughal portraiture still maintained Persian influence in style and composition, Jahangir's period saw a strong Western influence and the proliferation of portraiture due to regular contact with Christian missionaries from Europe. Painters at Jahangir's atelier portrayed him as the rightful successor of Akbar (Beach 1992). In this period, Mughal painters began to depict the sitter with careful observation in both the physical and the psychological senses. Many figures and objects were painted into the composition on the basis of either observation or sketches (Desai 1996). Desai and Leidy (1989) insist that Jahangir preferred more intimate and personalized renditions, which led to the popularity of portraiture in his reign. In Jahangir's later reign, portraiture is inclined to symbolism and allegory. For example, the flying putti and halo manifest Jahangir's holiness, which was a 'clear statement of absolute power' (Desai and Leidy 1989: 23).

The seventeenth-century reigns of Shah Jahan and Aurangzeb were characterized by 'formalised, public representations of Mughal

royal figures' (Desai and Leidy 1989: 23), the portrayal of the lesser courtiers and other non-courtly subjects. Desai and Leidy maintain that these reflected 'a degree of direct observation, psychological intensity, a sense of informality, and a greater absorption of the Western techniques of chiaroscuro and articulation of diminishing perspective' (Desai and Leidy 1989: 23). They also state, 'A similar kind of freedom of expression is also seen in the images of ascetics, teachers, and other nonroyal subjects in Mughal from the first half of the 17th century' (Desai and Leidy 1989: 23-4).

In contrast to Mughal portraiture, Tod (as cited in Desai 1994) argues that Rajput portraiture aims to represent the king's genealogy and munificence, for Rajput rulers were expected to protect their successive land and subjects. Desai reveals the characteristic, timeless virtue of kingship. Such an attitude among artists originates in ancient Hindu thought, which showed of both 'a ruler's absolute authority' and 'physiognomically specific royal portraiture' (Desai 1994: 314). At the same time, Desai classifies Rajput portraiture into three categories: (1) portraits rendered in the Mughal style with Mughal tastes; (2) portraits rendered in the Mughal style but with Rajput tastes; and (3) portraits rendered in the Rajput style but with Mughal tastes (Desai 1994). Desai accepts the geographical and political reasons why Mughal influences vary in ateliers and stresses a selective process by which Rajput painters can absorb Mughal conventions. It is seen as a sort of resistance to the new regulation, namely 'the temporal power and the historical position of rulers' (Desai 1994: 319-21), in the Mughal idiom.

Another version of Rajput portraiture is evident in the Pahari painting produced in the hill area of Punjab. Portraits in Mandi and Bilaspur are similar to those of Mughal ateliers. Instead, the local style is evident in Basohli, Mankot and Chamba, which shows 'the ruler bursting with strength and vigour, set against strongly coloured backgrounds' (Crill 2010: 34). Intriguingly, Goswamy claims that the image in Pahari painting seems to be bigger than it is, despite its actual small format. The figure's limbs, ornaments and instruments seem to penetrate the borders (Goswamy 1986). Moreover, the figure is rendered realistically for his 'spirit and memory' (Goswamy 1986: 198), as if he were alive, even if he had passed away. Crill claims that

this expression is 'to emphasise his uncontainable strength and presence' (Crill 2010: 34). Goswamy regards those of Balwant Singh of Jasrota and Sansar Chand of Kangra as the best examples of Pahari portraiture (Goswamy 1986). Moreover, Desai points out two characteristics of the portraits: (1) the fly whisk is most likely used; and (2) the absence of a halo (Desai 1994). She also demonstrates that Pahari portraiture is closer in style to Mughal portraiture, although the Pahari area is further from the Mughal powers than the Rajasthan plain. She hesitates to answer that Rajasthani rulers under the critical political situation demanded their strong and determined authority, whereas Pahari rulers seem to have been relatively rural and flexible (Desai 1994).

In this chapter, I use visual materials, including figure and portrait painting of the later Gurus: Guru Angad, Guru Amar Das, Guru Ram Das, Guru Arjan, Guru Hargobind, Guru Har Rai, Guru Har Krishan, Guru Tegh Bahadur and Guru Gobind Singh, in chronological order. These materials were produced in the Punjab region from the late seventeenth century to the early nineteenth century. This chapter comprises three sections: (1) Portraiture from Guru Angad to Guru Arjan; (2) Portraiture from Guru Tegh Bahadur to Guru Hargobind; and (3) Early Portraiture of Guru Gobind Singh.

1. Portraiture from Guru Angad to Guru Arjan

Guru Angad (1504-52), the Second Guru, is also important because only he saw Guru Nanak in person during his lifetime, and he succeeded to the Guruship directly from the first Guru.

Angad was not depicted in old age like Guru Nanak. The painting (Figure 4.1) shows Angad, inscribed in the top border, in the form of devotion, although Nanak is not rendered. He has a black beard and faces right in profile. He is sitting on his knees on the floral-patterned carpet on the terrace, and his hands are folded. He is wearing a yellow turban tied with a brown bandana and a white robe tied with a red band around his waist. He is leaning on a blue cushion the edges of which are painted green. The background beyond the terrace is coloured green. A black sky and white clouds are rendered at the top.

A painting from the Sikh Gurus' portraits in the *Ranjit Singh's*

Figure 4.1: *Guru Angad*. Gouache on paper. 19.6 × 15.2 cm.
Acc. no. 1844, Government Museum and Art Gallery, Chandigarh.
Photographed from the album by the author in 2016

Military Album shows Angad with a relatively clearer halo. Some Gurus, including Gobind Singh, do not have a halo in this series (Figure 4.2). Angad, who has a black beard and faces right in profile, is sitting with his legs folded on the pink cushion on the heavily decorated golden pedestal. He is wearing a yellow turban and robe tied with a luxurious band around the waist. An armlet embedded with colourful stones is encircling his right arm. Two rosary-like necklaces are hanging around his neck. He is leaning on a golden

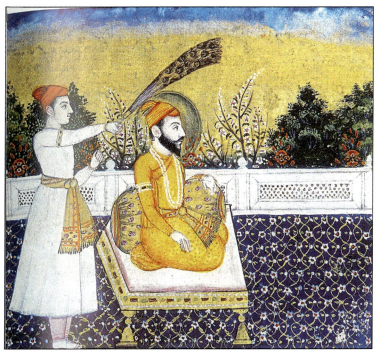

Figure 4.2: *Guru Angad*. From Military Manual of Maharaja Ranjit Singh. Probably the workshop of Imam Bakhsh Lahori. 1822-30. Acc. no. 1035. Maharaja Ranjit Singh Museum, Amritsar. Lafont (2002), plate 111

cushion on which red flowers are painted. A companion who has no beard and faces right in profile is standing on the blue carpet decorated with floral patterns. He is wearing a red turban and a white robe tied around the waist with a golden band whose edges are painted with flowers. An armlet embedded with colourful stones is encircling his right arm. He is holding a peacock feather fan in his right hand. Beyond the latticework, various kinds of vegetation are depicted. The background is painted boldly in gold and a blue sky appears at the top.

Guru Amar Das (1479–1574) is the third Guru and was inaugurated in 1552 at the age of 73. He is normally depicted as much a venerated sage as Guru Nanak.

The first painting shows traits similar to the third painting of Har Krishan regarding the environmental depiction (Figure 4.3). In this work, Amar Das, who has a white beard and faces left in profile, is

Figure 4.3: *Guru Amar Das ji.* Artist unknown. First half of the eighteenth century. Punjab. Acc. no. 74.284. Himachal State Museum, Shimla. Photographed by the author in 2016

sitting with his legs folded on a green flowered carpet on the terrace. He is wearing a white turban tied with a black and yellow striped bandana and a white robe with a similarly patterned shawl around his neck. He is holding a manuscript in his right hand. He is lying on a golden pillow decorated with floral patterns and red edging. On the right-hand side, an attendant, who has a black moustache and faces left in profile, is standing on the yellow carpet on the terrace. He is wearing a white turban and a purple robe tied with a red cloth. A white necklace is hanging around his neck. In his right hand he has a fly whisk, which is resting on his right shoulder. Latticework is shown both above and below the terrace. The background is painted solely in dark green, including mixed borders at the top, despite the blue sky and white clouds.

The second painting is a single portrait of Amar Das, whose name is written on the top (Figure 4.4). He has a white beard and faces left

Figure 4.4: *Guru Amar Das*. Artist unknown. Pahari. Acc. no. 1845b. Government Museum and Art Gallery, Chandigarh. Photographed by the author in 2016

in three-quarter view. He is sitting on his knees and is wearing a green turban tied with a red cloth and a white dotted robe with a red waistcloth, including golden edging. He is lying on a pink pillow with the same dotted patterns and is pointing ahead with his right hand. A white carpet is decorated with grey flowers, and the background is painted in dark blue. The three-quarter view reminds us of Guru Nanak's image, which is usually represented in that view.

The third painting is a work done at the Imam Bakhsh workshop (Figure 4.5). In this painting, Amar Das, who has a white beard and faces left in three-quarter view, is sitting on his knees on the pink carpet over the square pedestal, which is finely decorated with gold and stones. Intriguingly, he gazes straight at the viewer. He is wearing

Figure 4.5: *Guru Amar Das*. From the *Military Album of Maharaja Ranjit Singh*. Attributed to the Imam Baksh workshop. 1822–30. Acc. no. 1035. Maharaja Ranjit Singh Museum, Amritsar. Lafont (2002), plate 112

a white turban, and his head is encircled by a transparent halo. He is also wearing a tinted robe tied with a golden cloth, including floral decorations at the edges. A colourful scarf is draped from his right shoulder. He is leaning on a golden pillow decorated in floral patterns. On the right-hand side, an attendant, who has no beard and faces left in profile, is standing on the dark blue floral carpet. He is wearing a pink turban and a red robe tied with a cloth similar to Amar Das. He is holding a large peacock feather fan in his right hand. Beyond the white latticework, green trees and colourful flowers are depicted. The background is painted in gold and a blue sky over the rounded horizon includes white clouds.

Guru Ram Das (1534-81) is the Fourth Guru of Sikhism. He is famous for founding Amritsar, formerly known as Ramdaspur, the Sikh holy city. He is usually painted as a priest, like Guru Nanak, and is relatively distinct from the other Gurus.

In this painting (Figure 4.6), Guru Ram Das, who has a black beard and faces left in profile, is sitting on his knees on an orange carpet decorated with black spots. He is wearing a white turban tied with an orange bandana and a white robe tied with a red waistcloth. The sleeves are painted in the same orange as the bandana. He is leaning on an orange cushion decorated with floral patterns, the edges of which are painted in black. On the right-hand side there is an attendant who has a black beard and faces left in profile. He is standing on the orange carpet. In his right hand, he is holding a white fly whisk, which is resting on his right shoulder. He is wearing an orange turban and a pink robe tied with a black waistcloth whose edges are painted in yellow. The terrace is covered with a yellow carpet, the edges of which are painted more strongly and decorated with black calligraphy. The fine latticework is painted above and below. The background is painted in green mixed with brown under the blue sky and white clouds.

In this painting (Figure 4.7), Guru Ram Das, who has a white beard and a black moustache, faces left in profile. He is sitting cross-legged on the light green carpet decorated with red dots. He is wearing a white turban tied with a brown bandana, as well as a green robe decorated with black dots. A grey shawl is hanging from his left shoulder and on his right arm. He is leaning on a pink cushion

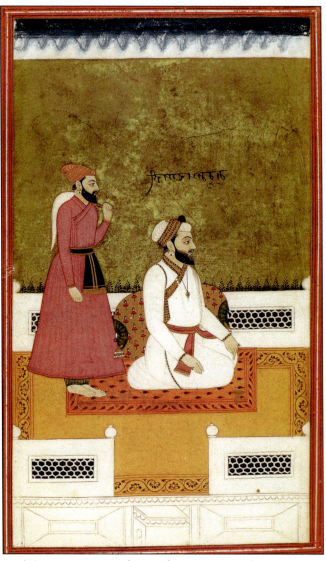

Figure 4.6: *Guru Ram Das, the Fourth Guru.* Artist unknown. A series of portraits of the Gurus. Punjab plains. First half of the eighteenth century. 24.9 (21) × 16.5 (12.3) cm. Opaque watercolour on paper. Acc. no. 74.285. Himachal Pradesh State Museum, Shimla. Goswamy (2000), plate 24

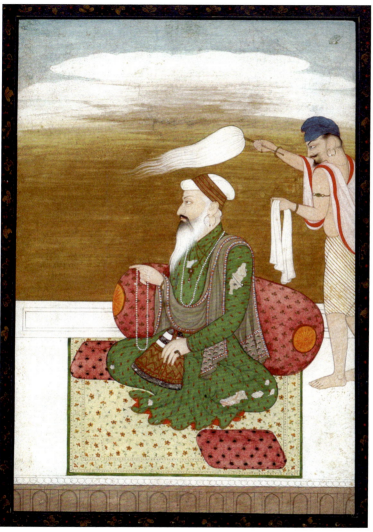

Figure 4.7: *Guru Ram Das, the Fourth Guru.* Leaf from a series of portraits of the Gurus. Pahari. From the family workshop of Nainsukh of Guler. *c.*1800. 21.9 × 16.1 cm. Acc. no. F-42, Government Museum and Art Gallery, Chandigarh. Goswamy (2006), plate 3.9

decorated with black dots whose edges are painted orange. Similar colourings are found in two cloths folded on the carpet. On the right-hand side, an attendant who has a black moustache and faces left in profile is standing on the white terrace, the bottom of which is painted brown. He is holding a white fly whisk in his right hand and a white handkerchief in his left hand. The background is painted brown under a light blue sky and white clouds.

In this painting (Figure 4.8), Guru Ram Das, who has a black beard and faces left in three-quarter view, is sitting with one knee bent

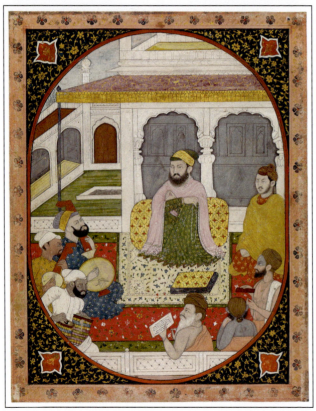

Figure 4.8: *Guru Ram Das*. Attributed to the second generation after Nainsukh. Guler, Punjab Hills. *c.*1825–30. 26 × 30 cm. Opaque watercolour and gold on paper. Photographed at the Braharad Babbar in 2017

on the white carpet decorated with fine floral patterns. He is wearing a grey turban tied with a yellow bandana, as well as a green robe under a purple shawl. He is leaning against a yellow cushion decorated with lattice-like patterns, including red crosses. On the right-hand side, an attendant, who has no beard and faces left in three-quarter view, is sitting cross-legged next to Ram Das. He is wearing a red skullcap and an orange robe with yellow dots under a golden yellow coat. On the left-hand side, there are three musicians in the lower level. One musician, who has a black beard and faces up in three-quarter view, is sitting cross-legged while playing a string instrument painted in light yellow and red. He is wearing a light blue turban tied with a golden yellow bandana, as well as a blue robe with yellow dots. Another musician, who has a thin moustache and faces right in profile, is sitting cross-legged while playing a string instrument painted in light yellow and red. He is wearing a white turban and a golden yellow robe with golden dots. The last musician, who has a black beard and faces right in three quarter view, is sitting cross-legged while playing a colourfully decorated percussion instrument. In the bottom right corner, three ascetics are depicted. One, who has a black beard and faces left in profile, is sitting while holding a dark brown scripture in his right hand. He is wearing a brown cap but nothing on his body. A white cloth is hanging from his left shoulder. His forehead is tinted with ashes. Another ascetic, who we see only from the back, is wearing a brown cap and a pink waistcloth, just like the other two. His body is fully covered with grey ashes. The last ascetic, who has a white beard and faces left in profile, is leaning against the white latticework at the terrace. He is wearing a brown cap and holding a white scripture in his left hand.

In this painting (Figure 4.9), Guru Ram Das, who has a black beard and faces left in three-quarter view, is sitting on his knees on the pedestal, the sides of which are decorated with colourful stones. His head is encircled with a red halo whose centre is transparent. He is wearing a white turban and a white robe tied with a golden waistcloth, whose edges are decorated with floral patterns. A red cloth is hanging diagonally from his right shoulder. He is leaning on a golden cushion with floral patterns similar to the waistcloth. An attendant, who has a thin black beard and faces left in profile, is standing on the navy

170 *Portraying the Guru*

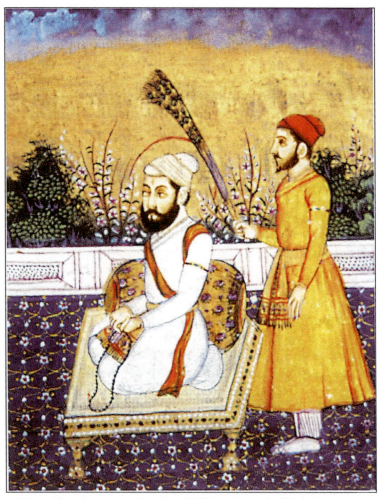

Figure 4.9: *Guru Ram Das. From Military Manual of Maharaja Ranjit Singh.* Attributed to the Imam Bakhsh workshop. Lahore, 1822-30. Acc. no. 1035, Maharaja Ranjit Singh Museum, Amritsar. Lafont (2002), plate 112

blue floral carpet while holding a golden fly whisk decorated with floral patterns similar to those of the cushion behind Ram Das. He is wearing a red turban and a yellow robe tied with a yellow waist cloth as well as white trousers, the edges of which are decorated with similar

floral patterns. Beyond the white latticework, colourful blossoms and green trees are painted in front of the golden background. A blue sky and white clouds are rendered at the top.

Guru Arjan (1563–1606) is the fifth Guru of Sikhism and is renowned as a commissioner of the *Adi Granth*, the prototype of the *Guru Granth Sahib*. His iconography is one of the least characteristic and hardest to distinguish from other Gurus.

In this painting (Figure 4.10), Guru Arjan, who has a black beard and faces left in profile, is sitting cross-legged on a yellow carpet whose borders are decorated with arabesques. He is wearing a white turban

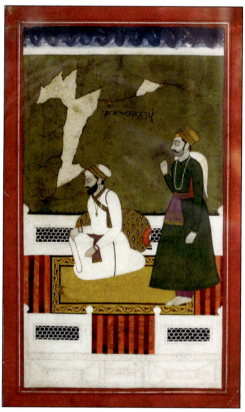

Figure 4.10: *Guru Arjan ji (Fifth Guru)*. Artist unknown. Punjab. First half of the eighteenth century. Acc. no. 74.286, Himachal State Museum, Shimla. Photographed by the author in 2016

tied with a golden bandana and a white robe tied with a golden waistcloth. The sleeves are painted in similar gold. He is leaning against a golden pillow decorated with floral patterns, the edges of which are painted in orange. On the right-hand side, an attendant, who has a grey beard and faces left in profile, is standing on the carpet. In his right hand, he is holding a white fly whisk, which is resting on his right shoulder. He is wearing a yellow turban tied with a golden bandana and a dark green robe tied with a purple waistcloth. A white necklace is hanging around his neck. The floor is covered with a carpet striped red and orange. The black and white latticework is depicted above and below the white terrace. The background is painted green and a blue sky is rendered on white clouds.

In this painting (Figure 4.11), Guru Arjan, who has a black beard and faces left in profile, is sitting on his knees on a white carpet

Figure 4.11: *Portrait of Guru Arjan Dev, the Fifth Guru*. Attributed to Purkhu's workshop of Kangra. Pahari. *c.*1800. 21.9 × 16.1 cm. Acc. No. 1847, Government Museum and Art Gallery, Chandigarh. Goswamy (2006), plate 3.10

Portraiture of Later Gurus up to 1849 173

decorated with floral patterns. He is wearing a white turban tied with a golden bandana and a white robe with red dots similar to the carpet. He is leaning against a red pillow with green dots, the edges of which are painted in green. Beyond the white terrace, the background is painted in light green underneath the light blue sky and orange clouds.

In this painting (Figure 4.12), Guru Arjan, who has a black beard and faces right in profile, is sitting cross-legged on the white floral carpet. He is wearing a pink turban tied with a yellow bandana and a red robe tied with a yellow waistcloth decorated with floral patterns. He is leaning against a turquoise pillow, whose edges are painted in red. Beyond the white terrace, the background is painted boldly in grey.

Figure 4.12: *Guru Arjan*. Artist unknown. Punjab. *c.*1800. Acc. no. 1846, Government Museum and Art Gallery, Chandigarh. Photographed by the author in 2016

174 *Portraying the Guru*

In this painting (Figure 4.13), Guru Arjan, who has a black beard and faces right in profile, is sitting cross-legged on a cushion on a pedestal, the edges of which are decorated with colourful stones. He is wearing a yellow turban and a white robe over yellow trousers. A yellow and green cloth is hanging from his right shoulder. He is leaning against a golden cushion decorated with floral patterns, the edges of which are painted in red. On the left-hand side, an attendant, who has no beard and faces right, is standing behind Arjan while holding

Figure 4.13: *Guru Arjan.* From a folio of *Military Manual of Maharaja Ranjit Singh.* Attributed to the Imam Bakhsh workshop. Lahore. 1822–30. Acc. no. 1035, Maharaja Ranjit Singh Museum, Amritsar. Lafont (2002), plate 114

a peacock feather fan over the Guru. He is wearing a red turban and a golden yellow robe tied with a golden floral waistcloth. He is also wearing red trousers with white stripes. Beyond the latticework, colourful blossoms and green trees are painted on the golden background. A blue sky and white clouds are rendered at the top.

2. Portraiture from Guru Tegh Bahadur to Guru Hargobind

Guru Hargobind (1595–1644), the sixth Guru of Sikhism, is usually represented in a manner similar to Guru Gobind Singh. He is frequently holding a hawk and mounted on a horse. Sometimes he is armed with a sword and a shield, because he fought with Mughal emperors such as Jahangir and Shah Jahan during his life.

In Figure 4.14, Guru Hargobind, who has a black beard and faces left in profile, is sitting with his legs folded on the orange carpet decorated with plant motifs. He is wearing a white turban tied with a golden bandana with stripes and a white robe tied with a red waistcloth. A black feather is attached to the turban and a similar golden cloth is wound around his neck and right shoulder. He is leaning on a golden cushion decorated with floral patterns, the edges of which are painted orange. A falcon is held in his right hand, on which he is wearing an orange glove. On the right-hand side, an attendant, who has a black moustache and faces left in profile, is standing on the floor rendered with pink and red stripes. He is wearing an orange turban tied with a golden bandana and a yellow robe tied with a pink waistcloth. In his right hand, he is holding a fly whisk, which is resting on his right shoulder, and a green handkerchief in his left hand. He is also wearing white trousers under his robe. Latticework is depicted above and below the terrace. The background is painted green, which likely represents a field. A blue sky, white clouds and mixed waves are shown at the top border.

In the first painting (Figure 4.15), Guru Hargobind, who has a black beard and faces left in profile, is standing on the terrace. He is wearing an orange turban tied with a green bandana and a long white robe with floral patterns under which he is wearing brown trousers. A stick is held in his right hand and a black string is hanging around his neck. On the right-hand side stands an attendant, who has a black

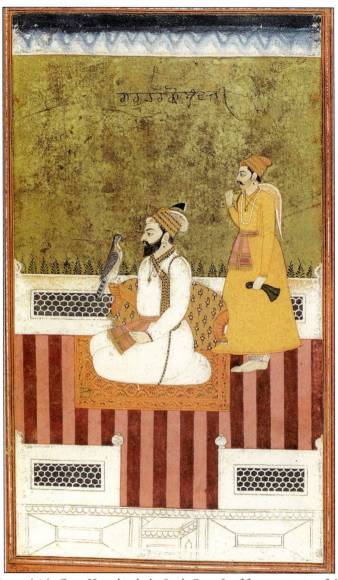

Figure 4.14: *Guru Hargobind, the Sixth Guru.* Leaf from portraits of the Gurus. Artist unknown. Punjab plains, first half of the eighteenth century. 24.9 (21) × 16.5 (12.2) cm. Opaque watercolour on paper. Acc. no. 74.287. Himachal State Museum, Shimla. Goswamy (2000), plate 25

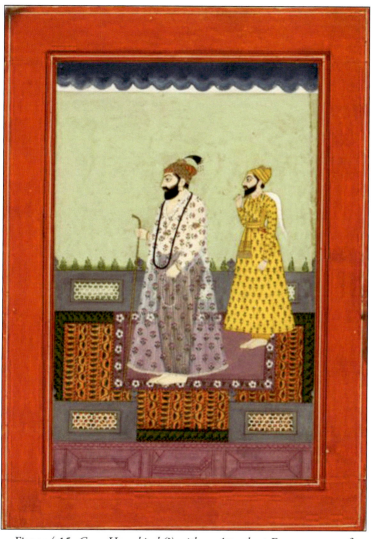

Figure 4.15: *Guru Hargobind (?) with an Attendant*. From a group of works of different themes but sold to the same person in the eighteenth century. Artist unknown. Punjab plains, *c.*1750. 25.4 × 18.4 cm. Opaque watercolour on paper. Acc. no. 1998.59. Asian Art Museum, San Francisco. Goswamy (2006), plate 3.11

beard and faces left in profile. In his right hand, he is holding a white fly whisk, which is resting on his right shoulder. The floor is covered by an orange-based carpet, whose edges are coloured green. A purple carpet rests on it; the edges of the purple carpet are decorated with floral patterns. Latticework is rendered on both sides of the terrace. The background is painted in light green and a blue sky appears with slender clouds.

In Figure 4.16, Guru Hargobind, who has a black beard and faces left in profile, is sitting on his knees on the light yellow carpet. He is wearing an orange turban tied with a yellow bandana to which a white feather is attached. He is also wearing a green robe tied with a white

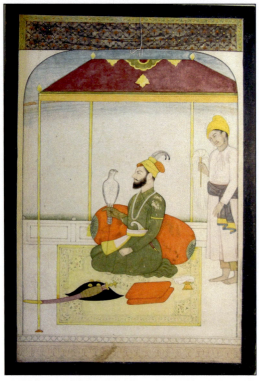

Figure 4.16: *Guru Hargobind Singh*. Attributed to the Seu-Nainsukh workshop. Pahari, first quarter of the nineteenth century. See Archer (1978), plate 3. Photographed by the author at Braharad Bhabbar in 2017

Portraiture of Later Gurus up to 1849 179

waistcloth, whose edges are painted in yellow. He is holding a falcon in his right hand and leaning against an orange cushion whose edges are painted green. His sword sheath, black shield, a pair of floor cushions and a base are also rendered on the carpet. On the right-hand side, an attendant who has no beard and faces left in three-quarter view, is sitting on the terrace. He is wearing a yellow turban and a white robe tied with a grey waistcloth whose edges are painted yellow. Above the terrace, there is a luxurious canopy that is painted purple and holds an emblem on the top.

In the second painting (Figure 4.17), Guru Hargobind, who has a black beard and faces left in profile, is sitting cross-legged on the terrace. He is wearing a green turban tied with a red cloth and a white

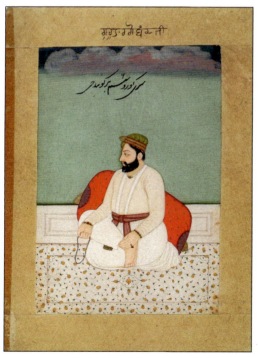

Figure 4.17: *Portrait of Guru Hargobind, the Sixth Guru.* From a family workshop active at Kangra. Pahari. *c.*1790. 20.1 × 15.3 cm. Opaque watercolour on paper. Acc. no. 1848, Government Museum and Art Gallery, Chandigarh. Goswamy (2000), plate 3.13

robe tied with a pink cloth. He is holding a black rosary in his right hand and leaning against a red cushion whose edges are painted purple. The floor is covered by a white carpet with colourful floral patterns. Beyond the edge, light green space is spread. A dark blue sky includes grey clouds over an inscription of his name in Persian.

In the third painting (Figure 4.18), Guru Hargobind, who has a black beard and faces left in profile, is mounted on a white horse. He is wearing a purple turban and a white robe tied with a red cloth edged

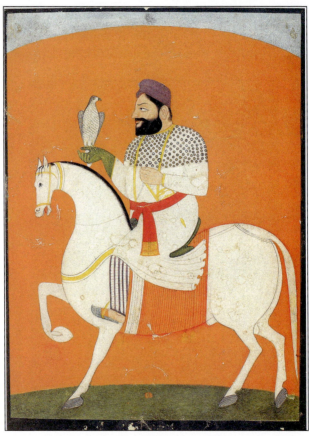

Figure 4.18: *Guru Hargobind Out Riding*. Leaf from a series of portraits of the Gurus. Artist unknown. Kashmir/Punjab; first quarter of the nineteenth century. 35 (28.7) × 27.5 (22.5) cm. Shri Harish Chander, Chamba. Goswamy (2000), plate 26

Portraiture of Later Gurus up to 1849

in yellow, although many black dots are displayed around his shoulders. White trousers with black stripes and a pair of grey shoes are worn. He is holding a falcon in his right hand, which is gloved in green. A yellow thread is hanging around his neck. The horse holds his right leg up and carries an orange cloth as a saddle. Above a green field at the bottom, an orange background is painted under a light blue sky. The borders are slightly curved at the edges.

In this painting (Figure 4.19), Guru Hargobind, who has a black and grey beard and faces left in profile, is sitting with his legs crossed on a white carpet. The carpet is decorated with red dots and covers a square pedestal. He is wearing Kashmir-style headgear, a kingly golden gown and a yellow shawl over a white inner robe with black polka dots. He is also wearing orange trousers with golden floral patterns. He is holding a white falcon in his left hand and is gesturing with his right hand. He has a black shield on his back and is leaning on a red cushion with golden dots. On the left-hand side, two attendants are standing behind the Guru. One, who has a black beard and faces left,

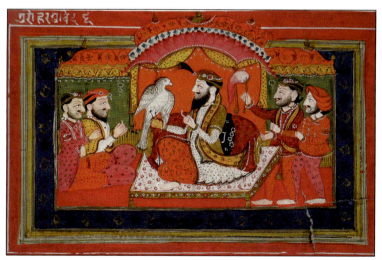

Figure 4.19: *Guru Hargobind, the Sixth Guru, with Followers and Attendants.* Painted leaf from the prayer book manuscript. Kashmiri/Punjab, first quarter of the nineteenth century. 11.3 × 17.8 cm. Opaque watercolour on paper. Acc. no. 3508, Government Museum and Art Gallery, Chandigarh. Goswamy (2006), plate 3.12

is standing while holding a lotus-like fly whisk. He is wearing green headgear and a red robe, as well as orange trousers. Two yellow scarves are crossed diagonally from his shoulders. The other, who has a black beard and faces left in profile, is standing while offering his right hand. He is wearing orange headgear and a robe with golden dots, and wearing pink trousers that also have golden dots. On the right-hand side, two followers are sitting cross-legged on the red carpet. One, who has a black and grey beard and faces right, is wearing orange headgear and a yellow shawl with black dots over a white robe. He is also wearing pink trousers with golden dots. His hands are clasped in front of his chest. The other, who has a grey beard and faces right in profile, is wearing green headgear and a pink robe as well as orange trousers. He is making a pinching gesture with his right hand. He is holding a white rosary, and a decorated armlet is encircling his right arm. All figures are under the orange canopy, which is edged in yellow. Another luxury canopy covers Guru Hargobind.

In this painting (Figure 4.20), Guru Hargobind, who has a black beard and faces left in profile, is sitting cross-legged on a pink carpet over a square pedestal the sides of which are heavily decorated with precious stones. He is wearing a yellow turban and a red robe with yellow dots tied with a yellow waistcloth, edged with floral patterns. His head is encircled by a shaded halo. He is holding a falcon in his right hand and leaning on a yellow cushion decorated in similar floral patterns. A white rosary and a sword with a yellow sheath are hanging around his neck. On the right-hand side, an attendant, who has no beard and faces left in profile, is standing behind the Guru. He is wearing a red turban and a white robe tied with a floral yellow cloth. He is also wearing yellow trousers. He is holding a peacock feather fan over Hargobind's head. The terrace is covered with a navy blue carpet decorated with floral calligraphy. Beyond the latticework, green trees and colourful flowers are depicted on a golden background. A bit of blue sky is barely visible at the top.

In this painting (Figure 4.21), Guru Hargobind, who has a black beard and faces left in profile, is sitting on his knees on a white carpet over a square pedestal. He is wearing a purple turban and a purple floral robe tied with a green waistcloth. His head is encircled by a

Portraiture of Later Gurus up to 1849 183

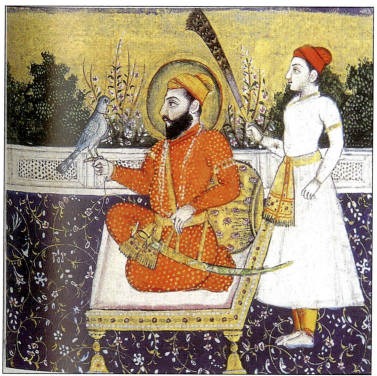

Figure 4.20: *Guru Har Gobind. From Military Manual of Maharaja Ranjit Singh*. Attributed to the Imam Bakhsh workshop. 1822–30. Acc. no. 1035, Maharaja Ranjit Singh Museum, Chandigarh.
Lafont (2002), plate 115

hollow halo. He is holding a blue bird in his gloved right hand. He is leaning on a yellow cushion with square block patterns, the edges of which are coloured blue. On the right-hand side, an attendant, who has a black beard and faces left in profile, is standing behind the Guru. He is wearing a white turban and a white robe while holding a peacock feather fan in his right hand and a red cloth under his right arm. Beyond the white terrace, a green field spreads and a twilight sky is painted, the border of which is deeply curved.

Guru Har Rai (1630-61) is the seventh Guru of Sikhism and was crowned at the age of 14. The most notable episode in his life is that

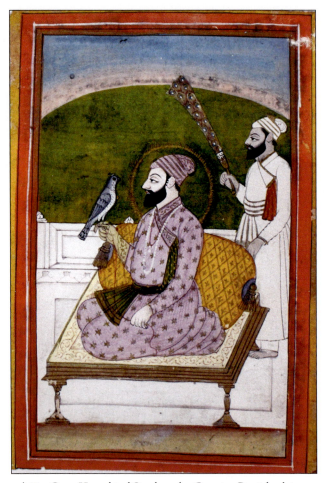

Figure 4.21: *Guru Hargobind Singh and a Courtier.* Punjab plains, second quarter of the nineteenth century. 20.5 × 15.2 cm. Watercolour on paper. Acc. no. 3663, Government Museum and Art Gallery, Chandigarh. Photographed by the author in 2016

he allowed Dara Shukoh, brother and enemy of Aurangzeb, to pass through his territories, which left Aurangzeb outraged. Har Rai is usually painted as a youth with a black beard.

In this painting (Figure 4.22), Guru Har Rai, who has a black beard and faces left in profile, is sitting cross-legged on the yellow and

Portraiture of Later Gurus up to 1849

orange carpet, the borders of which are decorated with lattice-like patterns. He is wearing a white turban tied with a golden bandana and a white robe tied with a golden waistcloth. The sleeves are painted in similar gold. He is leaning against a golden cushion decorated with floral patterns, the edges of which are painted in orange. On the right-hand side, an attendant, who has a grey beard and faces left in profile, is standing on the brown and pink carpet. In his right-hand, he is

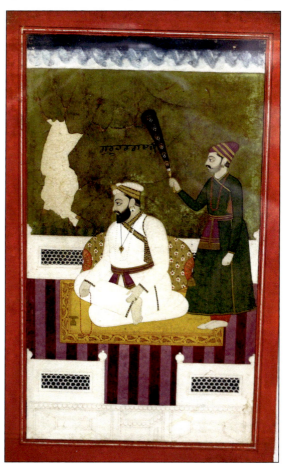

Figure 4.22: *Guru Har Rae ji (Seventh Guru).* Artist unknown. Punjab. First half of the eighteenth century. Acc. no. 74.288, Himachal State Museum, Shimla. Photographed by the author in 2016

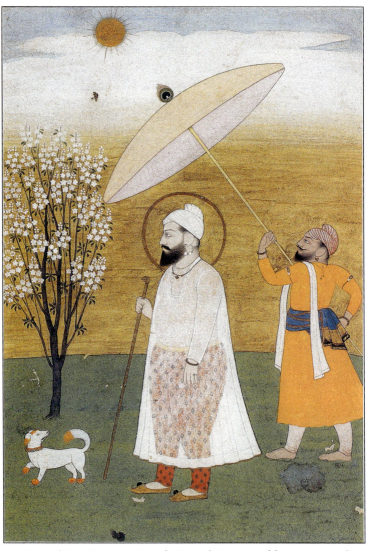

Figure 4.23: *Guru Har Rai, the Seventh Guru.* Leaf from a series of portraits of the Gurus. Attributed to the Seu-Nainsukh workshop. Pahari. first quarter of the nineteenth century. 22 × 16.2 cm. Acc. no. F-45, Government Museum and Art Gallery, Chandigarh.
Goswamy (2006), plate 3.14

holding a black peacock feather fan over Har Rai. He is wearing a purple turban tied with a yellow bandana and a dark green robe tied with a purple waistcloth whose edges are painted in gold. The black and white latticework is rendered above and below the white terrace. The background is painted in green and the blue sky is painted with white clouds.

In this painting (Figure 4.23), Guru Har Rai, who has a black beard and faces left in profile, is standing on the green grass while holding a stick in his right hand. His head is encircled with a red halo the centre of which is transparent. He is wearing a white turban and a white robe over red trousers with green dots. A necklace is hanging around his neck. On the right-hand side, an attendant, who has a black beard and faces left in profile, is standing on the grass while holding a parasol over Har Rai with his both hands. He is wearing a pink turban and an orange robe tied with a blue waistcloth. A white cloth is hanging from his left shoulder. On the left-hand side, there are tall white blossoms and a white dog whose hands, feet, tail and ears are painted orange. The dog is turning back its head to look at Har Rai. The sun is painted in the light blue sky over white clouds.

In this painting (Figure 4.24), Guru Har Rai, who has a small grey beard and faces right in three-quarter view, is sitting cross-legged on a white cushion on a pedestal, whose edges are decorated with colourful stones. His head is encircled with a red halo in which the centre is transparent. He is wearing a white turban and a white robe tied with a golden waistcloth, whose edges are decorated with floral patterns. He is also wearing a golden jacket decorated with similar floral patterns. He is leaning against an orange pillow with yellow dots. On the left-hand side, an attendant, who has a small moustache and faces right in profile, is standing on the navy blue floral carpet while holding a white fly whisk in his right hand. He is wearing a red turban and a green robe tied with a golden waistcloth, the borders of which are painted in red. He is also wearing red trousers. Beyond the white latticework, colourful blossoms and green trees are depicted below the golden background. A mix of blue sky and white clouds are rendered on the top.

Guru Har Krishan (1656-64), the eighth Guru, died at the age

188 *Portraying the Guru*

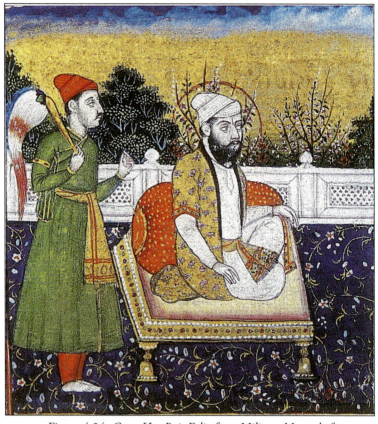

Figure 4.24: *Guru Har Rai. Folio from Military Manual of Maharaja Ranjit Singh.* Attributed to the Imam Bakhsh workshop. Lahore. 1822–30. Acc. no. 1035, Maharaja Ranjit Singh Museum, Amritsar. Lafont (2002), plate 116

of seven. As he was a child, he is one of the most identifiable images among the ten Gurus.

 His oldest image remains at Gurdwara Pothimala, built by the descendants of Guru Ram Das and Prithi Chand in 1745 (Figure 4.25). In this wall painting, the Guru, who faces right in profile, is mounted on a red and brown horse that is raising its forelegs and walking to the right. His head is encircled by a golden halo. He is wearing a blue vest and yellow trousers. His green turban is tied with

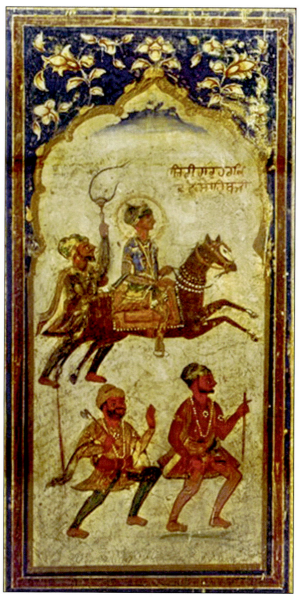

Figure 4.25: *A Fresco of Har Krishan*. Gurdwara Pothimala. *c.*1745. Wikipedia (https://commons.wikimedia.org/wiki/File:Sri_Guru_Har_Krishan_Ji_Gurudwara_Pothi_Mala.jpg)

a golden bandana. He is holding the reins by his hands. An attendant, who faces right in profile and has a black beard, is holding a fly whisk in his left hand above Har Krishan's head. He is wearing a green turban and a red coat. A stole is hung from his neck to his back. He seems to be barefoot. Two more attendants are depicted below them. On the one hand, the right figure, who faces right in profile and has a black beard, is holding a stick in his left hand. He is wearing a green turban, pink trousers and a red robe tied with a golden cloth around the waist. A golden stole and a white necklace are hanging around his neck. A flower decoration serves as a pendant and armlet. On the other hand, the left figure, who faces right in three-quarter view, is holding an axe by his right hand. He is holding his left hand, palm forward, in front of himself. He is wearing a yellow turban and robe tied with a red cloth around his waist and green trousers. A stole is hung on his right arm. Both feet are bare.

The second painting (Figure 4.26) was probably painted at the Seu-Nainsukh workshop active in the eighteenth-century Punjab hills, according to Archer (1973). In this painting, Har Krishan, who faces left in profile and has kuntal, or long sidelocks, is standing on the terrace. He is holding an arrow in his right hand and a bow in his left. His orange turban is tied with yellow and grey bandanas. He is wearing an orange robe under a gold coat dotted with green. On the right-hand side, two attendants are depicted. One, who is turning to look back in three-quarter view and has no beard, is holding a fly whisk in his right hand above Har Krishan's head, and in his left, a decorated dagger wrapped in a yellow cloth. He is wearing a white turban, a light purple garment tied around the waist and white vertically striped trousers. Another, who faces left in profile and has a grey beard, is holding a bow in his left hand and an orange quiver of arrows with his left arm. He is wearing a white turban, a green garment and light blue trousers. On the left-hand side, an ascetic, who is wearing a white turban and short-length pants under a black cloak, is bowing with his hands and knees on the floor. White dumplings are offered, placed between the Guru and the ascetic. The floor is decorated with pink and blue vertical stripes. Various flowers are painted in a regular pattern beyond the edge of the terrace. The background is coloured light blue and the deep blue sky is shown at the top.

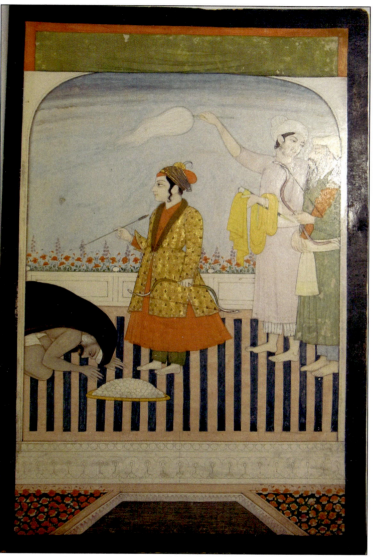

Figure 4.26: *Guru Har Krishan*. Probably from the workshop of Nainsukh of Guler. Pahari. *c.*1820. Photographed by the author at Prahlad Bubbar, London, 2016

192 *Portraying the Guru*

The third painting was executed in the early eighteenth century according to the caption provided by the owner (Figure 4.27). On the left-hand side, Har Krishan, who faces left in profile and has no beard, is standing on a terrace. He is wearing a purple turban tied with a gold bandana and equipped with a black feather. He is also wearing an orange garment decorated with golden drops under a golden floral cloak. A pendant and a white rosary are shown between the black collars of the garment. He is holding a flower in his right-hand and wearing trousers with pink and white stripes. On the right-hand side, an attendant, who faces left in profile and has a light beard, is standing and holding a black peacock feather fan above Har Krishan. He is wearing a white turban tied with a golden bandana and a yellow

Figure 4.27: *Guru Har Krishan*. Punjab. First half of the eighteenth century. Acc. no. 74.289, Himachal State Museum, Shimla. Photographed by the author in 2016

garment tied with a purple cloth around his waist. A pendant and a white rosary are hanging around his neck. He is wearing the same trousers with pink and white stripes as the Guru. A green carpet decorated with yellow drops and arabesques lies on the floor; there is fine latticework above and below the carpet. The background is painted boldly in green, although there is a big tear on the inscription. Blue waves are depicted in the white area, representing clouds under the blue area at the top.

The fourth painting is a series of Sikh Gurus from the *Military Album of Maharaja Ranjit Singh,* painted at the Imam Bakhsh workshop (Figure 4.28). Here, Har Krishan, who faces left in profile and has no beard, is sitting on his knees on the pedestal. His head is encircled by

Figure 4.28: *Guru Har Krishan. From Military Manual of Maharaja Ranjit Singh.* 1822-30. Acc. no. 1035, Maharaja Ranjit Singh Museum, Amritsar. Lafont (2002), plate 117

a golden halo. He is wearing a red turban and a red robe tied with a yellow cloth decorated with flowers at the edges. The robe has yellow polka dots. He has a white rosary around his neck, and an armlet with precious stones is encircling his left arm. He is holding a flower in his right-hand and is leaning against a finely decorated cushion with floral patterns, both edges of which are coloured green. The square quadruped pedestal is also decorated with red and green patterns. On the right-hand side, an attendant, who faces left in profile and has a small moustache, is standing and holding a golden peacock feather fan above the Guru. He is wearing a yellow turban and a pink robe tied with a luxurious cloth similar to that of Har Krishan. An armlet decorated with precious stones is encircling his left arm. He is also wearing trousers with red and yellow stripes. The floor is painted dark blue and decorated with floral patterns. Beyond the fine latticework, there is a white building on the right-hand side. Each panel of the building has a flower in a vase painted on it. A red scroll with yellow polka dots and borders is shown above the middle entrance. On the left-hand side, a bush and flowers are depicted below the fence. The top space is painted boldly in gold.

Guru Tegh Bahadur (1621-75), the ninth Guru of Sikhism, is famous for the numerous verses he wrote; many of these have been added to the *Guru Granth Sahib*, the Sikh holy text. Like Gobind Singh and Hargobind Singh, he is painted as a warrior, frequently holding a falcon and dressed with a sword and armour.

In this painting (Figure 4.29), Guru Tegh Bahadur, who has a black beard and faces left in profile, is standing on a carpet decorated with red and yellow stripes. He is wearing a yellow turban tied with a yellow cloth and a yellow robe without a waistcloth. In his right hand, he is holding a stick that reaches down to the floor. A white thread is hanging around his neck. He is also wearing pink and white striped trousers. On the right-hand side, an attendant, who has no beard and faces left in profile, is standing behind Tegh Bahadur. He is wearing a yellow turban tied with a yellow cloth and a green robe tied with a pink cloth whose edges are decorated in gold. The terrace is painted in white and the latticework is depicted as black and white mesh. The background is painted in green and the blue sky includes layers of wavy clouds.

Figure 4.29: *Guru Tegh Bahadur, the Ninth Guru.* A series of portraits of the Gurus. Artist unknown. Punjab plains. First half of the eighteenth century. 24.9 (21) × 16.3 (12.3) cm. Opaque watercolour on paper. Acc. no. 74.290. Himachal State Museum, Shimla.
Copied from Goswamy 2000

196 *Portraying the Guru*

In this painting (Figure 4.30), Tegh Bahadur, who has a black beard and faces left in profile, is standing in the centre on the grass while holding a navy hawk in his right hand. Interestingly, his head

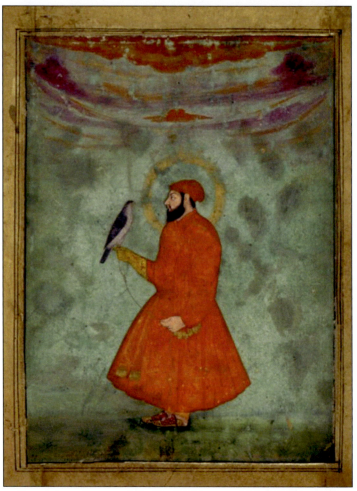

Figure 4.30: *Portrait of the Ninth Sikh Guru, Tegh Bahadur.* Artist unknown. Northern India or Pakistan. *c.*1670 (?). 27.3 (22.2) × 20.9 (16.5) cm. Opaque watercolour on paper. Acc. no. 1998.94. Asian Art Museum, San Francisco. Downloaded by the author in 2016 (http://searchcollection.asianart.org/)

Portraiture of Later Gurus up to 1849 197

is encircled with a golden halo, the centre of which is transparent. He is wearing an orange turban and robe. The background is painted in green, and purple and orange clouds are floating at the top.

In this painting (Figure 4.31), Guru Tegh Bahadur, who has a black beard and faces right in profile, is sitting cross-legged on the pedestal on a white cushion, the edges of which are decorated with

Figure 4.31: *Guru Tegh Bahadur.* Attributed to the Imam Bakhsh workshop. From *Military Album of Maharaja Ranjit Singh.* Lahore. 1822–30. Acc. no. 1035, Maharaja Ranjit Singh Museum, Amritsar. Lafont (2002), plate 118

floral patterns. His head is encircled with a red halo whose centre is transparent. He is wearing a red turban and a light yellow robe tied with a light yellow waistcloth. A red cloth is hanging diagonally from his right hand. He is leaning against a golden cushion decorated with floral patterns. He is holding a sword in a green sheath. On the left-hand side, an attendant, who has no beard and faces right, is standing on the navy floor decorated with floral patterns. He is wearing a pink turban and a pink robe tied with a golden waistcloth whose edges are painted with floral patterns similar to the cushion. He is holding a white fly whisk in his right hand and gesturing with his left hand. Beyond the lattice works, green trees and blossoms flourish in the golden background. A blue sky and a bit of white cloud appear at the top.

3. Early Portraiture of Guru Gobind Singh

Among the Gurus following Nanak, Guru Gobind Singh (1666–1708), tenth and last human Guru, has been the most popular and the most frequently depicted in paintings. He sometimes appears next to Nanak and sometimes pays homage to the first Guru. However, it is often difficult to identify Gobind Singh accurately because he is normally represented in the fashions of royalty and nobility. For example, the oldest rendering of the Tenth Guru might have been produced in the early eighteenth century shortly after his death in 1708, as the painted figure seems to be young; that is, his rendering is not from life. In this painting (Figure 2.5), a princely figure approaches a venerated Muslim sage. Goswamy suggests the possibility that the sage is Guru Nanak, according to the Persian inscription, 'Ceres Guru La'alu Nanak' (Sri Guru beloved Nanak); Goswamy has nothing to say about the princely figure.

In contrast, Patwant Singh points out that this princely figure is Guru Gobind Singh. He did not mention the painting Goswamy examined but focused on another painting in which similar characters were rendered (Figure 4.32). This painting is more like the Rajput style than the previous painting in Mughal style. Guru Nanak, who has a white beard and faces left in profile, is blessing a princely figure with his right palm held up. A mark is shown on his forehead. A long

Portraiture of Later Gurus up to 1849 199

Figure 4.32: *Guru Gobind Singh Encounters Guru Nanak Dev.*
Eighteenth century. From Singh, Patwant (1989)

stick is leaning on his right arm. He is holding a blue peacock feather fan in his left hand. He is wearing a white skull cap and a white robe decorated with broken black lines. Guru Gobind Singh, who has a black beard and faces right in profile, is holding a falcon on the brown cloth in his right hand. He is holding a white rosary in the same hand. His left hand is used to support the bird. The same mark as Nanak is shown on his forehead. He is wearing a brown turban with a black feather and a brown and white robe tied with an orange cloth around the waist. A black dagger is stuck in the cloth. His trousers are painted yellow with vertical red stripes. On the right-hand side, two more figures are depicted behind Nanak. One, close to Nanak, is perhaps Gobind Singh's attendant. He has a black beard and faces left in profile; his attire is luxurious. He is wearing a white turban tied with a blue cloth decorated with red and white stripes. He is also wearing a white robe under a brown gown decorated with many small flowers. While his arms are crossed, his left hand pokes out to hold a sword with a white handle and a black sheath. A black rosary is held in his right hand. His trousers are coloured blue with vertical yellow stripes. The last person looks entirely like Nanak. He is holding a falcon in his

Figure 4.33: *Guru Gobind Singh with an Attendant.* Punjab. First half of the eighteenth century. Acc. no. 74.291, Himachal State Museum, Shimla. Photographed by the author in 2016

arms. The only problem is that Patwant Singh did not describe where this important painting was stored.

The next painting shows Guru Gobind Singh, inscribed above his head, on a terrace (Figure 4.33). He has a black beard and faces left in profile. He is sitting on his knees on a yellow carpet with arabesque borders. His red turban is tied with golden bands and decorated with a black feather. He is wearing a white robe tied at the waist with a purple cloth patterned with golden stripes. A similar golden stole and a white rosary are hanging around his neck. He is armed with a sword in a red sheath, a golden bow, and arrows in a red quiver. One arrow is held vertically in his right hand. He is leaning on a golden cushion decorated with floral patterns whose edges are coloured in red. On the right-hand side, an attendant, who has a black beard and faces left in profile, is standing with a peacock feather fan held in his right hand. In his left hand, he has a red shield and something like a quiver. He is also wearing a red turban tied with golden bands. A purple robe is tied at the waist with a golden cloth. A white rosary is hanging around his neck. The floor is painted in green and decorated with floral patterns similar to those of the carpet. An unidentifiable object is placed on the carpet. The terrace is decorated with latticework, except for the entrance at the bottom. The background is painted boldly in green and the blue sky is rendered on the top border. The owner attributes this painting to the first quarter of the eighteenth century.

The same owner holds another Gobind Singh painting (Figure 4.34). The words inscribed on the bottom border in Persian script say, 'peshkash 'ali janab Sardar Gurmukh Singh Sahib, Sahib Bahadur President Council riyasat-i Patiala dam ... fidvi namak parwurdah Muhammad Sharif wald Basharatullah musavvir' [Presented to the honoured Sardar Gurmukh Singh Sahib, of exalted rank, President of the Council of the State of Patiala, by the humble and loyal (literally, feeding on his salt), the painter Muhammad Sharif, son of Basharatullah] (Goswamy 2000: 49). In this equestrian portrait, he has a black beard and faces left in profile. He is astride a horse who is rearing up on his hind legs. He is wearing a golden turban. A golden robe is decorated with floral patterns and its edge is painted in yellow. He is armed with a sword, a spear and arrows. An arrow is held in his left hand. He is

202 *Portraying the Guru*

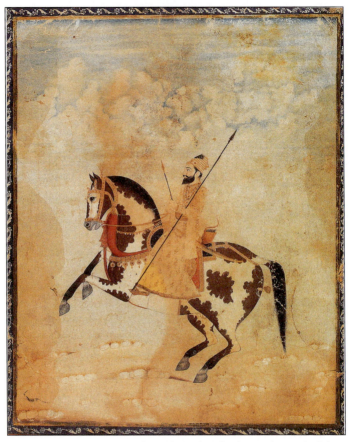

Figure 4.34: *Guru Gobind Singh on Horseback*. Patiala. End of the eighteenth century. Opaque watercolour on paper. 39.9 (28.5) × 25.3 (23.4) cm. Acc. no. 75.158. Himachal State Museum, Shimla. Goswamy (2000), plate 30

holding the reins in his right hand. A red cloth is interposed between the blue saddle and Gobind Singh. The horse is dappled in white and brown. The background appears to be blank, but we can see a light blue sky and light brown earth. The owner and Goswamy attribute this painting to the end of the eighteenth century.

The below painting shows Gobind Singh with similar iconography (Figure 4.35). The words are inscribed on verso in Devanagari and

Persian characters, saying, 'Sri Guru Gobind Singh 10' and in a later hand '10 Guru Gobind Singh' (Goswamy 2006: 146). Gobind Singh, who has a black beard and faces left in profile, is riding a horse coloured in black and white. His green turban is tied with a yellow bandana

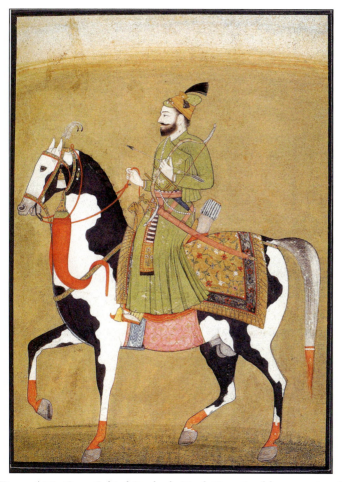

Figure 4.35: *Guru Gobind Singh, the Tenth Guru.* Leaf from a series of portraits of the Gurus. From the family workshop of Nainsukh of Guler. Pahari. First quarter of the nineteenth century. 21.4 × 16.2 cm. Acc. no. F-48, Government Museum and Art Gallery, Chandigarh.
Goswamy (2000), plate 29

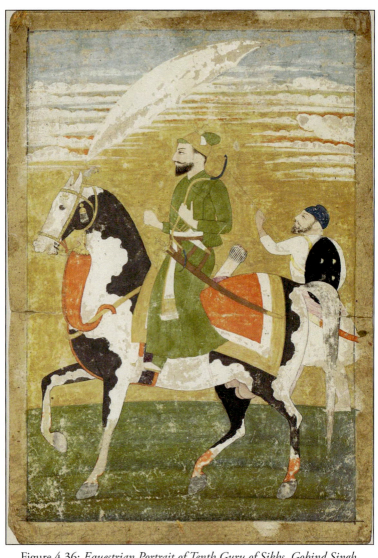

Figure 4.36: *Equestrian Portrait of Tenth Guru of Sikhs, Gobind Singh.* Attributed to Nainsukh family. Punjab. *c.*1800. Opaque watercolour on paper. 21.4 (23.5) × 14.6 (16.5) cm. Acc. no. 17.27.29, Museum of Fine Art, Boston. Downloaded by the author in 2017 (https://collections.mfa.org/collections;jsessionid)

and decorated with a black feather. He is wearing a green robe tied with a black and white striped cloth with golden edges. He is armed with a sword in a pink sheath and arrows in a pink quiver. He is holding a bow in his right hand and the red reins in his left hand. A luxury carpet decorated with floral patterns and grey borders lies upon the pink saddle. The background is painted in brown and the horizon is curved along the white sky. Some grass is rendered at the bottom.

In Figure 4.36, Guru Gobind Singh, who has a black beard and faces left in profile, is mounted on a horse in the centre. He is wearing a green turban tied with a yellow bandana and a green robe tied around the waist with a decorated white cloth. He is holding a bow in his left hand, which is also hanging on his left shoulder. His right hand seems to grab the reins, although it is likely not painted. The horse, whose colours vary in black and white patches, raises its right foreleg while walking. An orange carpet with yellow edges is used in place of a saddle. Another orange cloth is hanging from the reins. On the right in the painting, an attendant who has a black beard and faces left in profile is standing on the grass while holding a white umbrella over Gobind Singh's head. He is wearing a blue turban and a white robe and is carrying a black shield on his back. The background is painted in yellow, which seems to represent twilight. White clouds are floating under the blue sky.

The next painting (Figure 4.37) is a bit controversial in identification, although Archer (1966) regards the nobleman as Gobind Singh. He has a black beard and faces left in profile; he is paying homage to Nanak. He is sitting on his knees. He is wearing a purple turban tied with crossing black threads and a purple robe tied with a white cloth around the waist. A black thread is hanging from his right shoulder to his right side and a white cloth is hanging vertically from the right shoulder.

One of the most exquisite Gobind Singh paintings was executed by the family workshop of Nainsukh of Guler (Figure 4.38) (Goswamy 2006). In this painting, the Guru, who has a black beard and faces left in profile, is sitting on his knees on a white carpet with orange borders on a golden pedestal. His yellow turban is tied with golden bandana; a black feather is attached to it. His head is encircled by a

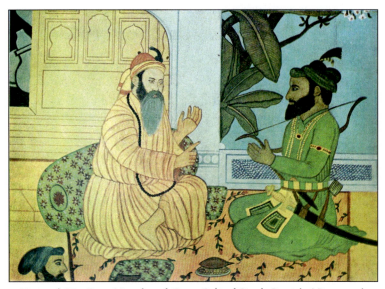

Figure 4.37: *Guru Nanak and Guru Gobind Singh.* Punjab. Nineteenth century. Courtesy Dr C.S. Chan, London. Srivastava (1983), plate XIII

green halo with a golden outline. He is wearing a yellow robe tied with golden cloth and decorated with polka dots. He has a black shield on his back and a sword in a red sheath around his waist. He is holding a golden bow in his right hand and making a symbolic sign with his left. He is leaning on a golden cushion decorated with pink floral patterns, the edges of which are painted in red. An unidentifiable black object is placed on the pedestal. On the right-hand side, an attendant, who has a white beard and faces left in profile, is standing on the red floor, holding a fly whisk in his right hand. His pink turban is tied with a golden bandana. He is wearing a flesh-coloured robe tied around the waist with a white cloth whose edges are gold, and green trousers. A white stole and a sword are hanging from his shoulders and waist, respectively. On the right-hand side, three figures and a horse are depicted outside the hexagonal terrace. A man, who has a black beard and faces right in three-quarter view, is holding a falcon in his right hand. He is wearing a green turban and robe tied with a red belt around his waist. Another man, who has no beard and faces right in three-quarter view, is holding a lotus-like awning that is

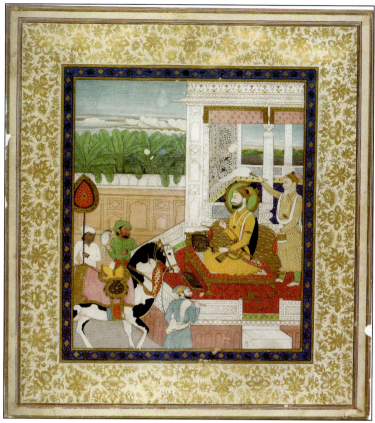

Figure 4.38: *Guru Gobind Singh Seated in Majesty.* Folio, possibly from a series envisioning the great Gurus. From the family workshop of Nainsukh of Guler. Pahari. *c.*1815. Opaque watercolour, gold and silver on paper. 17.5 × 15.6 cm. The Samrai Collection, London. Goswamy (2006), plate 3.16

painted in orange and has a golden outline. A black and white horse carries a gold and yellow saddle over the pink rug with golden borders. A princely figure at the bottom has a black beard and faces right in profile. He is holding a fly whisk in his right hand; his left is akimbo. His blue turban is tied with a golden bandana. He is wearing a blue robe tied with a white cloth around his waist. Behind Gobind Singh, there is a well-decorated room with large windows and a distant view

of green mountains and a river. Banana trees are flourishing beyond the wall. White clouds are floating and twilight is shown in the blue sky.

The next Gobind Singh painting is more identifiable in iconography (Figure 4.39). Lafont (2002) attributes this painting to the workshop of Imam Bakhsh Lahori. The Guru has a black beard and faces right

Figure 4.39: *Guru Gobind Singh*. From *Military Manual of Maharaja Ranjit Singh*. Probably from the workshop of Imam Bakhsh Lahori. Lahore. 1822-30. Acc. no. 1035. Maharaja Ranjit Singh Museum, Amritsar. Lafont (2002), plate 119

in profile. He is mounted on a white horse that is rearing up on its hind legs. The Guru's yellow turban is decorated with feathers of various colours. He is wearing a yellow robe tied at his waist and red trousers. He is carrying a black shield on his back, a bow on his right shoulder and arrows along his waist. It is important to note is that he is holding a bird in his left hand, as his later images are. His right hand is used to hold the red reins. Two rosary-like necklaces are hanging around his neck. He is sitting on the horse on a green cushion over a red carpet. On the right-hand side, a soldier, who has a black beard and looks back in profile, is leading the party. He is holding an orange flag decorated with yellow polka dots in his right hand and a sword in his left hand. His black turban is tied with yellow threads. He is wearing a white robe tied with a pink belt around his waist, from which a black shield is hung. A dog is playing with the sheath. On the left-hand side, two courtly attendants follow Gobind Singh. One, who has a black beard and faces right in profile, is holding a peacock feather fan. He is wearing a black turban tied with yellow threads, a pink robe tied with a yellow cloth around his waist, and red trousers. An armlet is encircling his right arm. The other, who has a black moustache and looks up in three-quarter view is holding a lotus-shaped awning decorated with pink stones to the Guru's head. The background is painted in luxurious gold. The grass field is depicted with a curved horizon. A small pond is rendered at the bottom.

In Figure 4.40, Guru Gobind Singh, who has a black beard and faces right in profile, is sitting on his knees on the throne, which has a red carpet, or Akali Takht. His head is encircled by a halo painted in gold. He is wearing a yellow turban tied with a golden bandana and a yellow robe. A golden thread is diagonally crossed from his right shoulder. He is holding a manuscript in his right hand. Opposite him, a courtier, who has a black beard and faces left in profile, is sitting on his knees on the terrace. He is painted in a much smaller size than Gobind Singh. He is wearing a red turban and a green robe. A red thread is hanging diagonally across from his right shoulder. Their setting is a terrace surrounded by an artificial pond and includes a golden temple known as Darbar Sahib, which is decorated and painted in gold. Four bathing devotees are depicted at the bottom, and two are rendered on the far side of the pond. The pond is surrounded by

Figure 4.40: *A Sikh Guru Seated in the Golden Temple at Amritsar*. From the family workshop of Nainsukh of Guler. Pahari. *c.*1825. Opaque watercolour and gold on paper. 17.8 × 15.2 cm. The Samrai Collection, London. Goswamy (2006), plate 2.3

white walls, in which many windows are shown on the top. Goswamy (2006) insists that the painter had never been to Amritsar.

The painting (Figure 4.41) shows Gobind Singh in an equestrian portrait. He has a long black beard and faces left in profile. He is mounting a blue and red horse that is rearing up on its hind legs. His black turban is decorated with a black feather. His head is encircled by a blue halo with a golden outline. He is wearing a white robe tied with a green and white cloth around his waist. He is holding the reins,

Figure 4.41: *Portrait of the Tenth Guru, Gobind Singh.* Punjab. *c.*1830. Opaque watercolour and gold on paper. 24.1 (18.4) × 20.9 (15.2) cm. Acc. no. 1998.95, Asian Art Museum, San Francisco. Downloaded by the author in 2016 (http://searchcollection.asianart.org/)

on which a falcon stands. He is also armed with a black shield on his back and a sword in a black sheath. An armlet is encircling his right arm. Alongside the Guru, two attendants, who have black beards and face right in profile, are accompanying the horse. Both seem to be dressed in the same manner: a grey turban, a white robe tied with a yellow cloth around their waist and a blue stole on their shoulder. They are each carrying a peacock feather fan. On the right-hand side, another attendant, who has a black beard and faces left in profile, is

212 *Portraying the Guru*

holding a lotus-like awning. He is wearing a yellow turban and a white robe tied with a green cloth around his waist. At the bottom, a river and some bushes are rendered with a peacock. The biggest tree is shown at the right edge. In the distant view at the top, towns are depicted on hills beyond the river. The landscape is dotted with woods and bushes.

In Figure 4.42, Guru Gobind Singh, who has a black beard and faces right in profile, is sitting on his knees inside the temple. He is painted on the same scale as he was. He is wearing a yellow turban and robe and is holding a white fly whisk in his right hand. A book is placed on the green and red cushion. The building is painted carefully in great detail. The upper part of the temple is painted in gold with

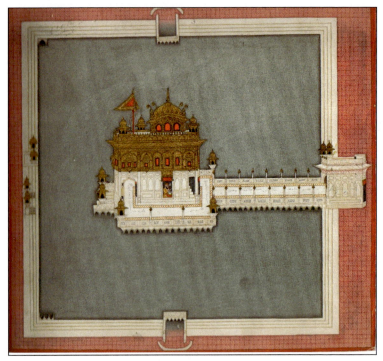

Figure 4.42: *Harimandir Sahib, the Golden Temple at Amritsar.* Punjab. *c.*1840. Watercolour and gold on paper. 25.4 × 27.6 cm. Asian Art Museum of San Francisco. Goswamy (2006), plate 2.2

red windows, while the lower part is painted white as the corridor to the outer garden. No one is bathing in the pond.

The following painting shows Gobind Singh meeting with his four sons, the Sahibzadas: Ajit Singh, Jujhar Singh, Zorawar Singh and Fateh Singh (Figure 4.43). All were killed by the Mughals in the Guru's lifetime. Gobind Singh, who has a black beard and faces left in profile, is sitting on his knees on a golden pedestal. He is wearing

Figure 4.43: *Guru Gobind Singh with His Four Sons, the Sahibzadas.* Punjab plains. Second quarter of the nineteenth century. 32.4 × 27.6 cm. Acc. no. 1842. Government Museum and Art Gallery, Chandigarh. Goswamy (2006), plate 3.17

a green turban tied with a golden bandana, and a green robe tied with a golden cloth around the waist. His head is encircled by a light green halo with a golden outline. He is stroking the breast of a falcon, who stands still on his left hand. He is leaning on a pink pillow, whose edges are coloured in yellow. A sword in a red sheath is placed on his knees. A dog is crouching beneath the pedestal. His four sons, who have no beards and face right in profile, are sitting on their knees opposite the Guru. They are similarly dressed in robes of yellow, pink, green and blue. They are also armed with swords in red sheaths, golden bows and blue shields. On the right-hand side, four attendants are standing behind Gobind Singh. One is holding a fly whisk over his head. Three have a black beard, whereas the remaining one has a white beard. They are armed with arrows in yellow quivers, red shields, swords in golden sheaths and arrows. On the left-hand side, three attendants, who have black beards, are standing on the white floral carpet. They are holding a spear, a stick and a bow, respectively. One, who has a spear, also has a red shield. All the figures are beneath the canopy, coloured in green and red. The background is the gradation from the top blue to the middle white. Green banana leaves are shown over the terrace. At the bottom, two bushes are rendered on both sides of the artificial square pond in front of the entrance to the terrace.

In Figure 4.44, Guru Gobind Singh, who has a black beard and faces left in profile, is sitting with his legs folded on the white carpet in which embroiders are decorated in floral patterns and the centre is dotted. He is wearing a black turban tied repeatedly with a golden bandana. His robe is painted in red, and he has a golden scarf edged with floral patterns around his neck. He is leaning on a golden cushion patterned with flowers. On the right-hand side, an attendant, who has a black beard and faces left in profile, is standing behind him. He is wearing a yellow turban and a decorated pink robe. He is holding a fly whisk in his right hand over Gobind Singh. On the left-hand side, a prince, who has no beard and faces right in profile, is sitting on his knees. He is wearing a red turban tied with a golden bandana that has a black feather. His robe is painted red and dotted. He has a golden scarf around his shoulders. The setting is a white terrace, beyond which a green field is painted. A blue sky and white clouds are also rendered at the top.

Figure 4.44: *A Sikh Guru and a Prince in Conversation.* Guler workshop. Himachal Pradesh. 1800-1825. Opaque watercolour on paper. 21.9 (29.2) × 16.2 (22.9) cm. Acc. no. P.2001.13.1, Norton Simon Museum. Downloaded by the author in 2017 (https://www.nortonsimon.org/art/search-the-collection).

Conclusion

Given the above, I have also examined portraits representing the nine Sikh Gurus who followed Guru Nanak. The Gurus were painted in the style of portraits of Sikh royalty and nobility of the times, due to the fact that the Sikh chiefs were the patrons of the painters. Hence, these portraits reflected the Sikh chiefs' aspiration to be as dignified as if they were the Mughal emperors and their subordinates.

CHAPTER 5

Colonial Portraiture of the Sikh Gurus

Beginning in the eighteenth century, the activities of the East India Company transformed the style of art in South Asia and created a new style known as 'Company painting', which disseminated from south India to Punjab (the term has recently been criticized; Dalrymple 2019). As British territories were expanding, local royalty and nobility, who had patronized court painting, disappeared. Few local painters survived as Company painters; they followed their patrons' liking and adjusted to the European manner of painting and drawing. Furthermore, the new patronage from the British East India Company and the British bureaucracy invited many European painters, who took up the patronage of local artists.

The British era in Punjab was a time of connecting traditional schools of art to broader pan-Indian and global trends. For example, Sher Mohammad was one of the successful artists in Lahore in the late nineteenth century who produced realistic portraits. Gahia Narottam of Mandi was engaged with Hindu subjects and portraiture in oil painting but sold them at low prices. Raja Ravi Varma also visited Lahore in 1887 for fair patronage of oil painting in Punjab. Bamapada Banerjee, another national artist, produced many portraits of the Bengalis in Punjab. Moreover, Sardul Singh rendered Gurus and Ranjit Singh, as Kessar points out, that a portrait of Gobind Singh, the tenth Guru, was reproduced from the original in Lahore in 1891 with a Gurmukhi inscription (Kessar 2003). In other words, Western art and technique transformed aspects of tasteful indigenous painting, while it created the new mode of art and integrated others into one.

As such, the artistic milieu was diverse and no dominant school existed in this period, for there were various Punjabi artists from

Kashmir, Pahari, Rajasthan, Delhi and Europe, even before the annexation. It is evident from the various classifications of Musarrat Hasan, an art historian in Pakistan and a pioneer of the study of art in British Punjab. Her volume, *Painting in the Punjab Plains* (1998), is published in Pakistan and contains plenty of illustrations in both colour and black-and-white with detailed descriptions.

To begin with, Hasan classifies European artists into two categories, professionals and amateurs, as all previous literature do as well. The former comprises four smaller groups: (a) accompanied professionals with administrative patronage, (b) unaccompanied professionals with later administrative patronage, (c) travelling professionals with later individual patronage, and (d) remaining finishers of sketches done by amateurs. The latter also comprises four categories: (a) British servicemen, (b) British soldiers, (c) civil and army officers, and (d) family members of servicemen. In addition, she divides the subjects into nine groups: (a) surveys and maps, (b) topographical drawings, (c) contributions to knowledge – drawings of birds, animals and plants, (d) landscapes, (e) portraits, (f) figure compositions, (g) pictures that make a humorous comment on a situation, (h) special interest pictures of topics that the artists found quaint and unusual, and (i) inventive drawing. Such a vast list narrates the diversity of subjects in Punjab of the late nineteenth century.

It is remarkable that the media and supporters expanded in late nineteenth-century Punjab. For instance, lithography arrived in Punjab in the 1850s. Combined with the spread of the printing press, there were a number of publications with illustrations such as the *Tulsi Ramayan* in Gurumukhi in 1871, *Qissa Puran Bhagat Jati da* in 1872, some love legends (Heer Ranjha, etc.) and *Pothi Gurbilas ki* in 1882. Woodcuts are another important but often missed art form. Kessar (2003) avers that they were imported from Germany. These phenomena were encouraged by the Singh Sabhas after their establishment from 1877 onwards. Kahn Singh Nabha published a booklet, *Hum Hindu Naahin Hain*, distancing the origin of Sikhism from that of Hinduism (Kessar).

In the late nineteenth century, European influence on the art of the Punjab region became more direct and obvious, exemplified by the establishment of the Mayo School of Arts in 1875. The Mayo

School of Arts was the fourth Western art school in the subcontinent, following Calcutta in 1839, Madras in 1850 and Bombay in 1851 (Guha-Thakurta 1992: 60; Mitter 1994: 29-62). The school was established based on the report of Baden Powell (1857-1941), who complained about the poor artistic milieu of that time and aimed to promote industrial art using art education known as the South Kensington style. While local craftsman, castes who traditionally engaged in the production of art, were rejected due to their conservative attitudes, the teachers struggled with the poor English ability of the lower castes. Since the British teachers did not approve of the artistic value of local products and regarded them as no more than artefacts, the students were primarily expected to receive training in line drawing. The Mayo School has existed in Pakistan under the name of the National College of Arts since 1958.

In addition, local painters of the early nineteenth century were still active in the following period. The best example is Imam Bakhsh and his descendants. Their workshop continued until the late nineteenth century and produced relevant works in Westernized style as they had done in the earlier period. These works portray the Sikh Gurus and royalty in the Sikh Kingdom, although earlier works were on paper and later works were on ivory. Another case is Mian Allah, who commissioned the wall painting and illumination (*naqqashi*) of the Lahore fort (Hasan 1998).

Likewise, Qazi Lutfullah's family, descendants of Kabur, was the most popular in the Gumti Bazaar. Another prominent figure is Mehr Bakhsh, who served the governor general of Punjab after studying at the Mayo School of Arts. Ustad Faqeerullah and Ustad Ziaullah were also patronized by British officers and servicemen. Kapur Singh was a rare painter who was dedicated to the traditional style of miniature but worked for British people. This was the case with Kisen Singh and Bishen Singh also, although they were keen on watercolours. Milkhi Ram was a multitalented artist in poetry and painting, and he published books with his own illustrations in lithography (Hasan 1998).

Despite the regional importance of the Punjab region, with its diverse culture, previous scholarship on South Asian art did not pay much attention to the colonial art of Punjab, except the studies of Abdul Rahman Chughtai (1894-1975), a national artist of Pakistan.

We can presume two reasons. First, the Punjab region, which was the last conquered region in pan-India, came to be controlled by the East India Company in 1849. Therefore, it is pointed out that the number of artworks produced for British patrons was minuscule. Second, researchers have mainly focused on artistic activities developed under the auspice of royalty and nobility. Although this suited all the regions under British control, the majority of local royalty and nobility, who were patrons of art before the colonial period, collapsed during the colonial period. As a result, local creative activities have been overlooked.

Considering the above, this research draws attention to the patronage of the newly-formed urban middle class in colonial Punjab. Local patrons in colonial Punjab had been veiled for a long time. The British colonial administration formed a middle class across religions and ethnicities in the Punjab region (Oberoi 1994: 260-2; Sohal 2008). The majority engaged in jobs newly-formed by the introduction of a capitalist-dominated economy [Specifically, the newly formed urban middle class constituted civil servants, doctors, lawyers, journalists and engineers (Sohal 2008: 255-62)], which employed local painters and commissioned the production of artworks representing traditional themes. Among the colonial art of the Punjab region produced in those social circumstances, this research focuses on Sikh art. This is because portraitures of Guru Nanak, the founder of Sikhism, started to be hung on walls during this period, which is considered to play a new social role as an actor constituting society. Since the newly formed urban middle class positively accepted Western culture, the custom of hanging painting on a wall is believed to have been adopted as part of Western culture [Like the author of this book, Crispin Branfoot also pointed out that wall-hung portraits were introduced to the subcontinent in the colonial period (Branfoot 2018: 23)]. It is significant that the Lahore Museum was founded in 1865 and brought together the urban middle class from throughout Punjab, where the traditional paintings known as miniatures were displayed on the walls.

In this chapter, I examine only figure and portrait paintings of the ten Sikh Gurus, for the *Janam-sakhi* paintings produced in the colonial period did not survive. These works were painted by local artists under the patronage of both the British and the new Sikh middle

Colonial Portraiture of the Sikh Gurus 221

class. This chapter comprises four sections: (1) Colonial Portraiture of Guru Gobind Singh, (2) Group Portraiture of the Ten Sikh Gurus in the Colonial Period, (3) Colonial Portraiture of Guru Nanak, and (4) Single Portraits of Guru Nanak in the Colonial Period.

1. Colonial Portraiture of Guru Gobind Singh

This section examines portraits of Guru Gobind Singh produced in the late nineteenth century.

In this painting (Figure 5.1), Guru Gobind Singh, who has a black beard and faces left in profile, is mounted on a horse that is painted in brown and that carries a white saddle with orange borders.

Figure 5.1: *Guru Gobind Singh.* Artist unknown. Punjab, nineteenth century. Opaque watercolour on paper. Acc. no. IM.2:128-1917, Victoria and Albert Museum. Downloaded by the author in 2015 (https://www.vam.ac.uk/collections?type=featured)

His head is encircled with a golden halo the centre of which is empty. He is wearing a yellow turban and a yellow robe while holding a blue falcon in his right hand. He is also carrying a black shield and a sword in an orange sheath. On the right-hand side, an attendant, who has a small black moustache and faces left in profile, is standing while holding a peacock feather fan in his right hand. He is wearing a purple turban and a blue robe, as well as orange trousers. The horse's legs are painted in orange and its hooves are painted in blue. A white dog is looking up from underneath the horse. A blue sky is rendered at the top, and an unidentified object is depicted in purple on the top-left side.

In this painting (Figure 5.2), Guru Gobind Singh, who has a black beard and faces left in profile, is mounted on a horse between a navy blue saddle on the white horse. The horse's legs are painted in orange and it is rearing up. The Guru's head is encircled by a white halo that has a black border. He is wearing a yellow turban and a

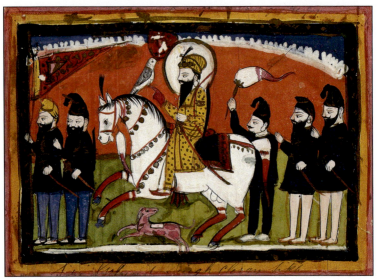

Figure 5.2: *Guru Gobind Singh*. From an album of Company painting. Artist unknown. Late nineteenth century. Watercolour on paper. Welcome Library, London. Downloaded by the author in 2016 (https://wellcomecollection.org/collections)

yellow robe with black dots, as well as a sword in a red sheath. He is holding a white-and-blue falcon in his right hand. On the right-hand side, three khalsas are depicted wearing black turbans and navy blue robes. They are holding sheathed swords and one holds a white fly whisk. Only the left person is wearing navy blue trousers. On the left-hand side, two khalsas are wearing navy blue robes and blue trousers. They are holding sheathed swords. One wears a yellow turban, whereas the other wears a navy blue turban. A pink dog who is turning back to look right is depicted underneath the white horse.

In this painting (Figure 5.3), Guru Gobind Singh, who has a black beard and faces left in profile, is sitting cross-legged on a pedestal with a red backrest. He is wearing a yellow turban with a black feather, as well as a yellow robe tied with a large black waistcloth. He is eating something served by a maid wearing a white shawl and a red robe. On the left-hand side stands an attendant, who has a small black moustache and faces right in profile. In his right hand, he is holding a white fly whisk over Gobind Singh's head. He is wearing a yellow turban and a red shirt, as well as a white half pant tied with a large grey waistcloth. He is carrying a black shield on his back. On the

Figure 5.3: *Guru Gobind Singh and Five Khalsas.* Artist unknown. Late nineteenth century. Chromolithograph. Welcome Library, London. Downloaded by the author in 2016 (https://wellcomecollection.org/collections)

right-hand side, five khalsas, who all have black beards and face left in profile, stand in a row paying homage to the Guru. Their attire is the same as the attendant, but the colours are more varied.

In this painting (Figure 5.4), Guru Gobind Singh, who has a black beard and faces left in profile, is mounted on a pink horse that is rearing up. The Guru is seated on a light green saddle whose borders

Figure 5.4: *Guru Gobind Singh*. From an album of Company painting. Artist unknown. Late nineteenth century. Watercolour on paper. Acc. no. 651529i, Welcome Library, London. Photographed by the author in 2015 (https://wellcomecollection.org/collections)

Colonial Portraiture of the Sikh Gurus

are yellow. He is wearing a yellow turban with a black feather and a yellow robe tied with a red waistcloth. He has a blue falcon in his left hand, a red bow on his right shoulder and a black shield on his back. On the left-hand side, an attendant, who has a small black moustache and faces right in profile, is holding a peacock feather fan in his left hand. He is wearing a blue turban and a blue robe. The sky is painted blue, whereas the ground is painted in pink. A yellow dog tied with a brown waistcloth is looking up from underneath the horse.

In this painting (Figure 5.5), Guru Gobind Singh, who has a black beard and faces left in profile, is sitting with his legs folded under him on a brown cushion, the border of which is painted in pink. His head is encircled by a red halo whose centre is empty. He is wearing a yellow turban and a yellow robe while carrying a black shield on his back. He is holding a white falcon in his right hand and a sword in a black sheath in his left hand. He is also leaning against a green cushion. On the right-hand side, two Khalsas are standing with similar attire of turban, robe and trousers. One, who is wearing a yellow turban,

Figure 5.5: *Guru Gobind Singh.* From an album of Company painting. Artist unknown. Late nineteenth century. Watercolour on paper. Welcome Library, London. Photographed by the author in 2016 (https://wellcomecollection.org/collections)

holds a green peacock feather fan. The other is carrying a black shield on his back. On the left-hand side, three Khalsas are standing with similar attire while all three are paying homage to the Guru. One is wearing a yellow turban, and the other is wearing a half-pant. The ground is represented by two green stripes.

In this painting (Figure 5.6), Guru Gobind Singh, who has a black beard and faces left in profile, is mounted on a blue horse while fighting a yellow tiger that is attacking him. He is wearing a yellow turban in Kashmir style and red armour while holding a lance in his right hand. Both the horse and the tiger are rearing up. On the left-hand side, there are a grey dear and two running dogs, one orange and one pink. Another pink dog is depicted underneath the horse. The orange dog lies in the top right corner.

Figure 5.6: Guru Gobind Singh. From an album of company painting. Artist unknown. Late nineteenth century. Watercolour on paper. Welcome Library, London. Photographed by the author in 2016 (https://wellcomecollection.org/collections)

2. Group Portraiture of the Ten Sikh Gurus in the Colonial Period

This section examines group portraits of the ten Gurus that were produced in the late nineteenth century.

The following painting shows an assembly of the ten Sikh Gurus, Bala, Mardana and an anonymous musician on the terrace beyond spacetime (Figure 5.7). Goswamy (2006) indicates that the medium is machine-made paper. A colophon is inscribed on the bottom border in Gurmukhi script.

Ambratsar ji. Bhai Prun Singh musavvar; Katra Ahluwalia, bazaar Kanjarianm, Mughali darwaza. Sammat unni sau untalis, saun…..ki.' [At Amritsar. Painter, Bhai Puran Singh, (resident of) Bazaar Kanhariyan, Katra Ahluwalia, (inside the) Mughal Gate. In the year (Vikrami) Samvat nineteen hundred and thirty-nine, in the … of the month of Sawan.] (120)

In this group portrait, Guru Nanak, who is inscribed in Gurmukhi script, occupies an eminent position at the top of the circle. He has a

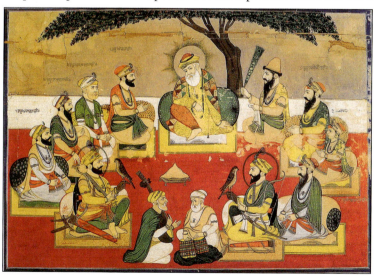

Figure 5.7: *Guru Nanak with the Other Nine Gurus.* By Bhai Puran Singh. Punjab. 1882. Watercolour on machine-made paper. 33.7 × 46.2 cm. Acc. no. 3787, Government Museum and Art Gallery, Chandigarh. Goswamy (2000), plate 23

white beard and faces left in three-quarter view and is looking at the audience. The top of his headgear is painted in red, like a Muslim skullcap, but the golden edges are shaped less like a crown. A black thread is tied to the headgear. His head is encircled by a light halo with several rays. He is wearing a yellow robe with dots and orange trousers. A triangular, colourfully patterned shawl covers his robe. He is resting his right elbow on his right knee and dropping his left hand to the floor. A black thread and a necklace with a stone are around his neck. He is leaning on a green cushion and sitting cross-legged on a white carpet that has yellow borders. A brown tree with green leaves and red blossoms covers not only Nanak, but all the characters. Nothing else is rendered in the background. On the right-hand side, Bala, who has a black beard and faces left in profile, is sitting on the red floor. He holds a peacock feather fan in his right hand and a white cloth in his left hand. He is wearing a flesh-coloured skullcap and a robe tied with a green cloth around his waist. He is also wearing a yellow shawl. Black threads and a necklace with a stone are around his neck. A finely decorated armlet is encircling his left arm. At the bottom, Mardana, who has a white beard and faces right in profile, is sitting cross-legged on the floor. He is wearing a yellow turban and a white robe tied with a yellow cloth around his waist. There is a green shawl over his robe. His string instrument is painted in yellow and brown. He is talking to another musician, who has a white beard and faces left in three-quarter view. He is playing a percussion instrument decorated in different colours on the green cloth. He is wearing a white turban and robe under a flesh-coloured shawl. Guru Nanak and Bala appear to be larger in size than Mardana and the musician. By excluding any Hindu gods and characters, this painting creates the original domain for the Sikh Gurus.

The second painting is an assembly of ten Sikh Gurus, Bala and Mardana on a terrace beyond spacetime (Figure 5.8). The only difference in Nanak's iconography from the first painting is the colouring of his headgear and trousers. The headgear has become completely yellow, while the trousers have become white. The carpet is also painted in white, with blue borders. On the right-hand side, Bala, who has a black beard and faces left in profile, is sitting on the floor. He is wearing a red skullcap and a pink robe tied with a yellow

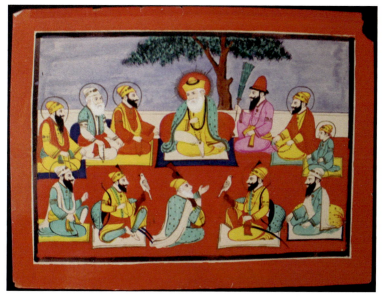

Figure 5.8: *Guru Nanak*. Artist unknown. Punjab. Late nineteenth century. Watercolour on paper. 9⅞ × 13⁷/₁₆ in. Acc. no. 2608, Government Museum and Art Gallery, Chandigarh. Photographed by the author in 2016

cloth around his waist. He is holding a peacock feather fan vertically in his right hand. Mardana, who has a white beard and faces right in profile, is depicted at the bottom. He seems to be speaking to Nanak, judging from the gesture he is making with his left hand. In his right hand, he is holding a string instrument painted in brown and yellow. His turban is painted yellow. He is wearing a green robe under a white stole that is hanging from his shoulder to his back. By excluding anonymous musicians besides Mardana, this painting purifies 'Sikhness' further than the previous work. Guru Nanak is represented in a more prominent manner by means of an idealistic halo.

There is another painting representing the ten Sikh Gurus, Bala and Mardana (Figure 5.9). The artist of this painting is likely to depict the characters with the style of a long face and fine flesh. At the top of the circle, Guru Nanak, who has a white beard and faces left in three-quarter view, is sitting with on a white carpet with yellow borders;

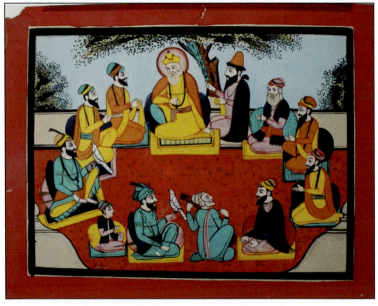

Figure 5.9: *Guru Nanak*. Artist unknown. Punjab. Late nineteenth century. 10 × 13 in. Watercolour on paper. Acc. no. 2598, Government Museum and Art Gallery, Chandigarh. Photographed by the author in 2016

one knee is up. His head is encircled by a pink halo with a red outline. His turban and robe, tied with a striped cloth around the waist, are painted in yellow. He is wearing an orange shawl and green trousers. The cushion he is leaning on is coloured blue. Bala, who has a black beard and faces left in profile, is sitting on the left hand side. He is wearing a red skullcap and a pink robe under the black shawl. He is holding a peacock feather fan in his right hand and a yellow cloth in his left hand. At the bottom, Mardana, who has a white beard and is looking up at Nanak, is sitting with one knee up. He is wearing a white turban and a blue robe. A white stole is hanging around his neck. A string instrument that he is holding is painted in brown. In the background, a brown tree grows between Nanak and Bala. The green leaves are painted using dots. The same patterned bushes are rendered on both sides of the background.

3. Colonial Portraiture of Guru Nanak

This section examines portraits of Guru Nanak that were produced from the late nineteenth to the early twentieth centuries.

The first painting shows Guru Nanak as a Muslim saint again (Figure 5.10). He has a white beard and faces left in three-quarter view and is reclining on the deep green carpet. His white dotted skullcap is tied with a black thread and a red bandana. He is wearing a pink robe tied with a red cloth, and white trousers. He has a necklace and a black thread around his neck. An armlet is encircling his right arm. He is leaning on a blue cushion and using another small red

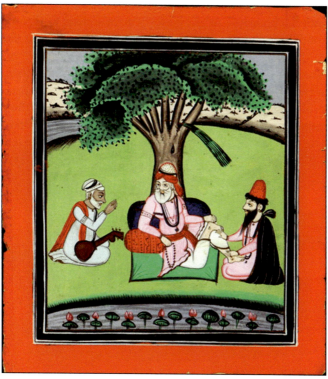

Figure 5.10: *Guru Nanak with Bala and Mardana*. Artist unknown. Punjab. Late nineteenth century. Watercolour on paper. 11¼ × 10¼ in. Acc. no. 2615, Government Museum and Art Gallery, Chandigarh. Courtesy of the museum

cushion as an arm rest. On the right-hand side, Bala, who has a black beard and faces left in profile, is sitting on the grass. He is massaging Nanak's left foot. His skullcap is painted red with black dots. He is wearing a black shawl over a pink robe. A black thread is hanging around his neck. On the left-hand side, Mardana, who has a white beard in profile, is sitting on the grass and paying homage to Nanak. His brown string instrument is resting on his knees. His white turban is tied with a black cloth. He is wearing a red shawl over a green robe. As to the environment, a tree is growing directly behind Nanak. This reminds me of a Kashmiri painting representing Nanak in front of a tree. The trunk is painted in shades of brown. Green leaves also show various shades. A green feather fan, possibly owned by Bala, is hanging between the branches. At the bottom, many lotuses are floating on the pond. White mountains are depicted beyond the river at the top. The horizon is slightly curved.

The next painting shows similar traits to *Guru Nanak Dressed in an Inscribed Robe*, although Nanak is accompanied by Bala and Mardana (Figure 5.11). Parallels are found in Nanak's slightly dropping

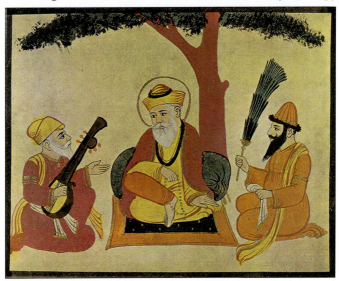

Figure 5.11: *Guru Nanak Dev with Bala and Mardana.* By Alam Chand, artist. Punjab. Nineteenth century. Courtesy Dr C.S. Chan, London (UK). Srivastava (1983), plate XII

gaze, a light halo, his posture and, most noticeably, the depiction of a tree that has no outline along the trunk. The leaves are rendered in a new technique, such as oil. At the same time, some differences can be seen between these paintings. Nanak's cap is painted completely in yellow. The inscription is gone from the robe he is wearing. The shawl has become red with yellow dots. The colour of his trousers has become orange. The rosary has become white. The cushion seems to be identical in form, but its colour is green. Nanak is sitting on a similar-sized carpet, although it is painted in cyan with yellow dots and orange borders. One of the biggest differences is perhaps the setting. It was a terrace in the previous portrait, whereas the present painting shows a forest. On the right-hand side, Bala is holding a peacock feather fan vertically in his right hand and clutching a white cloth in his left hand. He has a black beard and faces left in profile. The skullcap and loose robe are painted in orange. A yellow stole is hanging from his left shoulder. On the left-hand side, Mardana, who has a white beard and faces right in profile, seems to be speaking to Nanak. He is holding a string instrument painted in brown, yellow and orange in his right hand, and is stretching his left hand to Nanak. His turban and stole from his right shoulder are coloured in yellow. The red robe is tied with a white cloth around the waist. The artist of this painting is identified as Alam Chand, who appears to have worked for local patrons, according to his style.

Two paintings gifted from the same owner show identical iconography for Guru Nanak. The first painting displays Guru Nanak, Bala and Mardana on a terrace (Figure 5.12). Nanak's posture and attire resemble those of *Guru Nanak Dressed in an Inscribed Robe*. This is best represented by a combination of red skullcap with crown-like headgear. The major innovation of this painting is the use of an unusual flat red halo with black rays. The shawl and trousers have become green and light blue, respectively. He is leaning on a red cushion with yellow edges and sitting on a blue carpet with decorated green borders. A tree has clear black outlines, but the leaves are painted in a manner like oil paints. On the right-hand side, Bala, who has a black beard and faces left in profile, is sitting on the red floor. He is holding a fly whisk in his right hand. His skullcap and robe are painted in red and tied with a yellow cloth around the waist. His trousers are coloured

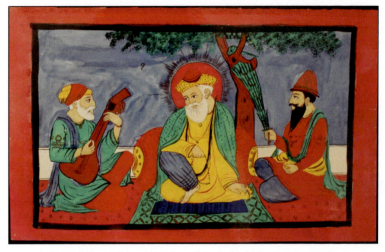

Figure 5.12: *Guru Nanak with Bala and Mardana.* Punjab. Late nineteenth century. Watercolour on paper. 8¼ × 13⅜ cm. Acc. no. 2643, Government Museum and Art Gallery, Chandigarh. Photographed by the author in 2016

in light blue. A green stole is hanging from his left shoulder. On the left-hand side, Mardana, who has a white beard and faces right in profile, is sitting on the floor. He is playing a red string instrument. A yellow turban is tied with a red bandana. His robe is painted green, whereas his trousers are coloured red. The background is smudged in light blue.

Guru Nanak now possesses a clear and idealized halo. The following painting shows him with Bala, Mardana, an ascetic and a noble (Figure 5.13). He, who has a white beard and faces left in three-quarter view, is sitting cross-legged as usual on a white carpet with red floral borders. His headgear looks like a combination of pink skullcap and red crown-like turban. His head is encircled by a green nimbus with a black outline. He is wearing a white robe under a pink shawl with black dots and green borders. Black threads are hanging around his neck, and he is holding a rosary in his right hand. On the right-hand side, Bala and Mardana are sitting on the white floor on the terrace. Bala, who has a black beard and faces left in profile, is holding a peacock feather fan in his right hand and a green cloth in

Colonial Portraiture of the Sikh Gurus 235

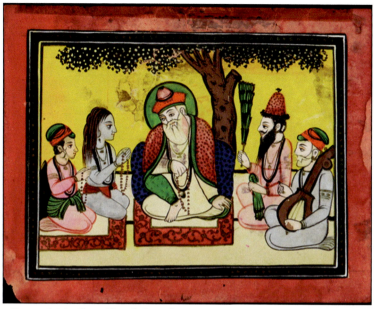

Figure 5.13: *Guru Nanak.* Punjab. Late nineteenth century. 13 × 10 in. Watercolour on paper. Acc. no. 2630, Government Museum and Art Gallery, Chandigarh. Courtesy of the museum in 2016

his left hand. He is wearing a red skullcap with black dots and a pink robe. He has a black thread hanging from his neck. Mardana, who has a white beard and faces left in profile, is holding a string instrument painted in brown and flesh tones in his left hand. His green turban is tied with an orange bandana. He is wearing a light blue robe. On the left-hand side, the ascetic and the noble, who face right in profile, are sitting on a carpet that has the same pattern as Nanak's. They are paying homage to Nanak with the same rosary in their hands as Nanak's. The ascetic's skin is coloured in blue due to ashes. He is wearing short red pants and black threads around his neck. The noble, who carries a black shield on his back, is wearing a green turban tied with an orange bandana and a pink robe tied with a green cloth around the waist. Neither one has a beard or a moustache, so they look younger than Bala and Mardana. The background is filled with a flat yellow space, except for a brown tree with dark leaves and white blossoms.

236 *Portraying the Guru*

The next painting shows a much more complicated composition, apparently narrating some kind of story (Figure 5.14). In the lower right area, Guru Nanak, who has a white beard, looks up to the mountains in three-quarter view. He is sitting cross-legged on a blue carpet with orange borders and black dots. He is wearing a yellow crown-like turban with a black cloth. His head is encircled by an orange halo with a number of rays, both large and small. He is raising his right hand, from which a rosary hangs, and is dropping his left hand to the ground. He is wearing a yellow robe under a red shawl and orange trousers. He is leaning on a patterned green cushion. Mardana, who has a white beard and faces left in profile, is sitting on the ground behind him. He is reaching with his right hand, as if speaking to Nanak. A brown and flesh-coloured string instrument is resting on his left shoulder. He is wearing a yellow turban and a dotted white robe tied with a green cloth around his waist. At the top left corner, a man, who has a white beard and looks down in profile, is

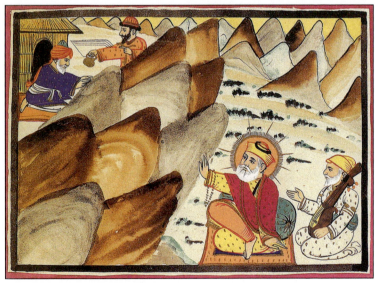

Figure 5.14: *Guru Nanak at Panja Sahib*. Punjab. Last quarter of the nineteenth century. Watercolour on machine-made paper. 20.9 × 27.9 cm. Acc. no. 2619, Government Museum and Art Gallery, Chandigarh. Goswamy (2000), plate 22

sitting on an orange carpet in front of a yellow hermitage. He is reaching both hands to Nanak in the bottom right corner. His skullcap is tied with a red turban, which is hanging down his back. He is wearing a blue robe that has golden polka dots and is tied with a white cloth around his waist. His attendant, who has a black beard and faces left in profile, is offering a golden vase to the man with his right hand. He is pointing at the vase with his left hand. He is wearing a red skullcap and an orange robe with golden dots. Very stylized but heavily shaded mountains are depicted between two groups of figures. Mountains of the same shape are rendered in the far distance. None of the hills are vertical; instead, they are leaning towards the right along with the mountain slopes. Grasses or bushes are painted in green and black, like oil in some places. Goswamy identifies this image as an episode of Guru Nanak at Panja Sahib, at Hassan Abdal, near Rawalpindi. The man is seen as Pir Wali Kandhari, a Muslim divine.

This famous painting was apparently executed in the last quarter of the nineteenth century (Figure 5.15). Four figures are inscribed in Gurmukhi script, and the name of the painter, '(Kal?)ian Singh artist, Amritsar', is written at the bottom border. Guru Nanak, who has a white beard and faces left in three-quarter view, is sitting cross-legged on a light blue carpet with red borders. His head is encircled by a white halo with a black outline and rays. He is wearing yellow headgear with a black bandana and a yellow robe under the red shawl. His trousers are painted green. All attire is patterned with small flowers. His posture is the one that has been established at this point. He is leaning against a green cushion edged in red and yellow. On the right hand side, Bala, who has a black beard and faces left in profile, is standing with a peacock feather fan in his right hand. He is wearing a red skullcap and a pink robe tied with a green cloth around the waist. A long yellow stole is hanging around his neck. At the bottom left corner, Mardana, who has a white beard and faces right in profile, is sitting cross-legged on the purple floor. He is speaking to Nanak, pointing towards him with his left hand. He is holding a string instrument painted in yellow and brown. His turban and stole are coloured yellow with dots. He is wearing a white robe tied with a red cloth around his waist. Behind the terrace, the space is light blue and includes a tree with a brown trunk that is flourishing with green leaves.

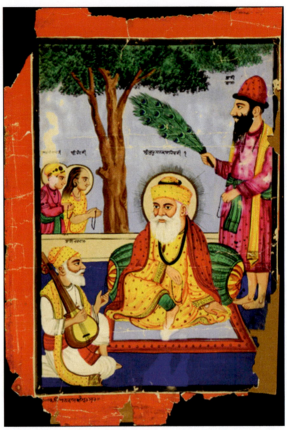

Figure 5.15: *Guru Nanak with Bala, Mardana, Sri Chand and Lakshmi Das*. Artist unknown. Punjab. Late nineteenth century. Watercolour on paper. 16 × 12⅛ in. Acc. no. 2639, Government Museum and Art Gallery, Chandigarh. Singh (2003), plate 2

On the left-hand side, his sons, Lakshmi Das and Sri Chand, are rendered in a smaller size and paying homage to Nanak. Neither of them has a beard. Both face right in profile and are encircled by white haloes outlined in black. Sri Chand, who founded the Udasi group, is depicted in the manner of an ascetic, with uncut hair and grey skin. He is wearing a yellow robe and holding a rosary in his hands. Lakshmi Das is wearing a yellow turban with black decorations and a red robe tied with a green cloth.

Colonial Portraiture of the Sikh Gurus

We see a similar composition in the following painting (Figure 5.16). The format has become horizontal and the setting has perhaps become outdoors, but the arrangement of figures is derived from the previous work. Guru Nanak, who has a white beard and faces left in three-quarter view, is encircled by a white halo with a black outline and rays. Although he is wearing yellow headgear with a black bandana and a yellow robe under the red shawl, as in the previous work, his body emphasizes its side view. Interestingly, he is talking to and pointing at Mardana who has changed into green attire with a red cloth at the bottom left corner. He is also holding a small manuscript in his left hand. The carpet is now blue and the cushion is green. Bala, on the right-hand side is sitting with the same attire as in the previous work. A tree now appears between Nanak and Bala. Sri Chand and Lakshmi Das are rendered between Mardana and Nanak. Sri Chand is dressed differently in Muslim fashion, such as a red skull cap, although he still keeps his hair uncut. Lakshmi Das lost the green cloth around his waist. They are both sitting on the green carpet. These

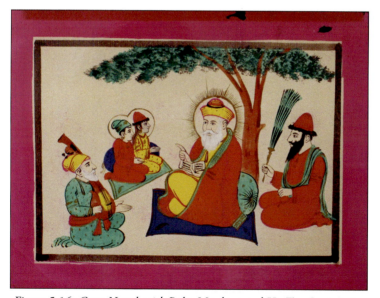

Figure 5.16: *Guru Nanak with Bala, Mardana and His Two Sons*. Artist unknown. Punjab. Late nineteenth century. 8¼ × 11 in. Acc. no. 2641, Government Museum and Art Gallery, Chandigarh

two works are inextricably linked. It is possible the second painting was produced later than the first, for the second painting has no inscriptions, and it is hard to identify the characters.

The following painting shows a combination of terrace with forest and returns to vertical format (Figure 5.17). Guru Nanak, who has a white beard and faces right in three-quarter view, is sitting cross-legged on the blue carpet on a hexagonal terrace, whose floor is painted red. His head is encircled by a transparent halo. His headgear and robe are painted yellow. A black thread is tied with the headgear and another is hanging around his neck. He is wearing a pink shawl and red trousers, and he is leaning a green cushion. He looks down to Mardana,

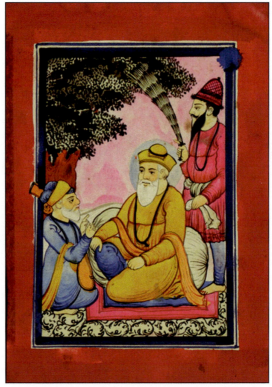

Figure 5.17: *Guru Nanak*. Artist unknown. Punjab. Late nineteenth century. Watercolour on paper. 8⅛ × 5⅞ in. Acc. no. 2636, Government Museum and Art Gallery, Chandigarh. Courtesy of the museum in 2016

who is sitting with one knee up on the grass and speaking to him, as he is stretching his right arm out at the left bottom corner. He is wearing a yellow turban and a blue robe tied with a red cloth around his waist. At the top right corner, Bala, who has a black beard and faces left in profile, is holding a white fly whisk in his right hand and a yellow cloth in his left hand. He is wearing a red skullcap and a robe tied with a yellow cloth around his waist. A brown tree is growing between Nanak and Bala and is flourishing with green leaves. The grasses are also painted green.

The next painting shows a slightly dense composition (Figure 5.18). Guru Nanak, who has a white beard and faces left in three-quarter view, is sitting cross-legged on a blue carpet with pink borders.

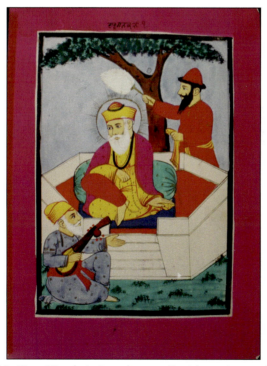

Figure 5.18: *Guru Nanak*. Artist unknown. Punjab. *c.* nineteenth century. Watercolour on paper. 11⅛ × 8³/₁₆ in. Acc. no. 2594, Government Museum and Art Gallery, Chandigarh. Photographed by the author in 2016

His head is encircled by a white halo. He seems to be smiling and paying attention to Mardana, who is sitting on the floor on the left-hand side and gesturing as he speaks to Nanak. Nanak is wearing yellow headgear and a robe. An orange stole is resting on both arms. A black thread is tied with the yellow headgear and a black necklace is hanging around his neck. He is wearing blue trousers and is leaning on a white cushion. On the right-hand side stands Bala, who has a black beard and faces left in profile. He is holding a black-and-white fly whisk in his right hand and a white cloth in his left hand. His skullcap and robe are painted in pink. A black bandana and a white cloth are tied around his headgear and waist, respectively. A black thread is hanging around his neck. He is wearing blue trousers. On the left-hand side, Mardana, who has a white beard and faces right in profile, is holding a brown string instrument. His blue turban is tied with a yellow bandana. A yellow stole is hanging from his right hand. He is wearing a blue robe and a black thread around his neck. The floor of the terrace is painted with black and white floral patterns. A bold brown tree grows behind Mardana; its leaves are painted in black and white.

4. Single Portraits of Guru Nanak in the Colonial Period

Now, let us examine single portraits of Guru Nanak painted in colonial Punjab. In this torso depiction (Figure 5.19), Guru Nanak is treated as a secular figure, possibly a Muslim king, which is evident in his gorgeous ornaments, such as a crown and a colourful shawl (Goswamy 2000). This work is part of a set of paintings that portray Sikh nobility. Another important aspect of this work is that it clarifies the establishment of the genre of a single portrait of Guru Nanak. Since such an ivory painting is small, the freedom of the artist's composition is likely restricted. It is assumed that the number of these single portraits increased during the colonial period from the late nineteenth century. Remarkably, a small portrait meant the owner could carry it, wear it as a pendant or send it as a gift. Considering the realistic depiction of Guru Nanak and the medium of ivory, I maintain that the patron of this painting was British, as the British ruled Punjab after 1849. Likewise, judging from its iconographic features, such as

Colonial Portraiture of the Sikh Gurus

Figure 5.19: *Guru Nanak*. Artist unknown. Lahore. *c*.1850–*c*.1870. Painted on ivory. Diameter 5.1 cm. Acc. no. IS.150-1954, Victoria and Albert Museum. Downloaded by the author in 2015 (https://www.vam.ac.uk/collections?type=featured)

Guru Nanak's face and personal ornaments, which derive from the tradition of the early nineteenth century, an artist who depicted this work likely belonged to a local workshop. [While this painting was used in a textbook in contemporary California, USA, the local Sikh community was strongly against it (McKinley 2007).]

Guru Nanak Dressed in an Inscribed Robe (Figure 5.20) is perhaps the most renowned portrait of Guru Nanak and is often inserted into catalogues. At first glance, this portrait is influenced by European painting, although traditional patterns have been applied. This is obvious in the shapes of the vegetation behind the terrace, which is painted with shading but without an outline. Realistic and refrained

Figure 5.20: *Guru Nanak Dressed in an Inscribed Robe.* Lahore. Late nineteenth century. 36 × 28.6 cm. The Government Museum and Art Gallery, Chandigarh. Acc. no. 2401. Photographed by the author in 2010

Figure 5.21: *Guru Nanak Dressed in an Inscribed Robe (Detail).* Lahore. Late nineteenth century. The Government Museum and Art Gallery, Chandigarh. Acc. no. 2401. Photographed by the author in 2010

Colonial Portraiture of the Sikh Gurus 245

colouring is used in the halo around his head. Guru Nanak, with one knee on the floor, is sitting on a cushion. A rosary is in his right hand, and his left hand is dropped to the carpet; this is derived from the iconography of narrative painting in the early nineteenth century. His colourful shawl appeared in the previously mentioned ivory portrait; here, however, Guru Nanak wears a crown-like cap rather than a crown. It is most noticeable that the verses of the Quran are written on Guru Nanak's cloak, which implies that this portrait could have been painted by a Muslim artist (Figure 5.21). In addition, its highly sophisticated style suggests the possibility that the workshop was a group of first-class painters serving Sikh royalty and nobility in the early nineteenth century.

So, who was the patron who commissioned *Guru Nanak Dressed in an Inscribed Robe,* while a Muslim painter executed the portrait? As I pointed out, this portrait is the work of an excellent painter who controlled and mixed traditional and Western styles. It is assumed that such artwork was expensive. At the bottom of the painting, the inscription is written in Gurumukhi script used for the Punjabi language: *Guru Nanak Patshahi Pehli ... Maharaj ... Sahib* ('Guru Nanak, the first king ... maharaja ... saint') (Figure 5.22). Such an inscription in the local language clarifies that this portrait was not commissioned by a British patron. Considering that Sikh royalty and nobility collapsed in the late nineteenth century, I argue that the patron of this painting was a member of the newly-formed urban middle class. The urban middle class possessed ample funding due to the benefits of a capitalist-dominated economy. Since its members received a Western education, they were likely to welcome things from foreign countries. Perhaps they purchased such a painting influenced

Figure 5.22: *Guru Nanak Dressed in an Inscribed Robe (Detail).* Lahore. Late nineteenth century. The Government Museum and Art Gallery, Chandigarh. Acc. no. 2401. Photographed by the author in 2010

by the West. The urban middle class of that time, who regarded Western culture as advanced, were able to manifest their social status, such as an innovative spirit and wealth, by owning the cultural capital of Westernized portraits. Remarkably, this painting was executed in a double size of traditional miniatures, which were derived from the manuscript paintings of Jainism and Buddhism and were most likely appreciated by individuals. In contrast, *Guru Nanak Dressed in an Inscribed Robe* was likely appreciated in a group and may have been hung on a wall.

Turning to the twentieth century, portraiture of Guru Nanak was frequently produced, but the number of artworks in existence is limited (W.H. McLeod, known as one of the pioneers in Sikh studies, mentions in his *Popular Sikh Art* that there are only a few portraits of the Sikh Gurus in existence because the leaders of the Singh Sabha were alleged to have prohibited idolatry (McLeod 1991). However, considering that some portraits of Guru Nanak were reproduced in this paper, it is assumed that their influence was limited, and people demanded Guru Nanak portraiture in everyday life. These portraits can be classified into two groups: the three-quarter face and the frontal. We now look at a group of three-quarter-face portraits. Figure 5.23 was painted in the early twentieth century by Ustad Hari Sharifis, who was born in Patiala in 1889. This painting showcases a depth typical of late Mughal painting in which Guru Nanak's head is encircled by a white halo. He is wearing a colourful shawl, typical of a portrait painted in the late nineteenth century, and a turban characteristic of the Sikhs. The same cloth seems to be used for his robe. However, it differs from late nineteenth-century portraiture in that no inscription written on the robe appeared in the early twentieth-century portrait. His attitude, sitting with one knee down, seems derived from the traditional image in narrative painting. Figure 5.24 was painted in the 1930s by Pannalal Gopilal, who worked in Nathdwara. In this painting, Guru Nanak is sitting under a large tree, and a castle is visible in the distance. His head is encircled by a golden halo, and his headgear is like that in *Guru Nanak Dressed in an Inscribed Robe* (Figure 5.20). His shawl has become simpler, but his image, with tilted head, resembles the image of *Guru Nanak Dressed in an Inscribed Robe* (Figure 5.20). Figure 5.25 is a portrait painted in Patiala in 1849 in Shan

Colonial Portraiture of the Sikh Gurus

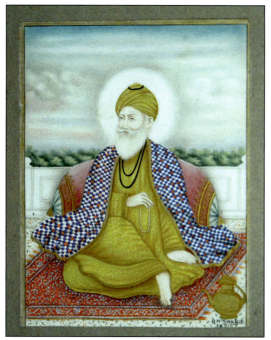

Figure 5.23: *Guru Nanak*. By Ustad Haji Sharifis. Punjab. First quarter of the twentieth century. Acc. no. 1469, Lahore Museum. Photographed by the author in 2010

Pratap Salwans. Intriguingly, the verses in Gurumukhi script are written on Guru Nanak's attire, which reminds us of *Guru Nanak Dressed in an Inscribed Robe* (see Figure 5.20) with Arabic inscriptions. Guru Nanak's pose and an object like a cushion follow traditional iconography [As a portrait of Guru Nanak painted in a three-quarter face in the early twentieth, *Nam Khumari Nanaka Chari Rehe Din Raat* is renowned (Kaur 1990: pl. 66)].

In contrast, among the portraits of Guru Nanak, there is another frontal tradition (Figure 5.26). The next single portrait represents him in the frontal view. He has a white beard and sits cross-legged on the green floor, staring straight at the audience. His head is encircled by a white halo. He is wearing yellow headgear and a robe under a dark green shawl with tiny yellow flowers. His trousers are white. The clothing patterns are painted by means of shading. He is leaning on

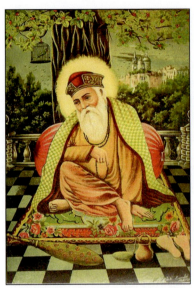

Figure 5.24: *Guru Nanak Dev.* By N.[athdwara], artist. Pannalal Gopilal. *c.*1930s. Chromolithograph. 50.7 × 35.8 cm. Acc. no. CP-9, Collection of Robert J. Del Bonta. Brown (1999), plate 21

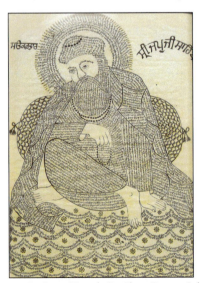

Figure 5.25: *Guru Nanak.* By Shan Pratap Salwans. Patiala. 1947. See Singh (2004: 62)

Colonial Portraiture of the Sikh Gurus 249

a purple cushion. He is holding a white rosary in his right hand and is placing his left hand on his right foot. Nothing is rendered in the blue background. Another painting (Figure 5.27) shows iconography of Guru Nanak that is almost identical to the previous painting. This single portrait was executed by Arjun Singh in 1935. Guru Nanak, who has a white beard and stares at the audience, is sitting cross-legged in the forest. He is wearing a white turban and a yellow robe under a black shawl. His head is encircled by a realistic, transparent halo. He holds a black rosary in his right hand and is touching his right foot with his left hand. The environmental depiction surrounding Nanak

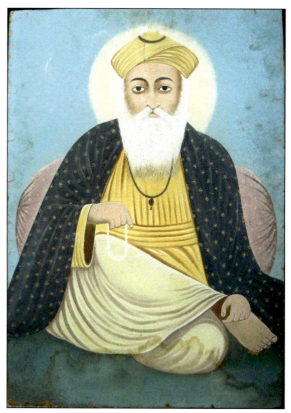

Figure 5.26: *Guru Nanak Cross-legged.* Artist unknown. Punjab. First quarter of the twentieth century. Watercolour on cardboard. Acc. no. 1545, Lahore Museum. Photographed by the author in 2010

Figure 5.27: *Guru Nanak Cross-legged*. By Arjun Singh. Punjab. 1935. Oil on canvas. Baba Baghel Singh Museum, Bangla Sahib Gurudwara, New Delhi

is outstanding. Blue and white flowers are rendered at the water's edge in front of Nanak. Forest trees are depicted on the right-hand side of the background. On the left-hand side, mountains and a river are visible in the distance. The long depth and naturalistic depiction are presumably derived from a Western education in art.

Conclusion

As I have discussed, the portraiture of Guru Nanak was frequently produced during the colonial period, but there was a huge difference in patronage in the commissioning of portraiture. Following the collapse of the royalty and nobility in the Sikh Kingdom, the emerging

urban middle class became a new patron of art. *Guru Nanak Dressed in an Inscribed Robe* (Figure 5.20) is the most important work of art in this period because three-quarter-face narrative painting was applied to a form of portraiture. In addition to the three-quarter view typical of narrative painting, the colonial portraiture of Guru Nanak applies a form of frontal view. This is partly because the Hindu-like image in precolonial portraiture remains and partly because these portraits were influenced by European portraiture, which applies different facial patterns.

Conclusion

This book focused on the portraiture of the Sikh Gurus, centring on Guru Nanak, and examined the colonial transformation of their images. I will summarize the findings of this book as follows. The Sikh holy text says that idolatry is criticized as being stupid and useless behaviour, yet it chiefly indicates a statue of gods made of stone and does not mention pictorial representations, such as narrative painting and portraiture. It was important in the precolonial period that Guru Nanak be painted in a three-quarter face in the paintings of the Janam-sakhis. While Hindu goddesses, ascetics and Islamic saints were also sometimes painted in a three-quarter face, a three-quarter face is exclusively used for the formal expression of Guru Nanak, as far as I have investigated. This tradition was not strictly applied in portraiture painted before the colonial period, and Guru Nanak was also painted in frontal format, which evokes the statue of Hindu gods. In contrast, after the Punjab region was annexed to the British East India Company in 1849, a middle class that received a Western education emerged. They started the Singh Sabha Movement, which discussed Sikh orthodoxy from the 1870s in opposition to expanding Christianity. Along with the British, the newly-formed middle class became a primary patron of the arts after royal and noble patronage collapsed. As a result, single portraits of Guru Nanak were executed for the Sikh urban middle class, some of which likely hung on walls. In portraiture painted during the colonial period, portraying Guru Nanak in a three-quarter face in mass-produced chromolithographs was crucial, and the origin of the images is obviously the paintings of the *Janam-sakhi*s. However, another tradition of the frontal in Guru Nanak portraiture succeeded from the precolonial period, and some frontal works produced in the early twentieth century were likely influenced by European portraiture.

How was portraiture of Guru Nanak disseminated in Sikh society? I have pointed out that the portraiture of Guru Nanak, specifically *Guru Nanak Dressed in an Inscribed Robe* (Figure 5.20), was painted for the newly-formed urban middle class, judging from its elegantly Westernized style and inscriptions in the local language. In the following period, it is assumed that the portraiture of Guru Nanak was disseminated among ordinary Sikhs. This period was likely characterized by mass-produced prints rather than independent artworks, which were produced by printing technology introduced in Lahore in the mid-nineteenth century. *Guru Nanak* (Figure 5.24) is considered the earliest mass-produced portrait in existence. While the path to ordinary Sikhs is unknown, I believe that portraits of Guru Nanak were initially installed in Sikh temples. This is because it was forbidden to hang portraiture of the Sikh Gurus in Sikh temples in the 1930s (Cole and Sambhi 1978: 45). It can be inferred that the portraiture of Guru Nanak was brought into ordinary Sikhs' homes in the 1920s, when the Akali Movement flourished. In contemporary Sikh temples, portraiture of Guru Nanak is sometimes installed in the hall of worship; however, in almost all temples, it is installed in less religious space, such as in a museum or langar hall. Portraiture of Guru Nanak tends to be installed in temples built in diaspora communities rather than Amritsar, where the SGPC carefully monitors the people. The museums in Sikh temples have been extensively examined by Murphy (2012, 2015).

How significant in Sikh society is the diffusion of portraiture of Guru Nanak, which was initially hung on walls during the colonial period? Remarkably, there is a dispute in contemporary academia over Sikh identity. Some scholars regard the union of the Khalsa in 1699 as a milestone in the transformation of Sikh identity, while others claim that colonialism in the late nineteenth century was the most influential milestone. Among the latter group, Oberoi's (1994) study was the most renowned. According to Oberoi, the boundaries of religious communities, such as those of Hindus, Muslims and Sikhs, were far more blurred in late nineteenth-century Punjab than in contemporary South Asia. Oberoi argued that the British administration demarcated the Sikhs and the Hindus via the Singh Sabha Movement in the late nineteenth century [Oberoi's study was criticized by scholars

who highlighted the union of the Khalsa by Gobind Singh in 1699 (Mann, Sodhi and Gill 1995)].

However, Oberoi's view that an inner conflict between the Singh Sabhas formed the modern Sikh identity was recently criticized (Oberoi [1994] designates the group of Amritsar Singh Sabha as Sanatan Sikhs, while he names the group of Lahore Singh Sabha as Tat Khalsa). For example, Pashaura Singh condemned the dichotomized view that the Amritsar Singh Sabha was Hindu-like, while the Lahore Singh Sabha sought Sikh autonomy (Singh 2012; Singh 2014). The Singh Sabha in Basaur was more fundamentalistic than the Lahore Singh Sabha. The Basaur Singh Sabha eliminated the hymns composed by the pagans and claimed that devotees who did not finish formal baptism should be exiled from the Sikh community (Mann 2004). Pashaura Singh concluded that the reason the Lahore Singh Sabha was dominant in thought in the twentieth century was that they were centrists in three Sabhas (Singh 2012; Singh 2014). Likewise, Mandair (2014) maintains that the reason the Lahore Singh Sabha came to be predominant in thought was because of the external factors of colonialism rather than the inner conflict between the Singh Sabhas.

Given the above, Oberoi's study has been criticized. However, I favour his argument that the Sikhs acquired a distinct identity that differed from Hindus during the colonial period. This is because the portraiture of Guru Nanak began to be hung on walls during Sikh revivalism from the 1870s to the 1920s. Like Sikhism, Hindu traditions and thoughts were reformed during the colonial period. While there was a view that idolatry is indeed part of the Hindu identity (Ramos 2015), these idols most likely refer to the statues of gods and goddesses made of stone and metal [In worship towards Krishna in Nathdwara, the painted image of the god is used instead of its sculpted image (Pinny 2004)]. In contrast, the Sikhs came to venerate wall-hung portraiture, namely, pictorial representation (I am using the term 'venerate' rather than 'worship' because Guru Nanak is most likely a prophet who mediates between God and devotees). In short, the art form created boundaries between them. Meanwhile, the portraiture of Guru Nanak differs from an Islamic custom in that the face of the prophet is not painted due to the denial of idolatry. In other words, the Sikhs demarcated themselves from Hindus and Muslims by gaining

wall-hung portraiture of Guru Nanak [apart from South Asian painting, Persian painting has a long tradition of portraiture of Muhammad (Gruber 2009)]. The Sikhs eventually believed that they were neither Hindus nor Muslims, but devotees of the new religion that reformed two sects. This means that Sikhism withdrew from its traditional doctrine that prohibited idolatry and evolved into the religion's modern form. Ramaswamy (2003) states, 'a society becomes truly modern when one of its chief activities is producing and consuming images of the nation' (xv). This claim supports the author's view that portraits of Guru Nanak came to be hung on walls by the urban middle class and be disseminated among people, which resulted in the opening of modern Sikhism.

However, this does not mean that the Singh Sabha Movement eliminated Hindu thought from the Sikh community. This is because the portraiture of Guru Nanak has constantly been painted both in Sikhism's distinct three-quarter face and in Hinduism's idolatrous frontal view. This was underpinned by the fact that Tat Khalsa, aiming for autonomous Sikhism, was becoming dominant in the Singh Sabha Movement, whereas Hinduized Sanatan Sikhs still existed. Figure 5.26, painted in frontal format, looks like a darshanized image of Hinduism in which the sitter opens his eyes. Figure 5.20 is a depiction of Guru Nanak wearing a robe inscribed with text from the Quran. These facts suggest the possibility that there were various and complicated attitudes of devotion opposing the intention of Singh Sabha's leaders, who attempted to demarcate Sikhism from other religions regarding the avoidance and denial of beliefs. Under these circumstances, depicting Guru Nanak in different images in portraiture likely contributed to maintaining Sikhs' cohesion in that the Sikhs, who had different thoughts and beliefs, venerated a common entity of Guru Nanak. In other words, Guru Nanak came to be expected to play a more religious and social role in Sikh society than ever before, which I claim is the reason portraiture of Guru Nanak has been venerated beyond the Sikh doctrine that prohibits idolatry. Since Guru Nanak portraiture is a cultural device that symbolizes the uniqueness of Sikhism and simultaneously includes different positions and views, it is fair to say that Guru Nanak portraiture is an indispensable viewpoint in the study of modern and contemporary Sikhism.

In recent times, there are instances where portraits of the Sikh Gurus generate public concern about contemporary Sikh identity. I would like to highlight an attention to several press articles, in which Guru's portraiture has been criticized as an idolatry; these articles have been published since the 2000s. They include the opinions expressed by Shiromani Gurdwara Parbandhak Committee (SGPC) and the Akali Takht. For instance, *The Times of India* reported on 12 September 2001 that statues of the Gurus were removed from Sikh temples in the State of Punjab, and introduced the scholarly opinion that the SGPC should bring together conventional views regarding the removal of Guru portraiture. In addition to above example, *The Tribune* states on 30 November 2015 that the governor of the Haryana State was photographed next to the statue of Guru Nanak, and Akali Takht condemned for this act. The article also mentions that only paintings of the ten Gurus are allowed to be used for public display or calendars. Likewise, Sikh24.com expresses its opinion that statues of the Gurus violate the Sikh doctrine, and reports that SGPG warned e-commerce sites, such as Amazon and Flipkart, not to sell idols of Guru Nanak. Later, SGPS also undertook several legal proceedings. These debates are not limited to idols and portraits of the Gurus, but also include images on the internet. *Hindustan Times* reported on 5 January 2016 that Akali Takht compared portraiture of the Sikh Gurus on the internet to 'distorted photos', and SGPC requested to remove it from websites. Similarly, this incident was in dispute in *The Tribune* on 6 May 2018.

Furthermore, I will examine the press articles in which SGPC and Akali Takht regard the representations of Gurus as sacred. For example, *Sikh News Network* mentions on 13 October 2013 that United Sikhs, an organization of the Sikhs based out of the United States, accused a bar in Hollywood of displaying portraits of the ten Sikh Gurus as an interior decoration, and requested those portraits be transferred into Sikh *gurdwaras*. *The Tribune* stated on 12 September 2009 that Sotheby's, a renowned auction house originating in the United Kingdom, attempted to sell a portrait of Gobind Singh, the tenth Guru of Sikhism. The SGPC sent a letter of intervention to the UK Prime Minister of that time. Similarly, *One India* reported on 31 March 2008 that Christie's, another renowned auction house,

attempted to sell a portrait of Hari Krishan, the eighth Guru of Sikhism, as Islamic art, while the SGPC demanded that Manmohan Singh, the former Prime Minister of India at the time, stop the transaction. In addition, the *Hindustan Times* announced on 25 December 2017 that the Congress, the ruling party in the Punjab, and the Shiromani Akali Dal (SAD), the Sikh religious party there, argued over the publication of an advertisement by the local government commemorating the 350 years of nativity of the tenth Guru, Gobind Singh. In this portrait, he was portrayed similarly to an equestrian portrait of Napoleon Bonaparte (1769-1821). The Congress claimed that the image of Gobind Singh was published on the website of Sikhism as a public space, and all the pictures and illustrations were a product of the maker's imagination. It is that SAD that should apologise the same, since they politicised the situtation. *The Tribune* reported on 19 July 2022 that portraits of semi-naked women painted in the Ajanta and Ellora caves were installed next to portraits of Guru Nanak and Maharaja Ranjit Singh (1780-1839) in a gallery in Amritsar. The gallery was managed by an organization led by Narendra Modi, the current India's Prime Minister, and a judge of the court is trying to solve the problem. Given the above, it is evident that Guru portraiture is regarded as sacred in Sikh daily life.

According to the previous articles, there are two views; one criticises portraiture of the Sikh Gurus, the other advocates its holiness. Prior to India's independence from the British Empire, the Singh Sabhas discussed the instalment of an idol in *gurudwaras*. For instance, all idols were removed from Harimandir Sahib and other *gurdwaras* in 1905 (McLeod 2009: 97; Oberoi 1994: 320-7; Singh 2006: 160). This implies that the idols were generally installed in Sikh temples prior to 1905 (Mcleod 2009: 97; Jones 1976: 211-12; Oberoi 1994: 323-4). Likewise, SGPC attempted to remove the idols from the Sikh community from 1926 onwards on the basis of Gobind Singh's phrase, 'God is a sacred text', which suggests the possibility that Sikh temples had an idol (Jacobsen and Myrvold 2011: 297-9).

As I have already mentioned, portraiture of the Sikh Gurus was banned in *gurdwaras* in the 1920s (Cole and Sambhi 1978: 45). It is certain that prohibition of idolatry was used for differing the Sikhs from Hindus. However, there is a distinction between past and present

disputes in that the idol changed from Hindu deities to the Sikh Gurus. This is chiefly because Sikh nationalism has been developed depending on their experiences from the separation, and independence and partition of India through the reorganisation of language provinces, namely the Panjabi Suba Movement, to the Sikh separatist movement known as the Khalistan movement. Considering that all articles were written in and after the 2000s, subjugation of the Khalistan movement in the Indian soil and Indian economic liberation, has resulted in its socio-political transformation, combined with the innovation of information technologies, including the diffusion of internet and SNS, which likely culminated in the dispute of representations of the Sikh Gurus.

Regardless of the above causes, it is evident from this research that Guru Nanak's portraiture is a product of British colonialism and Sikh revivalism, which has evolved into an indispensable medium that constitutes a socio-religious tie among the Sikhs. Hanging a portrait of Guru Nanak in *gurudwaras* in recent times on the wall is tacitly permitted. However, the portrait is not allowed to be hung near the sacred text, the *Guru Granth Sahib*. Furthermore, no Sikh visitor worships (*puja*) it in comparison with Hindus. Both the sacred manuscript and a portrait of Guru Nanak are religious authorities in a tangible form; the former is an instrument that mediates an oracle by scripture and the latter represents it more visually.

To sum up, Sikhism was initially based on a media couple, namely, a human Guru and the sacred text. Both shared hegemony in the Sikh community by mediating the Guru's words (*bani*). After that, the sacred text became temporally dominant in the reign of Guru Gobind Singh, the tenth and last human Guru. Today, the sacred text symbolises the holiness in the religious sphere, such as temple and oratory, while the portrait representing Guru Nanak plays the role of medium in the maintenance of the social bond among the Sikhs in the non-religious sphere, such as living-room and commercial store.

Bibliography

Agnihotra, V. K. 2010. *Indian History with Objective Questions and Historical Maps*, Twenty-Sixth Edition. New Delhi: Allied Publishers.
Aijazuddin, F.S. 1977. *Pahari Paintings & Sikh Portraits in the Lahore Museum*. London: Philip Wilson Publishers Ltd.
———. 1979. *Sikh Portraits by European Artists*. London, New York: Sotheby Parke Bernet.
———. 1981. 'Honoured Images: The Use of Portraiture in Sikh Diplomacy'. In *Maharaja Ranjit Singh as Patron of the Arts*, ed. Mulk Raj Anand, 89-94. Bombay: Marg Publications.
———. 1991. *Lahore: Illustrated View of the 19th Century*. Ahmedabad: Mapin Publishing.
Altintzoglou, Evripidis. 2010. 'Dualism and the Critical Language of Portraiture'. Doctoral thesis, University of Wolverhampton.
Aitkin, Molly Emma. 2010. *Intelligence of Tradition in Rajput Court Painting*. New Haven: Yale University Press.
———. 2017. 'Colonial-Period Court Painting and the Case of Bikaner'. *Archives of Asian Art*. 67, no. 1: 25-59.
Anand, Mulk Raj, ed. 1981. *Maharaja Ranjit Singh as Patron of the Arts*. Bombay: Marg Publications.
Ananda, Prakash. 1986. *A History of Tribune*. Chandigarh: Tribune Trust.
Anderson, Benedict. (1964) 1991. *Imagined Communities: Reflections on the Origin and Spread of Nationalism*. London: Verso.
Archer, Mildred. 1972. *Company Drawing in the India Office Library*. London: Her Majesty's Stationery Office.
———. 1992. *Company Painting: Indian Painting of the British Period*. London: Victoria and Albert Museum.
Archer, Mildred and Lightbown Ronald. 1982. *India Observed: India as Viewed by British Artists 1760–1860*. London: Victoria and Albert Museum.

Archer, William George. 1966. *Paintings of the Sikhs*. London: Her Majesty's Stationery Office.

Ashok, S.S. 1974. *Panjab dian Lahiran*. Patiala.

Axel, Brian Keith. 2001. *The Nation's Tortured Body: Violence, Representation, and the Formation of a Sikh 'Diaspora'*. Durham: Duke University Press.

Ballantyne, Tony. 2002. 'Looking Back, Looking Forward: The Historiography of Sikhism'. *New Zealand Journal of Asian Studies*, vol. 4, no. 1: 5-29.

———. 2006. *Between Colonialism and Diaspora: Sikh Cultural Formations in an Imperial World*. Durham: Duke University Press.

———. 2007. *Textures of the Sikh Past: New Historical Perspectives*. New Delhi: Oxford University Press.

Barrier, N.G. and P. Wallace. 1970. *The Punjab Press, 1880–1905*. Michigan: Research Committee on the Punjab.

Beach, Milo Cleveland. 1992. *Mughal and Rajput Painting*. New Cambridge History of India. vol. 1, part 3. Cambridge: Cambridge University Press.

Benjamin, Walter. 1973. 'The Work of Art in the Mechanical Age of Reproduction'. In *Illuminations*, ed. Hannah Ahrendt. London: Fontana.

Bourdieu, Pierre, translated by Richard Nice. 1984. *Distinction: A Social Critique of the Judgement of Taste*. Boston: Harvard University Press.

———, translated by Susan Emanuel. 1996. *The Rules of Art: Genesis and Structure of the Literary Field*. Cambridge: Polity Press.

Branfoot, Crispin, ed. 2012. 'Dynastic Genealogies, Portraiture, and the Place of the Past in Early Modern South India'. *Artibus Asiae*, vol. 72, no. 2: 323-76.

———. 2018. *Portraiture in South Asia since the Mughals: Art, History and Representation*. London: I.B. Tauris.

Brilliant, Richard. 1991. *Portraiture*. London: Reaktion.

Brown, Kerry, ed. 1999. *Sikh Art and Literature*. London: Routledge, in collaboration with the Sikh Foundation.

Brown, Percy. 1917. *Indian Painting*. Calcutta: Association Press.

Chahil, Pritam Singh. 1998. *Sri Guru Granth Sahib: Panjabi Text with English Translation*. Amritsar: Chattar Singh Jiwan Singh.

Cole, W. Owen and Piara Singh Sambhi. 1978. *The Sikhs: Their Religious Beliefs and Practices*. London: Routledge & Kegan Paul.

Coomaraswamy, Ananda K. 1916. *Rajput Painting*. London: Oxford University Press.

———. 1939. 'The Traditional Conception of Ideal Portraiture'. *Journal of the Indian Society of Oriental Art*, vol. VII: 74-82.

Copeman, Jacob. 2009. *Veins of Devotion: Blood Donation and Religious Experience in North India.* New Brunswick: Rutgers University Press.
Coward, Harold G. 2000. *Scripture in the World Religions: A Short Introduction.* Oxford: One World.
Crill, Rosemary. 2010. 'Portraiture at the Rajput Court'. In *The Indian Portrait 1560–1860*, ed. Rosemary Crill and Kapil Jariwala. 33-40. London: National Portrait Gallery.
Crill, Rosemary and Kapil Jariwala, eds. 2010. *The Indian Portrait 1560–1860.* London: National Portrait Gallery.
Dadi, Iftikhar, 2010. *Modernism and the Art of Muslim South Asia*, Chapel Hill: The University of North Carolina Press.
Dalal, Roshen. 2010. *The Religions of India: A Concise Guide to Nine Major Faiths.* London: Penguin Books.
Daljeet. 2009. *Divines and Mortals: Indian Miniature Paintings and Sculptures from the Collection of the National Museum, New Delhi*. Delhi: National Museum.
Dalrymple, William. 2019. *Forgotten Masters: Indian Painting for the East India Company.* London: Philip Wilson Publishers Ltd.
Dalrymple, William and Yuthika Sharma, eds. *Prince and Painters in Mughal Delhi, 1707–1857.* New Haven and London: Yale University Press.
Dane, Lance. 1981. 'Coinage of the Sikh Empire: An Outline' In *Maharaja Ranjit Singh as Patron of the Arts*, ed. Mulk Raj Anand, 13-4. Bombay: Marg Publications.
Dehejia, Vidya. 1997. *Indian Art.* London: Phaidon Press Limited.
Deol, Harnik. 2003. *Religion and Nationalism in India: The Case of the Punjab.* Abingdon, UK: Routledge.
Desai, Vishakha. 1996. 'Portraits in North India'. In *The Dictionary of Art*, ed. Jane Turner, 231-2. New York: Grove.
———. 1994. 'Timeless Symbols: Royal Portraits from Rajasthan, 17th-19th Centuries'. In *The Idea of Rajasthan: Explorations in Regional Identity*, ed. Karen Shomer. New Delhi: Manohar.
Desai, Vishakha and Leidy Denise Patry. 1989. *Faces of Asia: Portraits from the Permanent Collection.* Boston: Museum of Fine Arts.
Dhillon, Gurdarshan Singh. 'Religion and the Specter of the West: Sikhism, India, Postcoloniality, and the Politics of Translation: A Review by Dr. Gurdarshan Singh Dhillon'. Semanticscholar.com. Panjab University, Chandigarh.
Diamond, Debra, ed. 2013. *Yoga: The Art of Transformation.* Washington, DC: Arthur M. Sackler Gallery.
Elias, Jamal J. 2009. 'Islam and the Devotional Image in Pakistan'. In *Islam*

in South Asia in Practice, ed. Barbara D. Metcalf, 120-34. Princeton: Princeton University Press.

Falcon, R.W. 1986. *Handbook on Sikhs for Regimental Officers*. Allahabad: The Pioneer Press.

Fenech, Louis E. 2010. *Woven Masterpieces of Sikh Heritage: The Stylistic Development of the Kashmir Shawl under Maharaja Ranjit Singh 1780–1839*. Woodbridge, Suffolk: Antique Collectors' Club.

Fenech, Louis E. and W. H. McLeod. 2014. *Historical Dictionary of Sikhism*. Lanham: Rowman & Littlefield Publishers.

Flood, Gavin, ed. 2003. *The Blackwell Companion to Hinduism*. Oxford: Blackwell.

Freeland, Cynthia A. 2010. *Portraits and Persons*. Oxford, New York: Oxford University Press.

Gandhi, Surjit Singh. 1993. *Perspectives on Sikh Gurdwaras Legislation*. New Delhi: Atlantic Publishers & Distribution.

Gell, Alfred. 1998. *Art and Agency: An Anthropological Theory*. New York: Oxford University Press.

Gell, Simeran Mann Singh. 1996. 'The Origins of the Sikh "LOOK"'. *History and Anthropology* 10, no. 3: 37-83.

Gonzales, Valerie. 2015. *Aesthetic Hybridity in Mughal Painting, 1526–1658*. Burlington, VT: Ashgate.

Goswamy, B.N. 1968. 'Pahari Painting: The Family as the Basis of Style'. *Marg*, vol. XXI, no. 4: 17-62.

———. 1975. *Painters at the Sikh Court: A Study Based on Twenty Documents*. Wiesbaden: Steiner.

———. 1981. 'A Matter of Taste: Some Notes on the Context of Painting in Sikh Punjab'. In *Maharaja Ranjit Singh as Patron of the Arts*, ed. Mulk Raj Anand. 61-88. Bombay: Marg Publications.

———. 1986. 'Essence and Appearance: Some Notes on Indian Portraiture'. In *Facets of Indian Art*, ed. Robert Skelton, Andrew Topsfield, Susan Stronge and Rosemary Crill, 193-202. London: Victoria and Albert Museum.

———. 1999. *Painters at the Sikh Court: A Study Based on Twenty Documents*. The Expanded Indian Edition. New Delhi: Aryan Books International.

———. 2000. *Piety and Splendour: Sikh Heritage in Art*. New Delhi: National Museum.

Goswamy, B.N. and Eberhard Fischer. 1992. *Pahari Masters: Court Painters of Northern India*. Zurich: Artibus Asiae, reprinted by Oxford India Paperbacks in 1997.

Goswamy, B.N. and Caron Smith. 2006. *I See No Stranger: Early Sikh Art and Devotion*. New York: Rubin Museum of Art.

Greig, Charles. 2008. 'Artists from Afar: Company Painters in the Princely Courts of India 1770-1900'. *Portraits in Princely India. Marg*, vol. 59, no. 4: 16-29.

Grewal, J.S. 1990. *The Sikhs of Punjab*. Cambridge: Cambridge University Press.

———. 1997. *Historical Perspectives on Sikh Identity*. Patiala: Punjabi University.

Gruber, Christiane. 2009. 'Between Logos (*kalima*) and Light (*nur*): Representations of the Prophet Muhammad in Islamic Painting'. *Muqarnas* 26: 229-62.

———. 2016. 'Prophetic Products: Muhammad in Contemporary Iranian Visual Culture'. *Material Culture*, vol. 12, no. 3: 261-93.

Hans, Surjit. 1988. *A Reconstruction of Sikh History from Sikh Literature*. Jalandhar: ABS Publications.

———. 1987. *B-40 Janamsakhi Guru Baba Nanak Paintings*. Amritsar: Guru Nanak Dev University.

Hasrat, Bikrama Jit. 1977. *Life and Times of Ranjit Singh: A Saga of Benevolent Despotism*. Hoshiarpur: V.V. Research Institute Book Agency.

Hassan, Musarrat. 1998. *Painting in the Punjab Plains*. Lahore: Ferozsons.

Honigberger, J. Martin. 1852. *Thirty-Five Years in the East*. London: Bailliere.

Hutton, Deborah. 2006. *Art of the Court of Bijapur*. Indianapolis: Indiana University Press.

Ikeda, Atsushi. 2019a. 'The European Influence on Sikh Portraiture: Representations of Maharaja Ranjit Singh, Sher-e-Punjab (the Lion of the Punjab),' *Chitrolekha Journal on Art and Design*, Murshidabad: Aesthetics Media Services, 3(1), 1-16.

———. 2019b. 'Cultural Negotiation in Early Sikh Imagery: Portraiture of the Sikh Gurus to 1849,' *Sikh Research Journal*, 4(1), 21-44, Palo Alto: The Sikh Foundation International.

———. 2019c. 'Early Sikh Imagery in Janam-sakhi Painting: A Comparison of the B-40, the Guler and the Unbound Set', *Sikh Formations: Religion, Culture, Theory*, 16(3), pp. 244-68.

———. 2022. 'Portraiture of Guru Nanak, the Founder of Sikhism: Colonial Transformation and the Social Role', *Sikh Formations: Religion, Culture, Theory* (https://doi.org/10.1080/17448727.2022.2090793).

———. 2023. 'Portraiture of Guru Nanak, the Founder of Sikhism: Colonial Transformation and the Social Role', *Sikh Formations: Religion, Culture, Theory*, vol. 19, Issue 2.

(池田篤史、2021年、「スィック教創始者グルー・ナーナクの肖像画の成立と展開—植民地期における変容とその社会的役割」、『南アジア研究』、日本南アジア学会)

Jacobsen, Knut A. and Kristina Myrvold. 2011. *Sikhs in Europe: Migration, Identities, and Representations*. Farnham: Ashgate Publishing.

Jariwala, Kapil. 2010. 'Introduction'. In *The Indian Portrait 1560–1860*, ed. Rosemary Crill and Kapil Jariwala, 17-22. London: National Portrait Gallery.

Jones, Kenneth W. 1976. *Arya Dharm: Hindu Consciousness in 19th-century Punjab*. Berkley: University of California Press.

———. 1989. *Socio-religious Reform Movements in British India*. Cambridge: Cambridge University Press.

Kamboj, B.P. 2003. *Early Wall Painting of Garhwal*. New Delhi: Indus Pub. Co.

Kang, Kanwarjit Singh. 1981a. 'Wall paintings under the Sikhs' In *Maharaja Ranjit Singh as Patron of the Arts*, ed. Mulk Raj Anand, 51-60. Bombay: Marg Publications.

———. 1981b. 'Wood Carving'. In *Maharaja Ranjit Singh as Patron of the Arts*, ed. Mulk Raj Anand, 121-4. Bombay: Marg Publications.

———. 1985. *Wall Paintings of Punjab and Haryana*. Delhi: Atma Ram.

———. 2017. 'Visual Strategies of Imperial Self Representation: The Windsor Padshahnama Revisited'. *The Art Bulletin*, vol. 99, no. 3: 93-124.

Kant, Immanuel. 1790. *Critique of Judgement*. Translated by Werner S. Pluhar. Indianapolis: Hackett.

Kapoor, Sukhbir Singh and Mohinder Kaur Kapoor. 2005. *Janam Saakhi Parampara*. Amritsar: B. Chattar Singh Jiwan Singh.

Kaur, Gurdeep and Rohita Sharma. 2016. 'Influence of Sikh Lifestyle on Guler Miniature Paintings'. *Chitrolekha International Magazine on Art and Design*, vol. 6, no. 3.

Kaur, Surjit. 1990. 'Sobha Singh'. Doctoral thesis, Punjab University.

Kessar, Urmi. 2003. 'Twentieth-Century Sikh Painting: The Presence of the Past'. In *New Insights into Sikh Art,* ed. Kavita Singh. 118-33. Marg Publications.

Koch, Ebba. 1997. 'The Hierarchical Principles of Shah-Jahani Painting'. In *King of the World: The Padshahnama – An Imperial Mughal Manuscript from the Royal Library, Windsor Castle*, ed. Milo Cleaveland Beach and Ebba Koch. London: Thames and Hudson, 130-43.

Khalsa, Sant Singh. 2018. *English Translation of Siri Guru Granth Sahib*. Tucson: Hand Made Books.

Khandalavala, Karl. 1958. *Pahari Miniature Painting*. Bombay: New Book Co.

Lafont, Jean-Marie. 2002. *Maharaja Ranjit Singh: Lord of the Five Rivers*. Patiala: Punjabi University.

Lafont, Jean-Marie and Barbara Schmitz. 2002. *After the Great Mughals: Painting in Delhi and the Regional Courts in the 18th and 19th Centuries*. Mumbai: Marg Publications.

Lefevre, Vincent. 2011. *Portraiture in Early India: Between Transience and Eternity*. Leiden: E.J. Brill.

Llewellyn-Jones, Rosie, ed. 2008. *Portraits in Princely India 1700–1947*, vol. 59, no. 4. Mumbai: Marg Publications.

Losty, J.P. 1982. *The Art of the Book in India*. London: British Library.

———. 1990. 'From Three-Quarter to Full Profile in Indian Painting – Revolution in Art and Taste'. *Das Bildnis in der Kunst des Orients*, vol. 50, no. 1: 153-66.

———. 2010. 'Indian Portraiture in the British Period'. In *The Indian Portrait 1560-1860*, ed. Rosemary Crill and Kapil Jariwala. 41-7, London: National Portrait Gallery.

———. 2016a. *A Group of Sikh Miniatures on Ivory*. http://blogs.bl.uk/asian-and-african/2016/02/a-group-of-sikh-miniatures-on-ivory-.html

———. 2016b. 'Ascetics and Yogis in Indian Painting: The Mughal and Deccani Tradition'. https://www.academia.edu/27189427/ascetics_and_yogis_in_indian_painting_the_mughal_and_deccani_tradition

———. 2016c. 'Ascetics and Yogis in Indian Painting'. http://blogs.bl.uk/asian-and-african/2016/08/ascetics-and-yogis-in-indian-painting.html?utm_source=feedburner&utm_medium=email&utm_campaign=Feed%3A+asian-and-african+%28Asia+and+Africa%29.

———. 2016d. 'Ascetics and Yogis in Indian Painting: The Hindu Painting'. https://www.academia.edu/27189370/ascetics_and_yogis_in_indian_painting_the_hindu_tradition.

———. 2016e. *Ascetics and Yogis in Indian Painting: The Colonial Tradition*. https://www.academia.edu/27189298/ascetics_and_yogis_in_indian_painting_the_colonial_tradition.

———. 2016f. *Ascetics and Yogis in Indian Painting: Some British Library Images*. https://www.academia.edu/27783680/ascetics_and_yogis_in_indian_painting_some_british_library_images.

Mann, Jasbir Singh, Surinder Singh Sodhi and Gurbakhsh Singh Gill, eds. 1995, *Invasion of Religious Boundaries: A Critique of Harjot Oberoi's Work*, Vancouver: Canadian Sikh Studies and Teaching Society.

Macauliffe, M.A. 1909. *The Sikh Religion*. vols. 1-6. London: Oxford University Press.
Madan, T.N. 1994. 'Fundamentalism,' *Fundamentalisms Observed*, ed. Martin Marty and R. Scott Appleby, 604-10. Chicago: University of Chicago Press.
Maes, Hans. 2015. 'What is a portrait?' *British Journal of Aesthetics*, vol. 55, no. 3: 303-22.
Mallinson, James. 2013a. 'Yogis in Mughal India'. In *Yoga: The Art of Transformation*, ed. D. Diamond, 68–83. Washington, DC: Arthur M. Sackler Gallery.
——. 2013b. *Yogic Identities: Tradition and Transformation*. http://www.asia.si.edu/research/articles/yogic-identities.asp#bio.
Mandair, Arvind-pal Singh. 2009. *Religion and the Specter of the West: Sikhism, India, Postcoloniality, and the Politics of Translation*. New York: Columbia University Press.
——. 2013. *Sikhism: A Guide for the Perplexed*. London: Bloomsbury Publishing.
Mandair, Navdeep S. 2014. 'Colonial Formations of Sikhism'. In *The Oxford Handbook of Sikh Studies*, ed. Pashaura Singh and Louis Fenech, 70-81. Oxford: Oxford University Press.
Mann, Gurinder Singh. 2004. *Sikhism*. London: Laurence King Publishing Ltd.
McLeod, W. H. 1968. *Guru Nanak and the Sikh Religion*. Oxford: Clarendon Press.
——. 1980a. *Early Sikh Tradition: A Study of the Janam-sakhis*. Oxford: Clarendon Press.
——. 1980b. *The B40 Janam-Sakhi: An English Translation with Introduction and Annotations of the India Office Library Gurmukhi Manuscript Panj. B40, a Janam-Sakhi of Guru Nanak Compiled In A.D.1733 by Daya Ram Abrol*. Amritsar: Guru Nanak Dev University.
——. 1984. *Textual Sources for the Study of Sikhism*. Chicago: The University of Chicago Press.
——. 1989. *Who is a Sikh?: The Problem of Sikh Identity*. Oxford: the Clarendon Press.
——. 1991. *Popular Sikh Art*. New Delhi: Oxford University Press.
——. 2009. *The A to Z of Sikhism*. Metuchen: Scarecrow Press.
McLuhan, Marshall. (1964) 2001. *Understanding Media: The Extension of Man*. London: Routledge.
Mehta, H.R. 1929. *A History of the Growth and Development of Western Education in the Punjab*. Lahore: Languages Department, Punjab.

Metcalf, Barbara D. and Thomas R. Metcalf. 2012. *A Concise History of Modern India*. 3rd Edition. Cambridge: Cambridge University Press.
Meyrowitz, Joshua. 1985. *No Sense of Place: The Impact of Electronic Media on Social Behavior*. Oxford: Oxford University Press.
Mitter, Partha. 1994. 'The Formative Period (*c.* 1856-1900): Sir J. J. School of Art and the Raj'. In *Architecture in Victorian and Edwardian India*, ed. Christopher W. London, 1-14. Bombay: Marg.
_____. 1994. *Art and Nationalism in Colonial India 1850–1922: Occidental Orientations*, Cambridge: Cambridge University Press.
Murphy, Anne. 2015. 'Sikh Museuming'. *Sacred Objects in Secular Spaces: Exhibiting Asian Religions in Museums.* London: The Bloomsbury Publishing Plc.
_____. 2005. 'Materialising Sikh Past'. *Sikh Formations: Religion, Culture, Theory*, vol. 1, no. 2. 175-200.
_____. 2012. *The Materiality of the Past: History and Representation in Sikh Tradition*. Oxford: Oxford University Press.
Myrvold, Kristina. 2016. 'Sketches of Sikhs in the 1880s: The Swedish Vanadis Expedition and Hjamar Stolpe's Ethnographical Collection from Travels in Punjab'. *Sikh Formations: Religion, Culture, Theory*, vol. 12, no. 1. 1-27.
Necipoglu, Gulru. 2000. 'The Serial Portraits of Ottoman Sultans in Comparative Perspective'. In *The Sultan's Portrait: Picturing the House of Osman*, 22-61. Istanbul: Isbank.
Oberoi, Harjot. 1994. *The Construction of Religious Boundaries: Culture, Identity and Diversity in the Sikh Tradition*. Delhi: Oxford University Press.
Ochi, Toshiaki and Noboru Karashima, eds. 2002. Encyclopedia of South Asia (minamiajia wo shirujiten). Tokyo: Heibonsha (辛島昇、応地利明　他編『南アジアを知る辞典』平凡社、2002年)
Okada, Amina. 1992. *Imperial Mughal Painters: Indian Miniatures from the Sixteenth and Seventeenth Centuries*. Paris: Flammarion.
Ohri, Vishwa Chander and Roy, C. Craven, Jr., eds. 1998. *Painters of the Pahari Schools*. Mumbai: Marg Publications.
Onishi, Hiroshi. 1990. 'Portraits Patterned after Images of Famous Buddhist Personages'. In *Shozo-Portraiture*, ed. Shujiro Shimada, 72-87. Kyoto: Kokusai Koryu Bijutsushi Kenkyukai.
Osborne, Robin and Jeremy Tanner, eds. 2007. *Art's Agency and Art History*. Malden, MA: Blackwell Pub.
Panofsky, Erwin. (1939) 1972. *Studies in Iconology: Humanistic Themes in the Art of the Renaissance* . Boulder, Colo: Westview Press.

Parson, Gerald. 2012. *The Growth of Religious Diversity.* vol. 1: *Britain from 1945: Traditions*. London: Routledge.
Paul, Suwarcha. 1985. *Catalogue of Sikh Miniatures in the Chandigarh Museum*. Chandigarh: The Government Press, U.T.
Pinney, Christopher. 2004. *Photos of the Gods: The Printed Image and Political Struggle in India*. Chicago: The University of Chicago Press.
Prill, Susan Elizabeth. 2005. 'The Sant Tradition and Community Formation in the Works of Guru Nanak and Dadu Dayal'. Doctoral thesis. School of Oriental and African Studies, University of London.
Randhawa, M.S. 1971a. 'Paintings of the Sikh Gurus'. *Roop-Lekha*, vol. 39, no. 1: 13-20.
———. 1971b. 'Two Panjabi Artists of the 19th Century: Kehar Singh and Kapur Singh'. In *Chhavi*, vol. 1, ed. Karl Khandalavala. Banares: Bharat Kala Bhavan. 13-20.
———. 2000. *The Sikhs: Images of a Heritage*. New Delhi: Prakash Books.
Said, Edward. 1979. *Orientalism*. New York: Vintage Books.
Sandhu, Manveen. 2007. *Maharaja Ranjit Singh: Personalities Extraordinaire*. Punarjyot.
Sardar, Ziauddin. 1999. *Orientalism*. Buckingham: Open University Press.
Sasaki, Johei. 1990. 'Portraiture and Realism in Later Edo Period Painting'. In *Shozo-Portraiture*, ed. Shujiro Shimada, 101-8. Kyoto: Kokusai Koryu Bijutsushi Kenkyukai.
Schmitz, Barbara, ed. 2010a. *Lahore: Paintings, Murals and Calligraphy*. Marg vol. 61, no. 4. Mumbai: Marg Publications.
———. 2010b. 'Muhammad Bakhsh *Sahhaf* and the illustrated book in Ranjit Singh's Lahore'. In *Lahore: Paintings, Murals and Calligraphy*, ed. Barbara Schmitz, 86-103. *Marg*, vol. 61, no. 4. Mumbai: Marg Publications.
Shahbaz Naeem Khan, Nadhra. 2010a. 'Fresco in Ranjit Singh's Samadhi'. In *Lahore: Paintings, Murals and Calligraphy*, ed. Barbara Schmitz, 72-85. Mumbai: Marg Publications.
———. 2010b. 'Life at the Lahore *darbar*: 1799–1839'. *South Asian Studies: A Research Journal of South Asian Studies*, vol. 25, no. 2: 283-301.
———. 2012. 'Posthumous Homage Paid to Maharaja Ranjit Singh'. *Jamal: A Journal of Aesthetics*, vol. 1, no. 1: 65–74.
———. 2013. 'The Secular Sikh Maharaja and His Muslim Wife: Rani Gul Bahar Begum'. In *Indian Painting: Themes, Histories and Interpretations (Essays in Honour of B.N. Goswamy)*, ed. Mahesh Sharma and Padma Kaimal, 247-54. Ahmedabad: Mapin.

Sharama, Radha. 2007. *Contemporary and Later Perspectives on Maharaja Ranjit Singh*. Amritsar: Guru Nanak Dev University.
Shimada, Shujiro, ed. 1990. *Shozo-Portraiture*. Kyoto: Kokusai Koryu Bijutsushi Kenkyukai.
Sikhi Wiki. 2015a. 'Ranjit Singh'. Accessed 14 December 2015. http://www.sikhiwiki.org/index.php/Maharaja_Ranjit_Singh.
———. 2015b. 'Sher Ali Khan'. Accessed 29 December 2015. https://www.sikhiwiki.org/index.php/Sher_Ali_Khan.
Singh, Attar. 1906. *Bhaundu Sikh Prabodh*. Amritsar.
Singh, D.G. 2002. 'Idolatry is Impermissible in Sikhism'. *Sikh Review*, vol. 50, no. 5.
Singh, Ganda. 1981. 'Lion Victor of Battle: Maharaja Ranjit Singh: A Life Sketch'. In *Mahajara Ranjit Singh as Patron of the Arts*, ed. Mulk Raj Anand. Mumbai: Marg Publications.
Singh, Gopal. 1987. *Sri Guru Granth Sahib*. vols. 1-4. New Delhi: The Gondals Press.
Singh, Gurharpal. 2000. *Ethnic Conflict in India: A Case Study of Punjab*. Basingstoke: Macmillan.
Singh, Gurharpal and Darshan Singh Tatla. 2006. *Sikhs in Britain: The Making of a Community*. London: Zed Books.
Singh, Harbans. 1969. *Guru Nanak and Origins of the Sikh Faith*. Bombay. Asia Publishing House.
———. 1995. *The Encyclopaedia of Sikhism*. vol. 1. Patiala: Punjabi University.
———. 1996. *The Encyclopaedia of Sikhism*. vol. 2. Patiala: Punjabi University.
———. 1997. *The Encyclopaedia of Sikhism*. vol. 3. Patiala: Punjabi University.
———. 1998. *The Encyclopaedia of Sikhism*. vol. 4. Patiala: Punjabi University.
Singh, Harpreet. 2014. '"Western" Writers on the Sikhs'. In *The Oxford Handbook of Sikh Studies*, ed. Pashaura Singh and Louis Fenech, 201-11. Oxford: Oxford University Press.
Singh, Jagjit. (1941) 1973. *Singh Sabha Lahir*. Shimla.
Singh, Kashmir. 2014. 'Shiromani Gurdwara Parbandhak Committee: An Overview'. In *The Oxford Handbook of Sikh Studies*, ed. Pashaura Singh and Louis Fenech. 328-38, Oxford: Oxford University Press.
Singh, Kavita, ed. 2003. *New Insights into Sikh Art*. Mumbai: Marg Publications.
———. 2016. 'The Genesis and Development of Sikh Calendar Art'. *Sikh Research Journal*, vol. 1, no. 6: 1-17.
Singh, Khushwant. 2005. *A History of the Sikhs, Volume 2: 1839–2004*, Second Edition, New Delhi: Oxford University Press.

———. 2006. *The Illustrated History of the Sikhs*. New Delhi: Oxford University Press.

———. 2008. *Ranjit Singh; Maharaja of the Punjab, 1780–1839*. Delhi, London: Penguin India.

Singh, Kirpal. 2004. *Janamsakhi Tradition: An Analytical Study*. Amritsar: Singh Brothers.

Singh, Man Mohan. 1981a. 'Changing Faces of Maharaja Ranjit Singh in Portraiture'. In *Maharaja Ranjit Singh as Patron of the Arts*, ed. Mulk Raj Anand, 95-108. Bombay: Marg Publications.

———. 1981b. 'Maharaja Ranjit Singh's Court: Painters and Painted'. In *Maharaja Ranjit Singh as Patron of the Arts*, ed. Mulk Raj Anand, 109-20. Bombay: Marg Publications.

———. 1981c. 'Medals of Maharaja Ranjit Singh' In *Maharaja Ranjit Singh as Patron of the Arts*, ed. Mulk Raj Anand, 125-30. Bombay: Marg Publications.

Singh, Nahar. 1933. *Khalsa Istri ate Sikh Bibian di Vidya*. Moga.

———. 1955. *Namdhari Itihas*. Delhi.

Singh, Nikky-Guninder Kaur. 2015. 'Visual Phenomenology: Seeing-in Guru Nanak at the Asian Arts Museum'. *Sikh Formations: Religion, Culture, Theory* 11, no. 1-2: 61-82.

Singh, Nikky-Guninder Kaur. 2013. 'Corporeal Metaphysics: Guru Nanak in Early Sikh Art'. *History of Religions* 53, no. 1: 28-65.

———. 2011. *Sikhism: An Introduction*. London: I.B. Tauris.

Singh, Pashaura. 2014. 'An Overview of Sikh History'. In *The Oxford Handbook of Sikh Studies*, ed. Pashaura Singh and Louis Fenech, 19-34. Oxford: Oxford University Press.

Singh, Pashaura and Louis Fenech, eds. 2014. *The Oxford Handbook of Sikh Studies*. Oxford: Oxford University Press.

Singh, Patwant. 1989. *The Golden Temple*. ET Publishing Ltd.

———. 1999. *The Sikhs*. London: John Murray Ltd.

Singh, Ranjit. 2007. *Sikh Ideology, Polity and Social Order: From Guru Nanak to Maharaja*. New Delhi: Manohar.

Singh, Roopinder. 2004. *Guru Nanak: His Life and Teachings*. Kolkata: Rupa & Co.

Singh, Taihal. *Gurmat Riti Anusar Vivah Bidhi*. Lahore.

———. 1908. *Khalsa Rahit Prakas*. Bhasaur.

Skelton, Robert. 2010. 'The Portrait in Early India'. In *The Indian Portrait 1560-1860*, ed. Rosemary Crill and Kapil Jariwala, 17-22. London: National Portrait Gallery.

Smith, David. 2003. *Hinduism and Modernity*. Oxford: Blackwell.

Sohal, Sukh Dev Singh. 2008. *The Making of the Middle Classes in the Punjab (1849-1947)*. Jalandhar: ABS Publication.
Spinicci, Paolo. 2009. 'Portraits: Some Phenomenological Remarks'. Paper presented at *Proceedings of the European Society of Aesthetics*. vol. 1. http://proceedings.eurosa.org/1/spinicci2009.pdf
Srivastava, R.P. 1983. *Punjab Painting: Study in Art and Culture*. New Delhi: Abhinav Publications.
Stronge, Susan, ed. 1999. *The Arts of the Sikh Kingdoms*. London: Victoria and Albert Museum.
Stronge, Susan. 2002. *Painting for the Mughal Emperor: The Art of the Book 1560–1660*. London: V & A Publications.
_____. 2006. 'Maharaja Ranjit Singh and Artistic Patronage at the Sikh Court'. *South Asian Studies*, vol. 22, no. 1: 89-101.
_____. 2010. 'Portraiture at the Mughal Court'. In *The Indian Portrait 1560–1860*, ed. Rosemary Crill and Kapil Jariwala, 23-32. London: National Portrait Gallery.
Syan, Hardip Singh. 2010. 'Peace, Love and War: The Development of Sikh Militancy in the Seventeenth Century'. Doctoral thesis, School of Oriental and African Studies, University of London.
Takhar, Opinderjit Kaur. 2005. *Sikh Identity: An Exploration of Groups among Sikhs*. Burlington, VT: Ashgate Pub.
Talwar, K.S. 1968. 'The Ananda Marriage Act'. *The Panjab Past and Present*. vol. 2
Tambiah, Stanley J. 1997. *Leveling Crowds: Ethnonationalist Conflicts and Collective Violence in South Asia*. Berkley: University of California Press.
Tarar, Nadeem Omar. 2011. 'From "Primitive" Artisans to "Modern" Craftsmen: Colonialism, Culture, and Art Education in the Late Nineteenth-Century Punjab'. *South Asian Studies*, vol. 27, no. 2: 199-219.
_____. 2003. *'Official' Chronicle of Mayo School of Art: Formative Years under J.L. Kipling (1874–94)*. Lahore: National College of Arts.
Taylor, Paul Michael. 2016. 'Sikh Material Heritage and Sikh Social Practice in a Museum-Community Partnership: The Smithsonian's Sikh Heritage Project'. *Sikh Research Journal*, vol. 1, no. 1.
Taylor, Paul Michael and Sonia Dhami, eds. 2017. *Sikh Art from the Kapany Collection*. Palo Alto, CA: The Sikh Foundation.
Thompson, John B. 1995. *The Media and Modernity: A Social Theory of the Media*. Stanford, CA: Stanford University Press.
Tod, James. 1971. *Annals and Antiquities of Rajasthan in the National Gallery of Victoria*. Melbourne: National Gallery of Victoria.

Toor, Davinder. 2018. *In Pursuit of Empire: Treasures from the Toor Collection of Sikh Art*. London: Kashi House.
Uppal, Swinder Singh. 1966. *Panjabi Short Story: Its Origin and Development*. New Delhi: Pushp Prakashan.
Vaid, Mohan Singh. 1908. *Gurmat Virodh Binas*. Amritsar.
West, Shearer. 2004. *Portraiture*. Oxford: Oxford University Press.
Witz, Teresa. 2008. *Portraiture: Femininity and Style*. Doctoral thesis, University of East London.
Woodall, Joanna, ed. 1997. *Portraiture: Facing the Subject*. Manchester: Manchester University Press.
Wright, Elaine J. 2008. *Muraqqa: Imperial Mughal Albums from the Chester Beauty Library, Dublin*. Alexandra, VA: Art Services International.

Index

Adi Granth 25, 26, 42, 43, 45, 48, 61, 64, 71, 74, 80, 171
Ahmad, Mirza Ghulam 75
Aijazuddin, F.S. 32, 34, 35, 261
Akali Movement 254
Akalis 32
Akali Takht 209, 257
Akbar 157
Amritsar 25, 29, 34, 36, 37, 38, 41, 42, 46, 50, 210, 212, 254, 255, 258, 262, 265, 266, 268, 271, 272, 274
Amritsar Singh Sabha 74, 77
Anjuman-i-Punjab 68, 73
Archer, W.G. 30, 31, 33, 37, 40, 261, 262
Arya Samaj 70, 72, 75, 76
Auckland, Lord 36
B-40 Janamsakhi Guru Baba Nanak Paintings 37, 38, 49, 54, 56, 80, 81, 82, 83, 85, 86, 87, 89, 91, 92, 93, 94, 96, 97, 102, 104, 105, 106, 107, 108, 111, 265

Balak Singh 31
Basaur Singh Sabha 255
Bedi, Baba Khem Singh 73
Bhai Bala 31, 33, 38, 51, 80, 99, 105, 108, 109, 111, 123, 124, 127, 132, 136, 140, 147, 227, 228, 229, 230, 231, 232, 233, 234, 235, 237, 238, 239, 241, 242
Bhai Mardana 33, 51, 61, 83, 84, 85, 86, 87, 88, 91, 92, 93, 95, 96, 99, 102, 104, 105, 111, 117, 118, 120, 122, 124, 125, 126, 127, 130, 131, 133, 134, 136, 138, 139, 140, 141, 142, 143, 147, 152, 227, 228, 229, 230, 231, 232, 233, 234, 235, 236, 237, 238, 239, 240, 242
Blue Star Operation 59
Brahmo Samaj 69, 71
British East India Company 50, 60, 68, 217, 253
British Library 80, 81
British Museum 122
British: annexation of the Punjab 81; army 69; Empire 60; Parliament 68; Punjab 50, 218; Raj 40, 45; territories 54

Chandigarh 25, 29, 31, 41, 59, 81, 97, 100, 101, 103, 104, 117, 118, 119, 125, 129, 132, 135, 138, 149, 160, 163, 167, 172, 173, 179, 181, 183, 184, 186, 203, 213, 227, 229, 230, 231, 234, 235, 236, 238, 239, 240, 241, 244, 245, 261, 263, 270
Chief Khalsa Diwan 72, 76

Index

Christian 28, 30, 54, 55, 67, 68, 69, 71, 72, 75, 76, 77, 157, 253, 265
Chughtai, Abdul Rahman 219
colonial 28, 38, 39, 55, 56, 60, 66, 68, 69, 73, 77, 114, 152, 156, 219, 220, 242, 250, 251, 253, 254, 255, 259, 263, 267, 268
Company Painting 31, 217, 222, 224, 225

Darbar Sahib 26, 59, 64, 76, 209

Eden, Emily 34, 35

Gandhi, Indira 59
Golden Temple 36, 46, 210, 212, 272
Goswamy, B.N. 29, 31, 32, 33, 34, 37, 40, 41, 44, 46, 49, 55, 81, 90, 97, 98, 100, 101, 102, 104, 105, 106, 107, 108, 112, 113, 119, 120, 124, 125, 130, 131, 132, 133, 137, 141, 146, 147, 149, 151, 152, 158, 159, 166, 167, 172, 176, 177, 179, 180, 181, 186, 195, 198, 201, 202, 203, 205, 207, 210, 212, 213, 227, 236, 237, 242, 264, 265, 270
Government Museum and Art Gallery 41
Guler 30, 35, 37, 41, 46, 54, 55, 56, 81, 97, 98, 99, 100, 101, 102, 103, 104, 105, 106, 107, 108, 111, 128, 129, 167, 168, 191, 203, 205, 207, 210, 215, 265, 266
gurdwara 25, 45, 62, 68, 76, 257, 258

Guru Amar Das 55, 162, 163, 164
Guru Angad 55, 56, 109, 160, 161
Guru Arjan 26, 42, 55, 171, 172, 173, 174
Guru Gobind Singh 25, 26, 31, 33, 45, 49, 55, 56, 60, 62, 63, 64, 76, 82, 113, 119, 123, 124, 128, 134, 135, 136, 146, 159, 160, 175, 194, 198, 199, 200, 201, 202, 203, 204, 205, 206, 207, 208, 209, 210, 211, 212, 213, 214, 217, 221, 222, 223, 224, 225, 226, 255, 257, 258, 259
Guru Granth Sahib 26, 42, 48, 49, 51, 64, 144, 145, 171, 194, 259, 262, 266, 271
Guru Har Krishan 55, 56, 189, 191, 192, 193
Guru Har Rai 55, 56, 114, 115, 186, 188
Guru Hargobind 42, 43, 49, 55, 56, 176, 177, 178, 179, 180, 181, 184
Guru Nanak 25, 26, 27, 28, 29, 30, 33, 37, 38, 40, 41, 45, 46, 48, 49, 50, 51, 53, 54, 55, 56, 57, 60, 61, 62, 64, 75, 76, 77, 78, 79, 80, 81, 83, 84, 85, 86, 87, 88, 89, 90, 91, 92, 93, 94, 95, 96, 97, 98, 99, 100, 101, 104, 105, 106, 107, 108, 109, 110, 111, 112, 113, 114, 115, 116, 117, 118, 119, 120, 121, 122, 123, 124, 125, 126, 127, 128, 129, 130, 131, 132, 133, 134, 135, 136, 137, 138, 139, 140, 141, 142, 143, 144, 145, 146, 147, 148, 149, 150, 151, 152, 153, 154, 155, 156, 157,

Index

159, 161, 164, 165, 198, 199, 205, 206, 216, 220, 221, 227, 228, 229, 230, 231, 232, 233, 234, 235, 236, 237, 238, 239, 240, 241, 242, 243, 244, 245, 246, 247, 248, 249, 250, 251, 253, 254, 255, 256, 257, 258, 259, 265, 268, 270, 271, 272
Guru Ram Das 43, 55, 166, 167, 168, 170
Guru Tegh Bahadur 26, 55, 56, 195, 196, 197

Harmandir Sahib 43, 46
Hindu 26, 27, 28, 30, 31, 34, 40, 43, 44, 45, 47, 49, 50, 51, 55, 56, 218, 253, 254, 255, 256, 257, 258, 259, 264, 266, 267, 272

idol 26, 27, 28, 33, 50, 51, 53, 55, 61, 68, 69, 70, 77, 112, 113, 246, 253, 255, 256, 257, 258, 259
idolatry 26, 27, 28, 33, 50, 51, 61, 69, 70, 77, 112, 113, 246, 253, 255, 256, 257, 258
intellectuals 28, 68, 70
Islam 28, 50, 51, 60, 61, 72, 75, 95, 112, 156, 253, 255, 258, 263, 265

Jahangir 40, 47, 63, 157, 175
*Janam-sakhi*s, 33, 37, 38, 46, 49, 50, 54, 55, 56, 60, 78, 79, 80, 81, 83, 85, 86, 87, 89, 90, 91, 92, 93, 94, 96, 97, 98, 100, 101, 102, 103, 104, 105, 107, 108, 109, 110, 111, 114, 130, 220, 253, 265, 268

Jindan, Rani 32, 66

Kabir (saint) 26, 61, 74, 79, 95, 111, 150
Kang 30, 33, 35, 36, 37, 39, 42, 98, 108, 146, 147, 159, 172, 179, 266
Kangra 30, 35, 98, 108, 146, 147, 159, 172, 179
Khalistan 59, 259
Khalsa 27, 28, 30, 39, 60, 63, 64, 65, 68, 71, 72, 73, 74, 75, 76, 82, 97, 223, 225, 226, 254, 255, 256, 266, 272

Lafont, Jean-Marie 41, 42, 139, 161, 164, 170, 174, 183, 188, 193, 197, 208, 267
Lahore 28, 29, 31, 32, 33, 34, 35, 36, 37, 39, 40, 41, 42, 45, 46, 47, 48, 60, 63, 64, 66, 67, 68, 69, 70, 71, 72, 73, 74, 75, 77, 81, 82, 105, 106, 111, 128, 139, 155, 156, 170, 174, 188, 197, 208, 217, 219, 220, 243, 244, 245, 247, 249, 254, 255, 261, 265, 268, 270, 272, 273
Lahore Museum 28, 46, 47, 128, 220, 247, 249
Lahore Singh Sabha 73, 74, 77, 255
Lahori, Imam Bakhsh 41, 42, 47, 139, 155, 156, 161, 164, 170, 174, 183, 188, 193, 197, 208, 219

Maharaja Ranjit Singh 31, 32, 33, 34, 35, 36, 37, 40, 41, 42, 46, 47, 48, 50, 51, 54, 56, 64, 139, 159, 164, 170, 174, 183, 188,

193, 197, 208, 258, 261, 263, 264, 265, 266, 267, 270, 271, 272, 273
Majithia, Dyal Singh 67, 70, 71
Mayo School of Arts 36, 39, 273, 218, 219
McLeod, W.H. 38, 39, 77, 78, 79, 80, 81, 82, 95, 97, 103, 105, 108, 246, 258, 264, 268
Mughal 26, 32, 34, 38, 39, 40, 42, 46, 47, 50, 55, 60, 63, 64, 69, 82, 108, 111, 112, 113, 114, 151, 152, 157, 158, 159, 175, 198, 213, 216, 227, 246, 262, 263, 264, 266, 267, 268, 269, 273, 274
Muslim 26, 32, 40, 41, 42, 43, 48, 49, 50, 55, 61, 62, 65, 66, 68, 69, 72, 75, 76, 97, 99, 101, 102, 111, 114, 116, 120, 123, 132, 140, 151, 198, 228, 231, 237, 239, 242, 245, 254, 255, 256, 263, 270

Nadir Shah 63, 103
Nainsukh 31, 37, 41, 44, 55, 97, 98, 100, 101, 102, 103, 128, 129, 130, 167, 168, 178, 186, 190, 191, 203, 204, 205, 207, 210
Namdhari 31, 272
National College of Arts 219
Nehru, Jawaharlal 59

Pahari 18, 31, 36, 37, 38, 39, 40, 42, 43, 44, 47, 51, 55, 261, 264, 267, 269
Panjab 25, 31, 37, 40, 42, 259, 262, 263, 270, 273, 274

Panofsky, Erwin 51, 52, 269
Punjab 25, 26, 27, 28, 30, 31, 32, 33, 35, 36, 37, 38, 39, 40, 41, 42, 43, 45, 46, 49, 51, 54, 55, 56, 71, 218, 253, 254, 257, 258, 262, 263, 264, 265, 266, 267, 268, 269, 271, 272, 273

Ram Singh 31
Randhawa, M.S. 31, 46, 50, 270

Schmitz, Barbara 41, 42, 46, 47, 139, 267, 270
Schoefft, August 32, 35
Shah Jahan 40, 47, 157, 175
Sharif, Muhammad 41, 44, 45, 47, 50, 51, 71, 75, 112, 201, 256, 265, 270
Sher Mohammad 217
Shiromani Gurdwara Parbandhak Committee (SGPC) 59, 60, 76, 254, 257, 258, 271
Shish Mahal 37
Sikh-British treaty 64
Sikhism 25, 28, 30, 33, 40, 43, 47, 50, 51, 54, 57, 59, 60, 61, 62, 68, 75, 76, 77, 113, 156, 165, 171, 175, 183, 194, 218, 220, 255, 256, 257, 258, 259, 262, 263, 264, 265, 268, 271, 272
Singh, Bikram 73, 74, 75
Singh, Dalip 32, 44
Singh, Kapur 31, 41, 219, 270
Singh, Kavita 42, 43, 266
Singh, Kehar 31, 37, 41, 270
Singh, Nikky-Guninder Kaur 40, 48, 49
Singh, Sher 31, 51

Singh, Thakur 72, 73, 74
Singh Sabha Movement 28, 38, 54, 67, 70, 72, 73, 74, 75, 76, 77, 218, 246, 253, 254, 255, 256, 258, 271
Srivastava, R.P. 36, 37, 39, 206, 232, 273
Stronge, Susan 39, 46, 264

Sufis 26, 61, 156

Ullah, Bashart 41
Unbound set 46, 49, 55, 81, 105, 106, 107, 108, 109, 110, 111

Victoria and Albert Museum 31, 38, 261, 264, 273

Printed in the United States
by Baker & Taylor Publisher Services